TOMMY'S WAR:
July, 1914

Tom East

Tom East

Benybont Books

https://www.benybont.org/
First published 2019
Copyright © Tom East, 2019
All rights reserved

ISBN **978-1-9164942-6-8**

To Suki, Joseph, Edmund, Ping and Annabella

Tom East

ACKNOWLEDGEMENTS
I am grateful to JOYCE JAMES and JD HUMPHREYS, plus members of the former 05 Group (then JEAN BARRACLOUGH, JAN DAVIES, PAT FORSTER, ROWLAND HUGHES, CAROL JONES and DOMINIQUE SPEAREY) for their comments and suggestions on the text.

Tommy's War:

July, 1914

Introduction

This remarkable record, if record it is, was found in June, 2020, during a routine clearance of the archives of the psychiatric wing of a West London hospital. It was written in pencil in two tightly-inscribed (though entirely legible) blank foolscap notebooks produced for the Coronation of King Edward VII in 1902. The notebooks were part of the contents of a box file marked "Miscellaneous Patients' Documents, 1915-1924".

No major editing of the text was needed for this book, except for the correction of wildly misspelt French words.

Slipped in between the pages of one of the notebooks was a used ticket for a cross-channel ferry, dated 27th July, 1914. No other related papers have been found. Nor was there an index or other record concerning these or any of the papers stored with them (the others are unrelated). The admission and discharge books from the hospital for the period under investigation are incomplete.

For the present, what has been written is being regarded seriously, and not as a modern forgery. Detailed investigations are continuing. One aspect of this research concerns careful checks against available external records of the people named and events recorded. As far as can be ascertained at present, there is close correspondence between the two.

Some of the people named, like Queen Victoria and Charlie Chaplin are very well known. However some of the events recorded for both are not noted elsewhere and these are a particular focus of interest. Similarly, the background events of July, 1914 are widely known from history. What may be termed the 'foreground events' noted in this record are unknown.

Most of the people named who are not known to history do appear in public records. For example, John Jakes

is recorded as missing in action in Flanders during 1917; Archibald Montmorency Perkin did die of war injuries in 1919; Roger Arthur and Theresa Elizabeth Hartson were victims of the influenza epidemic in 1918. Even the shopkeeper Marcel Tresor appears in a number of French census and taxation records.

One puzzling feature is that there is no certain record of Thomas Percival Green after he volunteered for military service in August, 1914. Nor is there any unequivocal record of Mazod Betham in public records after her birth in Greenford. None of their descendants, as named in the text, can be traced. Various possible reasons as to why this should be so form an important part of the current investigations.

Tom East

Wednesday, 1ˢᵗ July, 1914

She smiled at me. Yesterday, she smiled at me!

Mazod Betham was wearing a simple yellow dress. In place of a formal bonnet she wore a jaunty straw hat, exactly as if she were an ordinary village girl. She held no parasol to protect her head.

I'd said, as would be expected, 'Good Morning, Miss Betham', and doffed my hat. I'd expected nothing more in return than the normal courtesy of an inclination of her head. Instead, she said, quite naturally, 'Good Morning Mr Green. How are you today?' She'd never spoken to me before.

'*How are you today?*' It was all I could do to stammer, '*Very well, thank you, Miss Betham.*' I was so surprised I didn't have the sense to enquire after her own health.

I swear her greeting was no mere courtesy of neighbours. My home was above my poor craft-shop; hers was at Greenford Green in the grand Betham House. She lived there with her uncle and aunt. Mazod Betham, as everyone in the village knew, was the sole descendant of the family of none other than Edward Betham.

But Mazod had smiled at me!

*

This morning, I felt like a king. The top of Horsington Hill was the one jewel in my small world. On summer mornings like this I enjoyed looking down upon what I vainly pretended was my Royal Domain The pin-sharp clarity of the early light revealed every detail of Perivale's fields. Further to the south, the small towns of Hanwell and Ealing looked like children's toys. To the east, it was easy to make out Hampstead, silhouetted on its own hill against the

morning sky. Far to the south-east lay the smudge of London itself.

Among the smoking chimneys of the City was where I'd spent a happy if hectic six months. Seven years have passed since then, but it may as well have been seven centuries. Working in London was the only time in my life I'd felt truly alive. Now, all too often, my gaze was drawn to the south-west and to the claustrophobic place of my birth, Greenford. I could never escape it.

This wasn't because I didn't like the village. There were many things in its favour. Perhaps it was simply that from this hilltop, I could too readily make out the path of the Old Field Lane, and be reminded of the brass plate on the wall next to my shop door. All too soon this would be calling me back to duty: 'Thos. Green & Son, High Class Calligrapher and Engraver'.

My name was Thomas Green right enough; Thomas Percival Green in full. I preferred "Tommy" and did my best to ignore the "Percival". It wasn't my name on the shiny plate. The Thomas Green named was my grandfather. The '& Son' referred to my father, Arthur. As for myself, I had no son, nor even a wife. There was small prospect of me having either.

'I wondered when you were going to notice me.'

I started.

He was standing a few feet to my left. How on Earth had he made it up the open hill without me catching even a glimpse of him?

I took in his appearance: round-faced, bluish eyes twinkling from beneath a mop of hair verging on auburn. He wore a fashionable dark blue suit, very expensively cut. His brown boots were polished to a degree of shine I'd have thought impossible. From his right hand he carelessly swung a brown Homburg. The finishing touch to his dapper

appearance was supplied by an ornate gold ring looking as if belonged to some past age. The ring glinted in the sun. His whole appearance was of someone ridiculously over-dressed for a morning stroll. Then I realised I was looking at no stranger.

'You!' I said.

'You're right; it's me. Do you remember the last time we met?'

'It was in London,' I answered. 'Shortly before I left my job with the newspaper. I was trying to sketch those Russian anarchists. The people in Fulborne Street had recognised one of their faces. Everyone was straining for a look. You picked up my pencil when the crowds jostled it from my hand. Then you disappeared. I didn't have time to thank you.'

'I couldn't stay long,' he said, as if this were enough of an explanation.

'I'd seen you three times earlier,' I said. 'Years before. The last occasion was shortly before my seventeenth birthday. You tipped your hat to me in the village. Then there was that day when I was a boy. I thought it grand when you held my coat so I could climb the big oak tree near the Rectory Cottage. I was furious when I clambered down to find my best Sunday jacket swinging from a branch. There was no sign of you. Let's see; I could have been no more than twelve then, perhaps less. I was still going to school, I remember that much. The first time I saw you was when I was only nine or ten: you winked at me as you walked past my father's shop in the Old Field Lane.'

'Well done,' he said. 'You've got a good memory. It should make things easier for us. There was one earlier occasion. You were very young then; a kid of no more than five or six. My father insisted on an early imprinting. Your memories show me how right he was.'

'I'm sorry. I haven't got the faintest idea of what you're talking about with your "*easier for us*" and "*imprinting*". I've got to go down the hill to open my shop. So, if you wouldn't mind...'

He laughed. The man threw back his head and laughed at me.

'Look here!' I said. I didn't care to share my early-morning domain with anyone, least of all with someone whose very appearance unsettled me.

'I'm sorry,' he said quickly. He could see he was annoying me. 'I didn't mean to offend you,' he continued, more soberly now. 'But with all the things about to happen in your life – and to the whole world – you won't be worried about "Thos. Green & Son, High Class Calligrapher and Engraver" for much longer.'

He spoke as if he were reading from the brass plate before him.

'You know about my shop?'

'You'll find I know a great deal about you.'

Who was this man? And why did he look today exactly – *exactly* – mind you, as he did years ago? I judged him to be a few years younger than myself - about twenty-five, say. This was the same age I'd have put him at all those years before. What was going on?

'Are you from Hanwell?' I asked him.

He laughed again, though more quietly than before. 'You know I'm not. Am I dressed like an escaped inmate of the London County Asylum? Look, you and I have some serious discussions ahead of us. Then we have important work to do.'

'And afterwards you're going to disappear again, are you? As you did when I saw you before?'

'No, I'm not going anywhere for a while. I do have to leave in twenty minutes or so, but I'll be back here tomorrow. So, let's start our discussion off on the right foot, shall we? Why don't we begin with proper introductions so we can get to know each other properly?'

'I thought you said you already knew all about me? It's you who needs to do some explaining.'

'Fair enough. It's true I know your formal biography. Your name is Thomas Percival Green. You were born on the thirtieth of January, 1885 in the village of Greenford. You're the only son of Arthur Green. He was born in May 1856 and died in July, 1907. And your grandfather was also a Thomas Green, born in July, 1819. It was your grandfather who-'

'Stop!' I shouted.

I was flabbergasted. I couldn't myself have named the month and year of my grandfather's birth. To me, he was nothing more than a shadow of memory from childhood; an old man sitting in a chair in the corner, with the smell of strong tobacco clinging to the corduroy trousers and jacket he wore. I don't recall him saying more than a few words.

'All right. You've made your point.' I said this quietly, trying to maintain a veneer of calmness. 'Suppose you tell me who you are?'

'I'm Jet – call me that for now. My father is named Ollie and my grandfather is called Wayne.'

'Wain? Nobody would dream of naming their son after a wagon. The authorities wouldn't allow such a thing. Sorry, you've picked the wrong man for your odd jest, whatever it might be. You'd better go.'

Equally, I could have said no sane person would use the word for a semi-precious black stone as a Christian name for a boy. As for 'Ollie', this wasn't even a proper word. I

was convinced the young man was taking a rise out of me. Yet he'd been speaking so matter-of-factly.

He looked alarmed. 'I'm sorry. This is going wrong. I spoke without thinking. Look - let me tell you your wife's name will be Mazod Betham. The twin sons you'll have together in 1921 will be named Bertie and Trevor. In 1928 the two of you'll have a daughter. You'll decide to call her Mary, after...'

'That's a pretty tumble of information. And all of it is rank nonsense. Why, how clever you must think you are.' I tried to fix him with a look of contempt, but inside I was alarmed and confused.

Not wanting to give him the chance to say anything further, I rose without another word and stalked off westwards down the hill, trying to maintain some sort of dignity. I didn't cast a glance backwards. To be honest, I was frightened. How could this man know so much about my family? Why should he be privy to my innermost hopes and dreams? Most of all, how did he know about Mazod Betham and my idle thoughts about her? She wasn't for the likes of me.

*

Now I didn't know whether to be more annoyed with the stranger - this man who claimed the ridiculous name of "Jet" – or myself for allowing him to harry me from my customary early-morning seat. I still had my usual mid-week breakfast of bread and cheese, unopened in its wrapping of newspaper in my jacket pocket. A new packet of Wills' cigarettes bulged the other one. These I'd bought from Raven's shop in the village only yesterday; I'd been looking forward to smoking one.

The only person to whom I'd dared give a hint of my feelings for Mazod Betham had been my friend John Jakes, the blacksmith. I could be sure John would have kept this

confidence to himself. I knew I hadn't shared any dream of "Bertie" and "Trevor" with anyone. As for them being *twin* sons with a sister named "Mary", this thought hadn't so much as entered my head, let alone left my lips.

When I'd walked half-way down the hill, I couldn't resist glancing back towards the spot where we'd met. Somehow, I wasn't surprised to see no-one. Was I suffering from lack of sleep? Was I the one who should be in Hanwell?

*

My head reeled as I reached ground level near the Grand Junction Canal. Breakfastless and disorientated, I hadn't given a thought to which way I'd be walking home. I decided to return by the quickest route; over the Black Horse Bridge at Greenford Green. Sitting on the canal towpath near the bridge, I'd have plenty of time for my bread-and-cheese. Whether I'd also have sufficient time to collect my scattered wits was another matter.

In my haste I'd come too far to the south to follow the footpath, so thought to cut straight across the hayfields. There was a light wind riffling the stalks of hay, like the waves of the sea I'd only read about in books. The stems were already growing high and I could see the seed-heads could be no more than two or three weeks from maturity. Soon these fields would be alive with the activity of the Hornsby threshing machines going about their July task.

When I was a boy, my father would often take me rambling across these fields. He would talk nostalgically about the days of his own youth, when the work of harvesting was done by men with scythes in their hands. Italian labourers would do most of the gathering. They'd sleep in barns before going back to their homes after a fortnight.

They'd return to Italy with no more than a pound or two in their pockets. 'It was a paid holiday for them,' my father liked to say. To me, it sounded like hard work. As for

my father, he'd never touched a blade of hay in his life. Stuck in the past, he was. This was the reason I was here in Greenford now, rather than London.

*

As I approached the Black Horse Bridge I could see the fat-rendering works, newly-opened on the Perkin Dye Works site, was already in foul-smelling full swing. My breakfast plans would have to change. I was annoyed, and barely remembered to acknowledge the cheery morning wave given by the bargee from the Northolt tile works as his boat glided down the canal behind a plodding horse on the towpath. Today, he had a cargo of bricks on his narrow boat. He'd be on his way to Paddington.

So anxious was I to escape the stench that, almost before I could realise it, Holy Cross Church came into view along the Old Field lane. It wouldn't do for me to be seen opening my breakfast-pack so close to home – someone from the village might have spied me eating at the side of the road like a tramp. I pressed on toward my shop. I was hardly in the best of tempers: I'd had my plans foiled by firstly the upsetting encounter with the peculiar man on Horsington Hill, and then by the stomach-churning smell made by the earlier-than-usual start at Smith's works.

Then I started thinking about meeting Mazod Betham yesterday and what the odd round-faced man had said to me this morning.

The trials of the morning fell away with the thoughts my mind conjured. As soon as I reached home, I swallowed my sandwich in three bites and changed into my shop clothes more quickly than was my habit. I was ready to open the shop before nine o'clock.

This was the earliest I'd unlocked the street door on any fine summer's day I could remember, even though nobody in the village would be expecting me to put up the

"open" sign before ten o'clock. Even then, I'd be lucky to see one or two customers for the rest of the morning. My existence was so dull. But I had the feeling that my life was going to change.

Thursday, 2nd July, 1914

In the early hours, I lay awake thinking of all that had happened on Horsington Hill. Most of all, I thought about Mazod Betham.

At the end of the eighteenth century, well over a hundred years ago, it had been Edward Betham, the most admired Rector in the history of this Parish, who'd founded the first school in the village. This I'd attended with John Jakes and other local children.

It wasn't in the original structure I'd done my schooling. By the time I was a pupil, Betham had become one of our Nation's Elementary Schools. The new building had gone up in the Rickyard Field a few years before I was born. But everyone knew this was still the old school. People always referred to it as the Betham School; at least they did when they weren't calling it 'The Clock School'. Mazod Betham had never been one of its pupils; she'd have had a governess like other daughters of the gentry. There were more than a few such families in the big houses around the village.

I lay awake for a long time. At some point I must have drifted off because the next thing I knew, the music of a strange orchestra was invading my dreams. Only as I became properly awake did I realise what I was hearing was no more than the gush of water pouring from the leaking downpipe against my outside wall. Today, there'd be every chance of the River Brent bursting its banks again.

Any thought of a morning climb of Horsington Hill on a day like this would be foolish, however much I wanted to speak to Jet. All through yesterday, I'd thought of little but his words: '*Your wife's name will be Mazod Betham and your twin sons will be called Bertie and Trevor. In 1929*

you'll have a daughter, Mary'. And yesterday Mazod had smiled at me...

Giving someone a friendly smile and becoming his wife and the mother of his children are worlds apart, especially when you're a daughter of the gentry and the man concerned is someone so much your social inferior. Yet I had to talk again to this infuriating, round-faced man. I had to try to find out more about his pronouncement.

Although I'd suffered a restless night, my attempts at further sleep proved to be fruitless. Every time I closed my eyes I saw the self-satisfied face, the auburn-tinted hair, the expensive blue suit and the polished brown boots. I knew the only way to make this teasing image fade was going to be to rouse myself from bed.

*

I was not in any humour to spend a couple of hours in idleness. Nor this morning was I in any mood to read. Reading was the usual way I frittered away my time; lately I'd had many hours to waste. My business was becoming more and more erratic. Even the poorest farm-labourers would be looking forward to a bounty of sorts at haymaking time. What did I have ahead of me, except for the wild hope planted in my mind by Jet? And this could be no more than a fantastic joke.

Then I remembered the partially read newspaper I'd bought on Monday morning. I'd crammed it onto the shelf behind the counter when a customer – the only one I'd seen so far this week – had walked into the shop. I'd been looking forward to reading the story behind the dramatic front page. The headline had caught my attention in Raven's shop and I'd paid a penny. Even this wasn't a sum I could afford to spend casually.

The newspaper I always bought was *The Daily Mirror*. I chose this mainly because it reminded me of the

one for which I'd worked in my brief career as a London journalist, *The Independent Record*. Sadly, the owner of the *Record* could never make up his mind whether he wanted to publish a popular paper like the *Mirror*, or to put his name and inadequate fund of money to something with loftier pretensions. He was always vacillating between the two extremes. It came as no surprise to anyone in the business when the *Record* closed its doors for the last time a few years after I'd left. By then, it had been in print for no more than eight or nine years.

My own career in the newspaper business was already history by that time. In the late June of 1907, I came home to Greenford because of my father's illness. If only I'd had the courage of my convictions to go back to London after he'd died. Now I was no more than a small-time craftsman in a village backwater.

The lead story in Monday's paper was dramatic. There were pictures of two murdered Royals in Central Europe below the headline, '*Heir to the Austrian throne and his wife shot dead in street at Sarajevo after bomb had failed*'. On page three the story continued with '*Austrian Heir Assassinated*'. The sub-heads said more: '*Archduke Francis Ferdinand and his wife shot dead in street*'; '*Bombs and bullets*'; '*Duchess mortally wounded in trying to shield husband*'; '*Bosnian crowd attempts lynching of student*'. The reporter made much of the brave part in the drama played by the Archduke's morganatic wife, the Duchess of Hohenburg. Where the realm of Hohenburg might be, I had no idea.

On the same page was a picture of the new Archduke, Karl Franz Joseph, with his wife, the former Princess Zita of Bourbon. Uncharitably, I found myself thinking, 'well, they've got a replacement already'. Immediately I became ashamed of this idle thought, realising the murder would probably lead to yet another Balkan War in which as many as fifty thousand soldiers might die.

Then, again on the same page, I saw there'd been another railway crash at Cannon Street Bridge. It seemed the driver of the Hastings train had been distracted by something. There was plenty of scope for distraction on that busy part of the line. A train crash at Cannon Street, like this in all respects, was the last story I'd covered for *The Independent Record*. Some things never change. Or perhaps they do: in 1907 I was covering the story as a keen young reporter. Now, seven years later almost to the day, all I was doing was reading a similar one.

*

Once again I opened the shop before nine o'clock. Five minutes later my first customer of the day – the first I'd seen since Monday – came through the inner door. At least, I thought it was a customer, especially when I saw the good-humoured face of Henry Trevithick. He'd ordered liberally from me in the past. I allowed myself to picture the morsel of bacon in my larder being joined by a larger piece with less fat on it, some eggs, suet pudding, and – joy of joys – even a small piece of beef. My spirits lifted and there was no pretence in my welcome.

'Mr Trevithick, Sir. How pleasant to see you! What can I do for you today?'

'Ah, Green. Today it's not what you can do for me, but what I can do for you.'

'I see,' was all I could manage. The suet pudding and joint of beef flew out of my mental pantry.

'Now, how long have you been running this shop? Tell me if you would.'

'It's been open since my Grandfather's time, Sir. He must have started the business all of sixty years ago.'

'That wasn't what I asked, was it? I said how long has the shop been *your* living?'

Trevithick was beaming at me. What could he want?

'For seven years, Sir. I came back from working on the newspaper in London when my father became ill. He died a few days later.' Trevithick already knew this. He'd been a customer of my father for years. It was only because Trevithick had been a good customer in the past I answered. And I admit I'd always liked the old man.

'Trade good, eh?'

'Not so bad.'

'Nonsense. It's been going downhill for years,' he said. 'From well before the time you took the shop over. Almost since you were a small boy, I'd say.'

The bare-faced cheek of it! I felt like throwing him out of the shop.

'Sorry; I didn't mean to shock you quite so much,' he said. 'I've got a business proposition I want to put to you. I didn't want us to waste time with this "No it isn't" and "Yes it is" nonsense. I've got a train to catch to Cornwall in a couple of hours.'

'Go on,' I managed to say. A business proposition from Henry Trevithick?

'You see, what I'd like you to do is move your shop to bigger premises in Ealing. This specialist business is in the wrong place here in Greenford. Most of your customers travel from Ealing, Acton or Chiswick as it is. If you had a place in Ealing, you'd begin to draw more people in from London itself. Your premises, if you don't mind me saying so, are too small as well as being badly sited. The antiquated two-door entrance system you use only makes matters worse.'

'I couldn't afford to do anything like moving the shop.'

'No, I've assumed you couldn't. That's where I'd like to come in. I've got my eye on some excellent premises in the Uxbridge Road, on the Acton side of Ealing. I'd be willing to rent them for a period of two years. All I'd ask in return is five per cent – only five per cent, mark you – of your profits during that time and for five years afterwards. I'd get a proper legal agreement drawn up by my solicitor, of course, but that would be the essence of it.'

'You'd lose money,' I said flatly. Five per cent of not very much would be even less. Shop premises on the Uxbridge Road didn't come cheaply.

'I'm sure I wouldn't. I've been into the subject carefully.'

The offer should have been wildly tempting. Even my father in his younger days had talked about moving the business further to the east. He'd never done anything about it. All his spurts of enthusiasm had ended with mumbles about it not being right to move away from the premises in which his own father had started to trade. Over the years brass nameplates had declined in fashion and turnover had become smaller. Even some of the shops here in Greenford now preferred to proclaim their existence with garish painted signs stretching above their doorways. In some cases, these went across the whole width of the building.

There was something else. If I said 'yes', I'd be committing myself to a lifetime as an engraver. A thought I'd hardly dared admit even to myself was that if my business foundered through no fault of my own, I'd be free to look for work in the newspaper trade. Maybe I'd be able to find a place on the staff of the *Daily Mirror*, so renewing and strengthening acquaintances I'd made in London.

Seven years ago, I'd convinced myself I owed it to family duty to carry on my father's business; this shop my grandfather had set up so long before. He'd escaped from a life of near-serfdom on Waxlow Farm to do it. Success in the

engraving trade had become the family dream, even if it was a dream I'd never shared. I couldn't blame myself if the shop failed despite my best efforts.

'Well,' said Mr Trevithick. 'What do you have to say?'

'I don't know,' I said. 'I'll grant you this shop isn't ideally situated. But brass name-plates have been going out of fashion for the last thirty years. Many of the newer businesses aren't interested in having one. It's hard to see engraving suddenly becoming a success.'

'Look.' He leaned over the counter to put his hand on my shoulder. 'Let me worry about profitability. As I've told you, I've already looked into this matter thoroughly. You're talking about shops. What about doctors' surgeries and so forth? Has anybody ever really given any serious consideration to the vast possibilities of expanding the use of nameplates for private residences? And never underestimate the power of advertising. Let me tell you that, within a year, I'm sure we'll have in mind a second and third branch of *our* business. Why, I can foresee branches in Kensington and other fashionable places.'

'I can't see myself living in Kensington.'

He beamed. 'You wouldn't have to move there. You wouldn't even have to live in Ealing. My thought is that we should employ a pretty girl or two to front the shops. You'd stay here and do what you do best in your workshop at the back, although I'm sure we'd want to think about getting new equipment and expanding the premises before long.' His eyes twinkled. 'I wasn't going to say this - I thought it might go to your head - but you're an artist, do you know that? As good as your grandfather was. Maybe even better.'

He'd appealed to my vanity there. In my heart of hearts I did think of myself as an artist. But my visions were

of myself as a creator working with sketches and words, not as a drudge engraving metal plates.

'It's all too much to take in,' I said. 'I need time to think.'

'Why, naturally you do,' said Trevithick. 'And you shall have time. As I said, I'm going to Cornwall later this morning. In four weeks, on Wednesday the twenty-ninth day of July to be exact, I shall return home.

'On the very next day, at precisely ten o'clock in the morning, I shall call to see you. Then you shall let me have your decision. There is, you will soon realise, only one decision you can make. Write down any questions occurring to you in the meantime and I will do my best to answer them. After our conversation, my plan is to go straight to the offices of Sharpe and Tolman in the Uxbridge Road and instruct them to draw up the necessary papers.'

'I don't know what to say, Mr Trevithick.'

'There is nothing further for you to say at present, Green. *Mr* Green, I should say. This is business. All you need to do over the next four weeks is some business-like thinking. And don't forget to write down those questions. Now, I really do have to be on my way to Paddington Station. There's one more thing I want to say to you. How do you think your grandfather, a poor labourer on Waxlow Farm who could hardly write, was able to afford to move into these small premises and start this business?'

'I don't know. My father never discussed it with me. I suppose my grandfather must have borrowed the money from somewhere.'

'Not exactly borrowed. My own grandfather recognised his skill and made a small investment. Your grandfather was able to pay the money back within four years. Remarkable.' He was wagging his finger at me, betraying the excitement he was obviously feeling. 'Now, I

want to do the same thing and make an investment in the talent of his grandson. But I am more ambitious, so want to make a grander investment. And you must match my ambition with your skill. There would be a delightful symmetry to all of this, do you not think?'

'I suppose there would be, yes.'

'You can do as much supposing as you like over the next four weeks, so long as you do so with earnest intent. Shall we shake hands upon your promise to do so?'

I held out my hand, somewhat nervously. He gripped it, shaking it with enthusiasm.

'Until ten o'clock on Thursday, the thirtieth day of July, then.' He fixed me with a serious look for an instant, turned on his heel smartly, and exited through the inner door. The entrance bell above it seemed to tinkle and dance for a long time after he'd left.

*

Henry Trevithick's visit had turned my cosy little world on its head. Yes, "cosy" is the right word, despite my lot of physical discomfort and penury. My larder might be all but empty. I knew there was a rainwater leak in the corner of my bedroom ceiling as well as to the outside downpipe. These, I told myself, I had not the money to get fixed. My bank account in Ealing held the paltry sum of thirteen guineas. This was little enough for the total fluid capital of a business of sixty years' maturity. By any calculation it would not be sufficient to sustain "Thos. Green & Son, High Class Calligrapher and Engraver" beyond the present year. Thirteen guineas was less than half of the sum in my bank account six months ago.

The leaking roof and bare larder matched the romantic image I secretly nursed of a failing business. If trade blundered downhill at its present rate, it would certainly fail soon. Then I'd be able to walk away from the shop with a

clear conscience. This was the brutal truth of the way I'd been looking at the future. Now Henry Trevithick had defaced this bleak but comforting picture with all his talk about business and artistry. He might know a thing or two about money, but what did the man ever know about art?

The more I thought about it, the more I came bumping up against uncomfortable reality. Even now, Henry Trevithick would probably be whistling in the train from Greenford to Paddington. Whistling was not what I wanted to do as I went out. The shop bell jangled above me in an irritating echo of its earlier behaviour.

*

'Hello Mr Green. What is it to be today? A packet of Wills or a *Mirror*?'

Mrs Raven was unfailingly cheerful. Whenever she could she'd serve me herself and bring me up-to-date with local news. Her reliably good humour was the reason I liked to walk down to her shop.

Beside my unopened cigarettes I had only two Wills in the packet at home but I couldn't afford more this week. Even a penny for a copy of the *Daily Mirror* would mean less bread tomorrow.

'Only a *Mirror*, thank you, Mrs Raven.

When I arrived back at my own shop, I couldn't stomach the thought of going back inside. So I stood by the street door and scanned the newspaper, something I'd never normally do in public. It gives the impression one is a loafer – something a successful trader should avoid. Today, whether or not because of Trevithick's visit, I couldn't be bothered to make even the pretence of success.

On the front page of the paper, there was a picture of Henley Regatta, with girls holding parasols. One of them looked remarkably like Mazod Betham, although of course

she'd carried nothing on that day to shade her head. As usual, the next page consisted entirely of advertisements. The most prominent mocked me with the heading, "*If you 'simply can't save money*". A feature on the next page asked, "*Does Senile Decay begin at 50?*" 'No, it begins at 29,' I couldn't prevent myself from muttering. I had the idle fancy of working through each of the advertisements in this grimly flippant way.

On page four, I noticed a further report on the Sarajevo assassination. It was a reprinted feature from the agrarian newspaper *Az Ujsag* published in Budapest, and comprised the full text of the confession from the murderer, a young man called Prinzep.

Suddenly, from the corner of my I eye, I saw Mazod Betham. She was some distance away but walking smartly in my direction. The sun caught her close-cropped, russet hair, and my pulse raced. I thrust the newspaper under my arm and retreated.

*

She was here. She was in my shop!

'Good morning, Mr Green. I thought I saw you out there, reading your newspaper.'

'Oh, I'm sorry. I don't usually stand outside with it. Something caught my eye on the way back from Raven's.'

'You're sorry?' She arched her eyebrows, looking mischievous. 'It makes no difference to me, Mr Green. A man is perfectly entitled to read his newspaper wherever he chooses, wouldn't you say? Before I left home, my uncle was complaining there'd been nothing of interest in his *Times* all week. Mind you, he was reading whilst standing in the hall doorway, blocking the passage of myself and of everyone else in the household.'

I felt obliged to say something in response, even if it was going to be no more than half-way true.

'I was reading about the Royal murder in Sarajevo, Miss Betham. There's another report today.'

'Sarajevo?' she said. 'My uncle said something about it. Isn't it in Austria-Hungary? Anyway, I can't follow all the goings-on on the Continent. They're always up to something over there, aren't they?'

I couldn't think of a smart response, and blushed at my social ineptitude. She looked at me directly. There were no traces of mockery or superiority in her expression.

'You'll be pleased to learn, Mr Green, that I want to put a small business transaction your way.'

'A business transaction?' For a moment I was reminded of my earlier conversation with Henry Trevithick.

'You're a calligrapher as well as an engraver, aren't you?'

'Yes. It's my favourite part of the work. Unfortunately, I don't get the chance to practise calligraphy as often as I'd like.' This was an understatement; I couldn't remember the last time I'd been asked to turn my hand to calligraphy.

'They all call you "The Engraver" in the village. Your sign says "Calligrapher and Engraver" clearly enough. Anyway, how much would you charge for writing out three lines of verse in copperplate?'

'Three lines? Is that all?' It was all I could do to prevent myself from saying I'd do it for nothing. I'd even pay her any part of the three shillings in my shop to let me do it. 'Oh.' I tried to appear relaxed. 'Sixpence for a card of anything up to foolscap size would be quite enough.'

'Sixpence?' she said. 'I want a proper job done, you must realise. And I'd like the result framed. Shall we say five shillings for calligraphy in thick-nibbed copperplate, framed and glazed? Then we'll see your best work. Foolscap is what I had in mind.'

'How about four shillings?'

'Now, come along, Mr Green. *I'm* the one who should be saying four shillings and *you* are the one who should be holding out for five. No, we'll settle for five shillings.'

'I'm a good calligrapher.' I couldn't help saying this. I hoped it didn't sound too immodest.

'I'm sure you are,' she said, looking at me with gentle amusement. 'Now, what colour card can you offer for my choice?'

'Pink perhaps? Lilac? Either would suit verse well.'

She wrinkled her nose. 'They're the last colours I'd choose. I'm sure you can do better. Anyway, you haven't yet seen the verse. The appearance should make the reader think of late autumn turning into winter.'

'I've got some very good pale green card. It might be just right.' I said this too quickly. I'd exhausted my meagre range of colours by naming the three I had.

'Hmm. I'm not sure.'

'Look,' I said. 'I've got some of the green card here under the counter. It'd be exactly right for the job.'

I pulled out a six-inch square from its wrapping of tissue paper, thankful it was not grubby despite two years of neglect. My hands were trembling as I passed it over. She examined it for what seemed an age, but what was probably no more than fifteen seconds.

'Well, all right,' she said, finally. I'm not sure if Mazod Betham really thought it would be a suitable colour or

whether she saw the look of desperation I was trying to keep from clouding my features. 'I'd like you to have a look at the poem I've written, if you would, so as to be sure this colour really would suit.'

'Yes, I'd be delighted. When can you bring it in?'

'I've got it with me. You surely don't think I'd walk all the way to your shop without it, do you Mr Green?' She looked at me teasingly when she said this, but I couldn't find the repartee for which she was clearly hoping.

She fumbled for a moment in her purse. Then she brought out a tightly-folded piece of paper and handed it to me. I carefully undid it and read:

Through mists to the south,

lilting high on woven wings;

fly, Red Admiral.

I looked at the verse intently. It seemed wonderful to me. But then, if Mazod Betham had written 'good morning' on a piece of paper and handed it over, I'd have thought the same. Was I supposed to respond?

'You don't like it! You want to say it doesn't rhyme!'

'No,' I protested. 'I wasn't going to say that.' Nor was I. I did know a thing or two about poetry. 'It's... beautiful.' Should I have said that? 'But it's very short. And it doesn't have a title.'

'It's a *Haiku*. A new Japanese form. Well, new to Europe at least. It's been around in Japan since the seventeenth century. *Haiku* don't have titles, though my secret title for this one is "November Admiral". Do you like that?'

'Yes.'

'So tell me honestly, do you really think the poem is beautiful or are you merely trying to make sure of your five shillings?'

'It's a wonderful poem.' I couldn't quite bring myself to say "beautiful" again. Not with Mazod's eyes shining as they were.

'Then you can do it? And you really think green card would suit the poem? How soon can it be ready?'

'Tomorrow morning? Or I can do it by this afternoon if you like.'

'No, no,' she laughed. 'That won't be necessary. I'm going to a tennis party in Ealing this afternoon and will be staying overnight. Perhaps I could call in for the poem at about eleven o'clock on Saturday morning? Then I can tell you a bit more about the *Haiku*. Does that sound all right?'

'Yes. That'd be perfect.' It would be heavenly.

'I'll see you then. Goodbye Mr Green.'

She bustled out of my shop, setting the bell above the door tinkling again. But even before it stopped I felt my heart sinking. Who was I to think a girl who went to *tennis parties* would have any time for me?

Friday, 3rd July, 1914

Friday dawned. So keen was I to see Jet that I was awake and bounding out of bed even before the alarm clock could wrench me from my sleep. There were a thousand questions crowding in. I wanted some of them answered.

The Hill seemed to promise solutions to so many mysteries. I found myself almost running up its southern slope. Then I slowed down. What if Jet had taken offence at the way I'd stormed off on Wednesday? What if he wasn't there?

Nor was he anywhere to be seen when I arrived at the top. My pocket-watch told me it wasn't far off seven o'clock. Exactly what had he said? "*I'll be back tomorrow*". Surely he wouldn't have climbed the hill yesterday in the rainstorm? I sat down on the old log and waited. There was nothing else for me to do.

It promised to be a fine day. A gentle breeze was playing through the long grass of the hillside, giving a wonderful freshness. The morning was altogether more pleasant than Wednesday. Then, the oppressive air had made everything seem leaden. After the early morning, it seemed as if a storm was waiting to break in the heavens. Indeed, by tea-time there was an alarming if brief downpour. The rain was a kind of prelude to the storms of yesterday.

Today should be better.

My breakfast over too quickly, all that was left was to try to assuage my hunger with water. I unhitched the flask I always carried slung across my shoulder on my morning walks.

'Ah, you're there. That's good. I thought I'd blown it all on Wednesday.'

It was Jet, looking as if *he* had been waiting for *me*. He must have crept silently to my side as I drank. What did he mean by that odd expression; "*blown it all*"? I choked on the water I was swallowing and had to mop my mouth with my sleeve. Why did the man have to sneak up in this way?

'Where did you come from?' I demanded. 'Where do you live, come to that?'

'Oh, I live in Islington. We're, er, staying with my parents locally at the moment.'

'Islington? I hope your home is in one of the better parts.' There weren't any "*better parts*" to Islington, so far as I was aware. The area I knew was a warren of slums. 'And who are your parents?' I said. 'I know most of the people in this part of West Middlesex.'

'They live in Hanwell. You wouldn't know them. They haven't been in the town for long. Look, I'm so sorry if I offended you on Wednesday. I'd hoped we could become good friends. The thing was, I was so excited to see you, I let it all spill out.'

This Jet was a peculiar one, with his eccentric appearance and speech. Now I was more than ever sure he was inventing every detail of his story. It was a fair step all the way from Hanwell to Horsington Hill. He'd need to have stirred from his bed before five o'clock to reach the hilltop at this hour. I looked at him again. He was immaculately groomed and dressed. Oddly, although he was wearing the same smart suit of clothes I'd seen on Wednesday, there wasn't the slightest crease.

I decided to let my mystification go unsatisfied for now. There were many greater questions on my mind. Which of my real questions should I ask first? It wouldn't do to let

them "spill out", to adopt his strange terminology. I tried to maintain a veneer of calmness.

'Sit down for a minute, why don't you?' I indicated the space beside me with a degree of welcome I wasn't feeling. There wasn't much about the man himself I disliked but his very presence made me edgy.

He responded eagerly. You'd think I'd gifted him a thousand guineas. He sat down, cupping his hands under his chin. This pose emphasised the elaborate gold ring that had so captured my attention when I'd seen him on Wednesday. Then he leaned towards me and spoke, as if imparting a great confidence.

'It really is good of you to let me sit here like this.'

'It's nothing at all,' I said, surprised at the intensity of his words. 'Up here, the land is free to anyone. Aren't you afraid you might crumple your smart suit by sitting on this old log?' What I really wanted to do was ask about the antique ring, but thought this would be too forward of me.

He looked surprised at my question. 'This?' he said, pulling at his trouser leg. 'Oh, no. It's no special material, just ordinary *Tufftex*. It won't wrinkle or stain or anything of the sort.'

A slum-dweller from Islington who owned an immaculate crumple- and stain-proof suit? I'd never heard of such a thing. Come to that, I knew nothing of this "*Tufftex*", nor any other kind of material with those miraculous properties. I decided to let it pass.

'Look!' he suddenly shouted. 'What's the contraption down there?' His finger was pointed to the first train of the morning, crawling across the countryside towards Perivale Halt. He was displaying more excitement than had the children of the village when the line was opened ten years ago. If he were really staying in Hanwell, he'd have had many opportunities to see far bigger trains on the main line.

'It's only the seven o'clock steam railcar from Ealing. There's nothing to get so excited about.'

He had no answer to this and looked crestfallen. At that moment, he looked like a lost little boy. Despite the way he'd annoyed me on Wednesday, and even though he was still putting far more questions in my mind than he was answering, I began to warm to him. I relaxed and decided to smoke my last cigarette,

'I'm sorry I haven't got one to offer you,' I said, pulling the battered paper packet from my pocket. 'This is all I've brought with me. The new packet is back in my shop.' In truth I had no cigarettes left at home. Still, it would never do to let this odd stranger know as much.

'What's the matter?' I asked. He was looking aghast at the Wills' packet.

'Surely you're not going to light that in the open air?' he said.

'That's the general idea when one wants to smoke.' I wondered where this conversation would take us next. 'I'm sorry. I know a few – *people* – who don't take kindly to anyone smoking next to them. Are you one?' I very nearly said "eccentrics" instead of "people".

'No, no. I'm not concerned about myself. I'm environmentally safeguarded. But what about the people in the villages? I know it's still legal to smoke in these times, but surely you must be aware of the dangers of passive smoking to those below?'

There he went again. Passive smoking? Environmentally safeguarded? These times? What was he blathering about? The nearest village was at least a mile away, and all of three hundred feet beneath us. Despite the expensive way he was dressed, I began to wonder whether he was after all an escapee from the asylum. I slipped the packet back into my pocket. It would be better to smoke later, in

company that didn't make me so nervous. There followed an awkward silence, one that he broke.

'What's the name of the village down there?'

'Perivale, of course,' I said.

'Yes, I thought it might be,' he said. '*Parish of enormous mayfields*'.

'What?'

'I was quoting from a poem. *Parish of enormous mayfields, Perivale stands all alone.*'

'*H*ayfields,' I said. 'Those are hayfields you can see down there.'

'Silly of me,' he said. 'You're right. Thinking about it, I was misquoting. "*Enormous hayfields*," is what I should've said. *Greenford* is the place where you'd see may fields in growth.'

'No you wouldn't,' I said. 'There are hayfields there, too. Look! Over there. That's Greenford.' I pointed to the right. 'There are *some* mayflowers there. In the month of May, they were in full bloom, exactly as in Perivale. There are flowers around the villages now, including many of the species that we first saw in May. But nobody in their right mind would waste time and money planting whole fields with wild flowers.' Where had this man come from? Why was he always saying these odd things?

'Who's the poet you were talking about, anyway?' I asked. I thought it safer to steer him toward saner topics.

'Betjeman. John Betjeman. He's a well-known poet.'

'Is he now? Well, I've never heard of him. I know the work of many of the poets, including most of the newer ones who are establishing a reputation.'

'He's young yet.'

'How young?' I didn't want to let him get away with another of his evasive answers. But this was exactly what he gave me.

'Oh, I don't know. Very young. He's living in London at the moment, I think. In Highgate, I believe it is. Yes, it's Highgate. You know. Where Karl Marx is buried.'

'Karl Marx? I've never heard of him, either. And Highgate isn't in London. It's in Middlesex. You can see it from the other side of this hill.'

'He was around in the nineteenth century. He died in this country about thirty years ago. You'll soon be hearing a lot about Marx's theories. I'm surprised you haven't already.' He seemed to be happy with this mysterious retort.

I was exasperated. Who was Karl Marx? And why was this young man's geography so bad? For some reason I had the distinct impression he really did know the biography of the poet he'd named. I tried to put my irritation to one side, and did my best to keep our conversation on a normal level. 'Do you know the rest of the Perivale poem by this Betterman?'

'Betjeman.'

'Sounds like a German name to me.'

'His was originally a Dutch family, I believe. At one time, they spelled the name with a double 'n'. They changed it when... when.' Here his voice trailed away. 'Yes, I think I know most of the poem.'

'Well, recite it then.'

With an air of embarrassment, he spoke the poem aloud, telling me its proper title was 'Middlesex'. At first he was shy with his recitation, but his voice became strong and clear as he warmed to his task. It demonstrated this Dutch poet had a fine sense of rhythm, if nothing else.

But the poem said some odd things. Where was this 'Ruislip Gardens' into which the electric train – electric, mind you – was supposed to run? Ruislip was the name of one of the local villages, but there was no railway line running anywhere near, let alone one carrying 'electric trains'. I had myself seen a few trials with engines running from electric power, although that was in London for the newspaper. It was the reference to our River Brent that outraged me.

'*Gentle* Brent? And the river doesn't wander *towards* Wembley; it flows *from* there, or from land adjoining the village, anyway. The river might be shallow and slow-flowing, but the damned thing floods frequently and causes havoc. You can tell the poet lives in London. I bet he's never been anywhere near to this part of Middlesex.'

'He may not have been, yet.' The way he slipped in the "*yet*" made it all the more infuriating. Again I managed to subdue my feelings.

'There are some things in the poem that are a mystery to me, too,' he continued. 'For instance, what on Earth is "*Drene*"? And what are "*Murray Poshes*" and "*Lupin Pooters*" when they're at home?'

'Well, "*Drene*" and some of the other words sound like trade-names to me' I said. 'But "*Murray Poshes*" are simply the well-off people who invade our county exploring the countryside as if they were in darkest Africa. Often, they carry a *Murray's Railway Guide* tucked under their arms. It's almost a badge of honour with people of that stamp. "*Lupin Pooters*" are the feckless people who "pooter" about the countryside making damned nuisances of themselves. Haven't you ever read *Diary of a Nobody* by George and Weedon Grossmith?'

'Er - no. I can't say I have. Why?'

'Murray Posh and Lupin Pooter are both characters in the novel.' He didn't even know that much, so it seemed.

'Mmm. Interesting; it sounds as if you could be right,' he said. Of course I was right. To what kind of damned fool was I talking?

'I'm glad to have that little puzzle cleared up,' he added.

It would be good if he'd clear up a few riddles for me. But it was another question about poetry I put to him.

'Do you know what a "*Haiku*" is?' I asked this on sudden impulse, remembering my conversation with Mazod yesterday.

'Yes, of course. It's a Japanese form of verse. It used to be very popular, especially around the close of the twentieth century. Why do you ask?'

I looked at him. He hadn't realised what he'd said. Some moments passed by before it dawned on him. Close of the twentieth century indeed!

'Sorry... I meant to say at the close of the *nineteenth* century,' he said.

'No you didn't,' I said. 'I happen to know the *Haiku* has only recently come to this country. What do you have to say for yourself now?'

'I've got to go. I'll explain everything next time we meet. I'll be back here on Monday morning. You'll see me at seven o'clock again.'

'You want to disappear again, do you? But why wait until Monday before showing yourself? What's wrong with tomorrow?' I asked. My tone was now revealing the anger and alarm that had been bubbling under the surface since I'd first seen Jet. There were too many people - too many "Lupin Pooters" - for me to want to make a habit of coming up the

hill on a Saturday. I especially didn't want to do it tomorrow, the day Mazod was going to come to my shop, but I wanted some answers. There were far more questions in my mind now than an hour ago.

'My visits are pre-programmed,' he said.

'Pre-programmed? What the Devil are you talking about?' I was getting seriously concerned. I don't mind admitting it. With whom or with what was I trying to hold a conversation?

'Sorry. My time's nearly up for this visit. I can't stay to talk any longer.'

'Tell me this. Are you a magician, a madman, or a ghost? Do I have some sort of brain-fever myself, or is this some enormous joke at my expense?'

Already he was up and running nimbly in the direction of the copse toward the east. 'None of those. You're my great-great-great-grandfather. That's all,' he shouted back at me across his shoulder.

I sprang to my own feet and sprinted after him into the trees. There were few of them; they hardly deserved to be dignified with the name of 'copse'. The greenery couldn't provide much of a hiding-place but nevertheless I searched thoroughly, for a solid ten minutes. There was nowhere Jet could have concealed himself. He had gone.

A cloud passed in front of the sun and I shivered, despite the warmth of the morning.

Saturday, 4th July, 1914

An unseen intruder in my shop early on that Saturday morning would have been sure he was witnessing the onset of brain-fever.

In an attempt to deaden the sound of entrance bell, I'd tied a piece of cloth around the clapper with an old length of wool. The result looked inelegant but I had to find some way of muting the infuriating tinkle.

Yesterday, after my return from Horsington, I'd purchased faggots, bread, fatless bacon, three eggs, butter and tea. A few potatoes would have been added to this list if my funds had permitted it. Now I had precisely one penny left. Goodness knew what would happen if Mazod didn't present me with the exact five shillings. With anyone else, I'd have been indifferent, but I couldn't put out of my mind a disturbing picture of myself stumbling over excuses for not having change in my cash-box. At least I'd breakfasted decently for the first time in a fortnight.

It's a surprising thing: I'd been worrying about destitution for months; now its approach was on the horizon, I found myself not unduly concerned about it.

*

Back in my shop, I was admiring my handiwork with the bell when it moved feebly and, I was gratified to note, silently. It was only twenty minutes after ten o'clock. Could this be Mazod, come early for our appointment? Eagerly, I waited as the inner door was pushed open and a woman entered the shop.

In came not Mazod, but my neighbour Mrs Raven. She was as cheerful as ever.

'Anything amiss, Mr Green?'

'No. Why should there be?'

'You're not your usual smiling self this morning. You've got the face of a man who's lost a guinea and found a shilling.'

Mrs Raven was full of thoughts about money today. The subject was always on her mind.

'No, there's nothing wrong.' I tried to show good humour, making a poor job of it. 'I was deep in thought, that's all.'

'Thinking hard were you? Penny for them?'

'Oh, I doubt they're worth so much.' Although I liked Mrs Raven, I wasn't going to tell her anything of my concerns. Besides, I couldn't be sure I could have explained these to anyone, even to myself. This morning Mazod Betham, rather than Jet, was in the forefront of mind. I knew she'd be in shortly and didn't intend to mention it to Mrs Raven.

'Trade secrets, eh?' she whispered. 'Well, we're not in competition. We've got quite different lines of business, the two of us. But I can see you don't want to talk about whatever it may be and that's enough for me. Don't you go getting yourself into a brown study, mind, Mr Green. Thinking too hard isn't for the likes of us.'

'Don't worry, Mrs Raven. I'll remember my station in life.' My smile was more natural this time, despite the irony of my words. 'What can I do for you this morning?'

'You know that brass plate outside my shop? Your father made it up for my husband's family. Or was it your grandfather? It was such a long time ago. That's the pity really: the sign's done its job well for all those years. It still polishes up a treat, I have to say. Only now it's beginning to show its age. Besides, I think we could do with a bigger sign. Something more in keeping with the good trade we're doing

these days. There must be a couple of hundred more people in the village than even five or ten years ago. Most of them come into the shop wanting their newspapers and cigarettes.'

'I thought you only recently had a sign painted above your shop?'

'We did, last year. But a business needs a brass nameplate to show it's serious, don't you think? Now, I'd like one as big as the sign outside your premises. Bigger, if you can do it.'

'Certainly I could. It'd be seven guineas for one like my own; more for a larger one, naturally. I'm expecting a special customer in a moment but as soon as I'm finished I'll pop down to your shop with my steel rule and illustrations of the lettering styles I could do for you. How does that sound?'

'Fine. Yes please. Who's this special customer? One of those London people that come here sometimes, I'll be bound. I always think the people who call on you add a touch of class to our village.'

'Not exactly. It's –'

But already Mazod Betham was coming through the door. The muffler with which I'd gagged the shop bell had done its work too well and I hadn't heard her approach. She saw I was with someone. Mazod would've been quite prepared to wait her turn for service, but Mrs Raven almost curtsied out of the shop as soon as the young lady entered.

'Good morning, Miss Betham,' she said. 'I'm sorry to be in the way like this.'

'No, really,' said Mazod. 'You finish first. I can wait.'

But Mrs Raven was already backing out of the doorway. She looked as though she'd been caught with a hand in my cash-box.

'I'll be along directly, Mrs Raven,' I called. I'm not sure if she heard. 'It's all right,' I said, turning to Mazod. 'We'd more or less finished. I'd arranged to go down to her shop to do some measuring.'

'It's good to see you busy at work,' said Mazod. 'I hope you've found time to do the calligraphy and frame the poem for me?'

'Oh yes.' I dived beneath the counter to produce the framed poem, the *Haiku* as she'd called it. Had I found time? I'd finished the job within the hour after she'd left.

She examined my handiwork. After I'd framed it I doubted any shade of green would have been reminiscent of autumn. But she'd been so dismissive about the pink or lilac I'd suggested. What if she didn't like this colour? My heart was in my mouth. I had more than five shillings invested in this job.

After a moment or two she raised her eyes and looked at me. 'You've done some wonderful work, Mr Green. Simply perfect. And this shade of green is an exact match for the mood of the poem, as you promised. What did we agree? Five shillings? It's worth every penny.'

'You did say you were going to tell me about *Haiku*,' I reminded her.

'I hadn't forgotten, Mr Green,' she laughed. 'But let's get the business side out of our way.' She reached into her purse and drew out two florins and a shilling piece. That she'd tendered the exact sum was an immense relief. Now I wouldn't be embarrassed.

I unlocked the cash-box and dropped the coins inside. Although I tried to make the action seem casual, I was deliberately dropping the coins upon the solitary penny and then on top of each other to make it sound as if I had more money in the box. The effect wasn't remotely convincing.

'The *Haiku* is a Japanese form, you were saying?'

'Don't you have to enter the five shillings in a ledger?' said Mazod, ignoring my question.

'I can do it later. You'll be too busy to wait while I fool around with cashbooks.'

'No, I'm not too occupied,' she said. 'Are you sure you've got time for my explanation?'

'Yes, oh, yes please,' I said. My words betrayed the eagerness I was feeling.

'You mustn't think I'm an expert on the *Haiku*, Mr Green. In fact, few people are outside of Japan. I learned all I know earlier this year from a seminar given by Mr Ezra Pound, the American poet. You've heard of him?'

'Yes,' I said, grateful to be able to tell the truth. The American was the leading light in the Imagist group of poets, I remembered. I knew something about poetry, but never before Thursday had heard of this *Haiku*. Jet had spoken of it as commonplace.

'*Haiku* may be said to have begun in Japan in the seventeenth century,' Mazod began. 'The first of the Four Great Masters of *Haiku* was Matsuo Basho. You might say he was the oriental equivalent of a wandering minstrel, going from town to town, writing and reading poetry. He actually wrote in the ancient form called *renga*, or linked poems. The word *Haiku* means 'play verse'. Is this too boring for you Mr Green?'

'No, not at all.' It wasn't. If she'd been reading the local trade directory I'd have been equally entranced.

'Well, Basho was really interested in the first verse of what they called a *renga*. The *hokku* they named it. He ...'

The shop door opened. A small man in a grey suit entered. I hadn't seen him before.

'Sorry; they told me you wouldn't be busy. I'll come back later,' he said. As he spoke he was putting his hand on the door-handle

'Come back in a few minutes,' called Mazod over her shoulder. 'We were just finishing. I promise not to be long.'

'But you were telling me about the *Haiku*,' I protested, as soon the man had closed the door.

'And he looked like a paying customer to me,' said Mazod. 'You can't afford to turn those away, Mr Green. On Thursday you wanted to charge me only four shillings for your work. A few minutes ago you didn't even enter our transaction in your ledger. And they told me in the village you don't usually open your shop in the summer months before ten o'clock. You need to display more business sense, Mr Green, if you don't mind me saying so.'

'I was interested in the *Haiku*,' I said, more sulkily than intended. 'You'd barely started to talk about it.'

'Yes, she said. 'I'd done no more than begin my explanation. That's the trouble; it was selfish of me to make such demands on your time during working hours.'

'So now I'll never learn about the *Haiku*?'

'Of course you will,' she said. 'You don't work all the time, do you? What are you doing tomorrow, after Church?'

'Nothing.' This week I hadn't intended to go to Church.

'Well then. If it's a fine day we'll go for a walk and I'll tell you more. How does that sound?'

'Walking out, you mean?'

'I hadn't thought of it in quite that way.' She looked at me quizzically, and then in a way more direct and appraising. 'But that's the way you can think of it if you like. Yes, why not?'

*

The rest of morning passed as if it were a dream. When he returned about five minutes later, the grey-suited man, a Mr Stephens, proved to be after a small name-plate for his shop. It turned out he'd travelled from as far away Chiswick. It was as well I wrote down the particulars of his order in a careful daze, as it were, because I'd never have remembered a single detail otherwise. In fact, I didn't even have the slightest recollection of his face. I failed to recognise him a few days later when he called to collect his nameplate, simply because on that occasion he'd worn a brown suit.

There were four more callers to my shop that morning. At ten minutes before noon I had orders for thirty-two guineas' worth of nameplates. All four customers paid me the standard deposit of ten shillings. Now I had precisely two pounds, five shillings and one penny in a cash-box holding only the forlorn penny at the start of the day. Then I suddenly remembered: I hadn't yet called to see Mrs Raven.

*

'I'm so sorry it's taken me so long, Mrs Raven. The fact is I've had a rush on.'

'Busy, eh?' She looked at me as if she didn't believe a word. And who could blame her? I could hardly credit it myself. 'That's good to hear,' she said. 'You know, a specialist business like yours could do very well if you put your mind to it. Our second shop in Hanwell is coming along splendidly in its first four months. Old Raven is always going on about being run off his feet.'

She habitually referred to her husband as 'Old Raven'. Both of them could have been no more than ten or twelve years older than me. They'd become the principals of the village tobacconist and newsagent three years before, when Mr Raven's parents had retired. The genuine affection

between the couple was obvious. They'd both worked in and around the shop for as long as I could remember. Mrs Raven must have been 'Miss Something-or-other' once, but I couldn't remember that time. The two of them were as if born for retail work. I couldn't claim as much.

'I'm glad to hear the Hanwell corner-shop is doing well, Mrs Raven. The engraving business is altogether different.'

'Why, I'm not sure,' she said. 'The basic principles of any retail concern must be the same: carrying the right stock, targeting your customers and so on. If you ask me, it's –'

'I have to get back Mrs Raven. Especially with trade being so good. Now, you wanted a new sign in the style of mine, did you say?'

I did like her, but not when she embarked upon these tedious monologues about good business practise. And, although I knew she liked me, I was aware I was ultimately a disappointment to her, in that I'd failed to make a success of my grandfather's shop.

'Yes. A sign exactly like yours I want. The same kind of lettering, too. Only mine must definitely be bigger.'

*

The sign Mrs Raven wanted proved to be a grand fifteen-guinea one. She insisted on paying a whole pound in deposit. I didn't argue: this would only lead to another lecture.

I was going to buy a *Daily Mirror* from her, but she insisted on giving it to me without charge: '*makes business sense, Mr Green. We're strengthening the links between our shop and yours. Mind you, you can pay for your newspaper tomorrow.*' She said this last with a stern look, to be quickly replaced by a broad grin and a shake of the head when I

asked her if she was also going to make me a gift of the packet of Wills I'd planned to buy this morning.

Back in my own shop, I scanned the newspaper and read that Joseph Chamberlain, the Birmingham politician, had died. The paper was full of this news today. There were Chamberlain pictures on the front and back covers, and several more inside the paper, as well as three or four news pages extolling the great man's career. There seemed little enough other news. On page eighteen there was a picture of the Archduke's murderer being arrested in Sarajevo, but it was the same one the newspaper had carried earlier in the week. The European story the *Mirror* editor had so tried to sensationalise was already fizzling out.

I'd thought to spend most of the afternoon in my shop reading the paper at leisure but, unless one happened to be an admirer of Mr Chamberlain, there was little news. This was as well. As soon as I started to flip through the pages of my *Daily Mirror*, the muted bell above the door twitched to announce the first of six customers of the afternoon.

Sunday, 5th July, 1914

Our local church gloried in the name of 'The Exultation of the Holy Cross'. Really, although some parts of it were supposed to date back to Norman times, it was an unassuming structure. It was said to have been erected by the descendants of a knight called Geoffrey de Mandeville, who'd come over to fight at Hastings with William the Conqueror. Nevertheless, for a reason I'd never grasped, it provided a much sought after living by Churchmen of a certain ambitious kind.

Over the years the living had been held by several Rectors who'd risen to high places in the Church. The present one was a modest man; more like you'd expect someone in Holy Orders to be. In this he was unlike many of the previous incumbents, especially Andrew Brember. This worthy graced the Church at the turn of the century. If I say I hated Brember, I wouldn't be exaggerating.

The flummery of the Sunday service was a thing I despised. As a local businessman, albeit one of modest pretensions, I had to be seen in church fairly regularly. My attendance made me feel like a hypocrite, because I'd been a silent unbeliever since the day my mother died. I was then a week short of my sixteenth birthday.

My mother was taken from us on Tuesday, 22 January, 1901. She was the solitary fatality in a grim echo of the severe typhoid outbreak we'd seen in the village the year before. The date was the one on which Queen Victoria died. The difference was that the Queen was eighty-one and my mother only forty-one. Also, you might say the two women held different stations in life.

How could our neighbours display greater outpourings of grief for an old woman most of them had never even seen than for my mother, a gentle soul who'd shared their simple lives? And how could the Rector, a ferret-faced man with

darting eyes, be '*too busy preparing a sermon on the lessons to be drawn by the people of Greenford from the passing of Our Gracious Monarch*' to spare even a moment for a grief-stricken boy? Brember's exact words were etched on my memory.

The Rector hadn't even found time to give a word of comfort to the boy's father. In my more thoughtful moments I'd have to admit I'd too often been unfairly critical of my father since my mother's passing. He'd been even more crushed than me when the typhoid took my mother. Although then only forty-four, overnight he became as if ten or fifteen years older. My father had always been a quiet man, never one to push himself forward. But from that day until his own death, not much more than six years later, he seemed to fade into the modest furnishings of the shop. No wonder the business had been going downhill for years.

These thoughts always filtered through my mind when I came to the eleven o'clock service on those Sundays I felt I couldn't stay away from Holy Cross Church for another week. My reluctance was the main reason I normally left it to the last possible minute to slip into the church. Today, though, I was really coming to church to see Mazod, so I'd arrived before any of the congregation. Last week I'd made my 'duty call', so this should have been one of my precious 'Sundays off'. But today, I wouldn't have missed the service for the world.

I'd spent half-an-hour pacing the oval marked out by the Rectory, the tiny Oxford Street, Greenford Hall and the Rectory Cottage. Finally, I'd stationed myself under the oldest oak – some said it was at least five hundred years old – close by the last of these. This was the same oak-tree I'd climbed sixteen years before, when Jet had made his inadequate job of holding my coat for me. My mother was then still alive and in vigorous health.

From my leafy vantage-point, half-concealed by the lower branches, I could watch the congregation arriving. Ambling along in a loose knot was the Bennett family, Mr and Mrs Otter, Tigwell the market gardener, William Markham and finally the Stanhope Hansons. A few minutes later arrived Frederick Crees, one of the grander local farmers, with his family dutifully trotting along behind like a row of geese.

Crees himself was in some finger-wagging discussion with Mr and Mrs Raven. The farmer came from Devon, and when he arrived had been very critical of the farming methods used in West Middlesex. He'd called them 'wasteful, old-fashioned, and inefficient'. By the look of things he was giving the Ravens the benefit of his great wisdom on something now. This was probably a few hints about running the business of a tobacconist and newsagent, something the Raven family had been doing for years.

Not long before eleven Archie Perkin sauntered up to the church door. Besides Crees, Perkin was the only person in the village I couldn't stand. He was the sole great-nephew of the William Perkin who'd founded a dye factory on land next to The Black Horse in the middle of the last century. Apparently, the speciality of the company used to be the manufacture of a purple dye. At that time, it was the only chemical production of the colour anywhere in the world, so I'd been told. There was a huge explosion in the factory just fifteen or twenty years after it opened. It claimed the lives of two of the factory's workers, and a few years afterwards the dye-works had closed.

All this happened before I was born, but the manufacture of that particular colour of dye must have been a money-spinner, because everybody knew Archie Perkin was by far the wealthiest person in the village. Aged a few years younger than me, he'd been the inheritor of all those purple riches a year ago. Nobody was aware of his fortune more than Perkin himself. He strutted around Greenford as if he

owned every building. He'd hardly ever deign to speak to someone like me. Much of the time he'd barely move his head in acknowledgement of my greeting if I passed him in the street. The talk was that he'd been given extended leave from his regiment for "family reasons" and was soon to return to duty. This event couldn't come soon enough for me.

It was true he'd walked out a few times with Mazod Betham and I'd have to admit there was jealousy in my knowledge of this. Still, I was the one who'd be with her later today. This I still couldn't quite believe. But the truth was, even without the complication of Mazod, I wouldn't have cared for the man. There was, for instance, his affectation of calling Perivale 'Greenford Parva-Vale'. He'd pronounce that this was the original name of the place. Nobody else used this name. Everyone laughed at Perkin's silliness behind his back. Well, I did, anyway.

I studied his ostentatious entry into the church, but my real concern was with Mazod Betham. Where was she this morning? She should have arrived with her Aunt and Uncle by now. It was almost eleven when I did see them, coming down Cow Lane. They must have detoured for some reason.

I slipped as quietly as I could into the church as soon as I could after the three arrived, trying to make it look as if I hadn't been following them. By this time, the service had already begun. The Rector, Edward Terry, caught my eye as I came in and looked at me with an ecclesiastic disapproval that said 'late again'. If only he knew I'd arrived at the Church an hour ago.

*

'Well, where shall we go?' asked Mazod.

'Are you sure Mr and Mrs Hartson won't mind us being together like this? Wouldn't they prefer it if you walked out with Archie Perkin or someone of his class?'

'Archie?' she laughed. 'Archie's a dear boy, but he can be a bit – well, *tiresome* sometimes, with his endless jokes and talk about boxing and motor-cars.' I hoped Mazod wouldn't find *me* boring, especially since I became so tongue-tied every time I looked at her. 'My Aunt and Uncle know exactly who I'm with and they don't mind at all. This is the twentieth century we're living in, I'll remind you. Anyway,' she smiled. 'It isn't as if we'd plotted to elope or to go on any wild adventures, is it? We were only going to talk about the *Haiku.*'

'No I - That is – .' I was intensely embarrassed.

'Come on, you silly ass,' she said, taking my arm as if it were the most natural thing in the world. Mazod Betham taking my arm! I would've been walking on the clouds if I hadn't been so nervous. 'Everyone is looking at us. Now, where shall we go?'

She guided me away from Holy Cross. I was relieved to be away from the eyes of the Churchgoers. Mazod paid not the slightest heed to their stares and soon we'd left them all behind. This was it; this was the moment I'd been rehearsing in my mind every minute since she'd come into my shop.

'Well? Where are we going?' asked Mazod again.

'Er, let's follow the route of Coston's Brook down to the Brent.'

'Are you sure it's a good idea?' Mazod looked doubtful. 'We had a lot of rain on Thursday. These are only light shoes I'm wearing.'

'Yes. It'll be fine.' I tried to sound more confident than I was feeling. The path might indeed be boggy underfoot in parts and, more importantly, I'd remembered how foul the River Brent could sometimes be. On the last occasion I'd made this walk, alone, I'd seen a solitary turd floating defiantly on the surface of the river at its confluence with the brook. All too often there was a collection of

unsavoury flotsam to be seen at that point. Now I became nervous as I remembered the words of Jet's poet Betjeman: the excreta might have 'wandered from Wembley at will', as river-borne debris so often did, but I'd have died of shame if Mazod saw anything of that nature while she was with me.

Coston's Brook was more of a ditch than anything else and the countryside along its route was featureless. I was glad that Mazod kept up an enthusiastic monologue on the *Haiku*, meaning I didn't have to talk too much. She knew much about the technical aspects of the form: the European convention looked as if were going to settle on lines of five, seven and five syllables; the poem should be about the seasons; there should be what they called a *kireji* or 'cutting-word' at the end of the second line; and so on.

Once we'd reached the part of the brook where the footpath to the Greenford Hall crossed over it by means of an attractive wooden footbridge, I asked her about Ezra Pound. After all, she'd spent a whole day in the poet's company.

'Tell me about Ezra Pound. The man who ran the seminar for you,' I said. 'From the poetry I've seen, I'd imagine he'd be quite a character.'

'Oh, he's every bit of that. Mr Pound knows a lot about the *Haiku*. He read us an interesting example of his own. It was called *In the Station of the Metro*. Mr Pound told us wasn't written as a *Haiku*, though. His intention had been to write what they call an 'Imagist' poem. Then he went on to tell us of a storming row he'd had with some cigar-smoking American woman about what an Imagist poem should be. The way he told his story was so funny.'

'I didn't quite mean that. What I'm asking is, how did you find him as a man? Is he brawny and devil-may-care? It's the way I'd imagine him to be from his poetry.'

'No,' she said. 'He's not like that at all. In fact he's got a tendency to plumpness and hunches his shoulders more

than a young man should. He's only about the same age as you, but you wouldn't think so sometimes. Oh yes; apart from the time when he was telling us about the American woman – Amy Lowell was her name – you'd have to say he was very softly spoken. Most of the day I'd even have to say he was a bit nervous and fidgety.'

'Not like Archie Perkin, then?'

'No, not a bit' she said, surprised. 'That's a strange thing to ask. Why do you say such a thing? That's the second time you've mentioned Archie today. Why?'

'Oh,' I tried to improvise. 'Archie Perkin is someone we both know.'

'Archie's a friend of yours? I wasn't aware of that.'

'Well, he's not a *personal* friend,' I stammered. 'I know him by sight.'

'What exactly is it you *are* trying to say, Mr Green?' Her look became confrontational.

'Well, you did say that Archie Perkin was a bit pompous, and – '. Immediately this had left my lips I knew I'd said the wrong thing. Mazod rounded on me furiously.

'I *didn't* say Archie was pompous. All I said was that he could sometimes be a tiny bit tiresome. Tiresome, is exactly what you're trying to be now.'

'He calls Perivale Greenford Parva-Vale.' I knew I was making things so much worse, but couldn't stop myself.

Mazod looked very cross for a moment. Then her face broke into a grin, and soon she was laughing aloud.

'I ought to box your ears for you, Mr Green. Anyway, isn't this a question of the pot calling the kettle black?'

'What do you mean?'

'What's the name of the hill you climb every morning?'

'Horsington. Horsington Hill. Why do you ask?'

'Everybody else calls it *Horsendon* Hill, Mr Green. It used to be called *Horsington* centuries ago. Nobody else calls it *Horsington* anymore.' She smiled wickedly. 'Even Archie.'

What she said was true. The only reason I thought of it as *Horsington* was because my father had persisted in using the old name.

'I'm sorry, Miss Betham. I shouldn't have mentioned Archie Perkin's name.'

'Don't you forget your manners in future. If you do I'll never walk out with you again.'

'You mean you *will* walk out with me again? When? Tomorrow evening? I'm really sorry to have spoken about Mr Perkin as I did. I was – jealous – I suppose.'

She looked at me very directly. I was glad I'd told the truth.

'No, no. Not tomorrow,' she said, her expression softening. 'I'm going to stay with my other aunt, Aunt Hattie, for a few days. She lives in Sudbury. How about us meeting on Friday evening?'

'That would be wonderful.' It would be all that and more. But there was another question forming itself in my mind. I hardly dared to ask it. 'Miss Betham, how did you know I climb Horsington- Horsenden, I mean - Hill in the mornings? And how did you know I called it by the old name?'

'Why, Mr Green, I've been quietly finding out about you in the village for some time. How else do you think? And there's no need for you to be jealous of Archie. Or to be

worried about anyone else. Now, shall we walk down to the river?'

*

We didn't exchange another word during the rest of our walk along the path of Coston's Brook. Mazod linked her arm with mine more tightly than before. I felt more able to enjoy her company; it was heavenly to be so close to her. And it was a relief to see that on this occasion the Brent was excrement-free. In fact, after all the rain, the current was faster than usual, so its appearance was more dignified than the normal sluggish flow allowed.

We were even lucky enough to find a dry patch on the otherwise waterlogged river-bank. The only thing spoiling the perfection of the moment were ominous clouds gathering in the sky above. Although I was brimming over with my feelings for Mazod, I knew I shouldn't try to express them yet. There was still a question about the *Haiku* in my mind, so I put this to her instead.

'You've told me a lot about the *Haiku*, Miss Betham. But what would you say is its essence? Where would you say is its soul?'

'Phew! That's a big question. If you're going to ask me questions as deep as that, don't you think you should call me by my first name? You know it's "Mazod", don't you?'

'I'd really like to call you by your first name. It's lovely.'

'Well, *Mr Green*, for the moment I think you'd better call me by my Christian name only when we're alone together. You know how old-fashioned the people of Greenford can be.'

'Aren't you going to call me by my first name, too?'

'You haven't yet asked me, have you? Besides, I'm not sure what I should call you. The people I know refer to

you as "Green" or simply as "The Engraver". So, what is your given name? I know that the nameplate outside your shop refers to a "Thomas", but that could be your father for all I know.'

'It's my grandfather. He put the sign up. But my name is "Thomas", too, though I'd prefer it if you called me "Tommy". Everyone calls me that - Mazod.' It gave me a thrill to be able to use the name.

'Of course I will - Tommy.'

'Now, would you like to answer my question?' I didn't think it would be the right thing to use her name again so soon, as much as I wanted to.

'What question?'

'About the *Haiku*.'

'Yes, well, Mr Pound did describe it in a memorable way. He said the Haiku was a record of *a moment of communion with nature*. Rather good, don't you think?

I thought this brought more life to the form than all this nonsense about syllable-counting and the like, and was trying to think of a way to say so without sounding peevish. However, at that moment I felt a single large raindrop striking my cheek. It was warm and, by itself, not unpleasant. But others quickly followed. Nature had decided to have its own *moment of communion* with us.

'We'll be soaked,' said Mazod. 'There's no shelter here!'

'Quickly!' I said, and grabbed her by the hand, hurrying back along the footpath.

It was a heavy downpour; one of those they call a 'summer cloudburst'. Mazod's shoes were light, but not designed for running. When we had gone not more than a dozen yards I remembered to snatch off my jacket and throw

it around her shoulders. The gesture might have been gallant but it slowed her progress. By the time the footbridge came into view we were both soaked to the skin. It mattered not at all that by then the rain had pattered to a halt. Mazod said nothing. Whether this was because she was tired after our undignified run, or whether she was unhappy about the way our time together had turned out, I did not care to ask.

We approached the footbridge at a slow, silent walking pace, Mazod trailing wetly after me. Suddenly, as I was crossing the bridge, there was a yell from behind.

Mazod was sitting in an undignified position in the middle of the footbridge. She'd slipped on the surface-water, still lying in pools on the wooden structure. The cornflower blue frock she was wearing was stained with ugly brown streaks. Her hat was tipped comically over one eye, though I couldn't see the funny side of this. Neither could she, to judge by her frown.

I leaped forward to help her to her feet. But I was over-eager. In my haste I lost my own footing on the slippery wood of the bridge and ended up sprawling across her slender frame. She was half-winded by my heavy fall across her. She looked surprised and outraged, as well she might.

Then she laughed, loud and long. She didn't even stop laughing when it started to rain again. As the rain drenched us I couldn't help joining in with the mirth. But I didn't laugh for long. I soon sensed she became aware of the arousal I was beginning to feel. This physical manifestation of my baser feelings shamed me. I helped her up, trying awkwardly to hide my embarrassment. I was able to give more than monosyllabic replies to her few questions for the rest of our traipse back to Greenford Green.

Monday, 6th July, 1914

Today I'd find answers. I was sure of this as I watched Jet emerge into view adjacent to the copse below. This time, he made no attempt to disguise his sudden arrival. In fact he looked sideways at me, a sly grin on his face as he solidified, as it were, into my presence. He was clearly pleased with his conjuring trick. I played him at his own game and tried to betray no trace of reaction on my face. Inside, I was in turmoil.

It was disconcerting to see his figure forming from the thin air, but I'd been half-expecting some kind of extraordinary manifestation. After all, if this man really were my great-great-great-grandson and I now believed – to be honest I now wanted to believe – he was, he'd have to be some kind of time-traveller.

So where was his time machine? I could see nothing, nor had I on his previous two visits. Despite my apprehensions, this morning I'd resolved to be the first to speak.

'Good morning, young Jet,' I called to him. 'Did you have a good journey?'

I deliberately framed my question as if I were asking if the trams were running on time. If he was put out by my mocking tone, he didn't show it. He strode easily up the hill to come closer to me. Then he paused to take off his Homburg, holding it before him in his characteristic way before answering.

'It wasn't a trip in the way you'd think of one. And please don't call me "young Jet", if you wouldn't mind.' He raised his eyebrows in a good-natured way as he said this. 'You're only a few years older than me, after all.'

'Well, that would depend on your point of view.' In spite of the way I felt, I decided to have a little fun with him. 'I was born on 30 January, 1885. When were you born?'

'On 20 March 2020.'

He looked at me in a challenging way, at the same time displaying an air of amusement I found irksome, so I spoke again as matter-of-factly as I could.

'Well, by my reckoning that would make me more than one hundred and thirty-five years older than you. I'm your senior by some margin, wouldn't you say?'

'From my perspective it's the twenty-fifth of May, 2046, and I'm twenty-six years old.'

'And from my own point of view it's the sixth of July, 1914, and I'm twenty-nine years old. Now, I'd say you are most definitely on my territory. Or at least as far as I'm concerned you are. So, I'd think my mathematics rather than yours hold good, wouldn't you?'

He answered in a calm way. Infuriatingly, he wasn't rising to the bait.

'Well, yes, I can see why you think that. But I'm sort of in two places and experiencing two times at once. It's difficult to explain.'

'I wish you'd at least attempt to make things clear.' Now I was starting to let my exasperation show. 'We're not all stupid in 1914, you know. Even the folk here in Greenford. For a start, you might like to tell me where you've hidden your time machine, if you're really a time-traveller.'

This time, Jet winced. He didn't answer immediately but slowly took the remaining paces up the hill join me. He sat beside me without asking for my leave, even by means of a gesture. But his tone became quiet and serious as he turned to face me.

'Look, we shouldn't try to prove to each other how smart we are. My IQ and knowledge measures are reasonably high, as measured by the standard Government tests. I can show you my Idee if you like. But I know – a great many people in my time now know – you were far more of an original thinker than I could ever be.'

There he went again. He was always doing this. What on Earth were "*idees*"? "IQ" sounded as if it may be an

abbreviation of *Intelligenz-Quotient*, the concept of which the German Willhelm Stern had recently been trying to convince the scientific community. Surely such an outlandish idea could never have caught on?

What did he mean by saying "*a great many people know*" about my cleverness? This surely couldn't be me he was talking about. I'd spent all my life in the quiet village of Greenford, save for the regretfully brief period when I worked for *The Independent Record* and lived in London. And in those days I was nothing more than a junior reporter. Still, although I was itching to make some retort, I thought it would be more productive if I held my tongue. I nodded to him to continue.

'Fortunately,' he said. 'Exactly what I'd planned to do on this visit was to try to tell you more about time travel. It's important you know some things, if not all the technical detail. Like most people, I have no more than a sketchy knowledge myself, anyway. But first, I thought we should have another go at introducing ourselves. I've told you my name's "Jet". It's Jet Green, as you may have guessed. You're my paternal ancestor. Can I call you Thomas? Please say "yes". It wouldn't feel right to call you "great-great-great-grandfather".'

'No; I'm sure we'd both feel awkward.' The young man's tone was so imploring and his air of superiority of a few minutes before had evaporated, so I decided for the moment at least to take him at face value. 'But call me Tommy if you would. I'd prefer that. And I'm to call you after a semi-precious stone, am I?'

'After a propulsion system from the mid-twentieth century, as a matter of fact. Nearer to your time than mine, as it happens,' he said. 'To tell you the truth I don't care much for the name. My father must have been feeling nostalgic for old technology when he gave it to me.'

'Your father with the strange name?'

'Ollie is a very popular name in our time. Many people say my father is the foremost genius of the twenty-

first century. And, after all, we are talking about your own great-great-grandson.'

I was secretly pleased to see his readiness to leap to the defence of his father. I was starting to like this young man, even though we always seemed ready to argue. But I wasn't going to let him off the hook too easily.

'Well, aren't you going to show me your time machine?' I said.

'There's no machine, at least not in the way you think of one. Have you ever read HG Wells' *The Time Machine*?'

'I've read it four times,' I said. 'Mr Wells is my favourite author, especially for his scientific romances.'

'I felt sure you'd be familiar with the book. I've read it five times, myself,' said Jet. 'It's a brilliant book, and you can hardly blame the author for dealing glibly with the mechanics of time travel. After all, he did write his novel a century and a half ago.'

Mr Wells' book was written less than twenty years ago, as far as I was concerned, but I thought I'd better let this pass, too. It seemed when I was talking with Jet I had to let many things go unquestioned.

'Go on,' I said.

'There's no such thing as a time machine. Not in the way you're thinking of one, anyway. We all have it within us to be time-travellers. Many of us are, briefly.'

What was he saying now? *"We all have it within us"*? But again I managed to resist the impulse to harry him, and once more indicated he should continue.

'You know when you "drift off" when you recall a moment from the past? I'm talking about those times when the experience can be so vivid that when you came back to the present, it can be quite a shock.'

'That's no more than a wandering of the mind,' I said. 'We all do it'.

'Much of the time it can be no more, I'll grant you. But there are occasions when it's something else. It's then you're experiencing a rudimentary kind of time travel'.

Involuntarily, I thought of last Wednesday morning, when I was crossing the hayfield. For a few seconds, it really was as if I were a young boy again. The image of my father swishing through the tall stems and looking down at his cocksure son was especially vivid. "Cocksure" would have described me only too well in my younger days. My father had glanced down at me that day with the uncertain, anxious-to-please look he wore like the old suit of clothes he always dressed himself in. As I made my way across the hayfield last week, it really did feel for a moment as if he were there again.

'It's an interesting way to look at things, I'll grant you,' I said. 'But who's to say whether we really go back in time at such moments?'

'My father. He can say it: Ollie Green, your great-great grandson with the odd name. My father had the brilliant idea of writing a special routine for a psi-computer and of finding a way to link it to a person's consciousness at those special moments. The experiments he started five years ago won him the Nobel Prize for Physics in 2043.'

There was another swell of unpretentious pride when he spoke about his father. It would be something to have such a man as my great-great-grandson. But my thoughts were racing ahead of themselves.

'And you're going to tell me you're part of those experiments, are you?' I said. For some reason, I was anxious not to let the enthusiasm I was starting to share show too readily.

'In a way,' he continued. I could see he was determined to finish his explanation. 'But our present plans are more serious than any purely scientific experiment, even a radical one like those my father prefers. What we're doing now goes far beyond any Government-sanctioned investigations. I'll tell you about all of it soon, but please be patient with me. I've got so much to tell you and not enough time to do it in.'

'Suppose you start by explaining what a "psi-computer" might be? "Psi" means something to do with the mind I know, but a "computer" is no more than a mechanical device, like the metal slide-rules I've read about. They use them for calculations, I believe.'

I was proud of this knowledge. Jet looked perplexed. For a moment he didn't answer, but then drew a deep breath and continued.

'I knew I'd have to explain this. I've spent hours and hours preparing for it. But now, sitting here face-to-face with you, it seems an impossible task. The idea of trying to summarise one of the greatest technological developments of the twentieth and twenty-first centuries is intimidating.'

Jet rose to his feet and paced around. As much as I wanted to say something to fill the gap, I thought it would be best to hold my silence. Then he stopped and leaned forward slightly, hands on thighs, to speak to me. It was the stance my father would have taken when he tried to answer one of my interminable questions as a young boy.

'Look, I suppose it would be right to say the first computers did indeed have a lot in common with the metal slide rules you're talking about. The early ones, in the middle of the twentieth century, were not much more than calculating machines, to be frank. Although you'd have to remember they were powered by electricity. Physically, they had more in common with your electric lights, telephones and radios – or wireless sets, as I think you'd know them.'

'Yes, go on.' I was naturally perfectly familiar with the operation of the electric light bulb and had used the telephone frequently as a journalist. Even now, I often used the instrument behind Raven's shop to order brass plates from the Pressings and Stampings Company in West Ealing. But I'd done nothing more than read a few lines about the theory of wireless broadcasting. I'd never seen a wireless-set, not even in London. Still, I wasn't going to say anything to Jet about this: I didn't want him to think of me as some kind of yokel. I couldn't quite see how any of these things related

to the calculating machines he was talking about. Wireless-sets were some kind of theoretical sound-box, so far as I was aware.'

Jet stood there and ploughed on with his explanation like the inexperienced didact he was.

'Later in the twentieth century, due to the invention of printed circuits and then microchips - never mind for now what they are – computers became vastly more sophisticated. Not only were they able to make super-fast calculations – or perhaps I should say *because* they were able to do this – computers were also able to do so much more. They could play chess; make sounds and music; use language. They could perform so many things it would astound you.'

'You're trying to tell me steel rules and electric light-bulbs are going to develop into a grand electronic brain, are you?'

Jet's face fell when I said this. He sat down beside me with an audible sigh. When he spoke again, it was with a lot less animation.

'No, I'm not quite saying that. In many ways, the computers we had in the early part of our century or at the end of yours could work much more quickly than the human brain. But the brain operates in a different way; its powers of learning and intuition are of a different quality.'

'I see,' I said. I didn't really see at all, but wasn't going to admit as much.

'That's where psi-computers came in,' he said, his enthusiasm returning. 'My father was heavily involved with the prototypes. Research engineers found ways of interfacing the computer directly with the human brain, so enhancing the powers of both. My father said it was a natural development for us to harness and magnify the mind's primitive ability to travel in time. Many people couldn't believe it when he was able to put his theory into practice.'

This was all extraordinary. I didn't know what to say. Later this evening, I'd sit quietly and turn it all over in my mind very carefully. It was the way in which I dealt with

complex ideas. This had served me well throughout my adult life. But I could see a difficult time ahead when I tried to puzzle this one out. I remained silent, trying to let the concepts sink in. Jet respected this, and sat without saying anything. It was I who was forced to break the long silence.

'So now you can hop around in time as your fancy takes you, then?' I said. My words sounded unnecessarily facetious.

'No, he said. He was being very patient, but this exasperated me all the more. 'It's not as simple as that. We can only "hop" back into the past – travel to the future is a logical impossibility, is what my father tells me –and then only along those timelines where we have some kind of connection. Like our family one.'

Here he fixed me with a searching look, as if he were expecting me to interject. I didn't flinch and he continued.

'Before we attempt to travel, we have to make a lot of careful preparations. The whole process takes an extraordinary amount of computing power. The times and the durations of our visit have to be pre-programmed for this very reason. I hope we've got it more or less right this time.'

'You got it badly wrong last Thursday, if you came then,' I said. It was raining hard.'

'Yes, we did get it wrong. I came, as I said I would. We're working from inadequate weather records, I should explain. When I arrived and saw what kind of day it was I guessed you wouldn't be joining me. I had to spend thirty minutes sitting here watching the rain. A pre-programmed thirty minutes.'

I laughed. He laughed, too. The tension between was relieved for a moment.

'Aren't you worried about the disruption you might cause to the fabric of time?' I said. I thought I should show him I wasn't a complete dunce when it came to outlandish theories.

'I know you won't,' I continued. 'Or at least I *hope* you won't murder your poor old great-great-great-

grandfather, but let's think for a moment about the possibility. If you did such a thing it would cause a few problems, wouldn't it? You'd cease to exist yourself for a start. Or it needn't be anything as dramatic as a murder. Haven't you heard of the "butterfly effect"? The smallest thing you in the past did might cause immense unforeseen changes.'

'You've heard of the "butterfly effect" theory?' He looked surprised.

'Yes. I've read all about it. The theory says that small variations of the initial condition of a non-linear dynamic system may produce large variations in the long-term state of the thing concerned,' I said, quoting verbatim from memory.'

I could see he was following what I had to say closely, so I pressed on.

'It's called the "butterfly effect", because the most common illustration given is that the flapping of a butterfly's wings might create tiny changes in the atmosphere so as ultimately to cause a hurricane to appear.'

His expression told me he was expecting me to continue further, so this was what I tried to do.

'In this case, the flapping wing represents the small change in the initial condition of the system that might cause a chain of events leading to large-scale change in future weather. If the butterfly hadn't flapped its wings, the trajectory of events over time would have been vastly different.'

'Very impressive,' he said. It was good to detect a note of simple respect in his voice. Or was he being ironic? 'You obviously know this so much better than I do,' he said. 'Can you say any more?'

'Not really,' I had to admit. 'I've read Pierre Duhem's 1906 book, but I'm no mathematician.' I didn't tell Jet I'd read the book as recently as last March.

'Well, it's an intriguing theory, but I'm afraid it's wrong.'

'What?' I said.

Jet laughed again.

'Oh, don't you worry. It was accepted by more or less everyone until about six years ago. My father was the one who finally proved it to be in error. His alternative theory was called "The Elasticity of Time". Sounds impressive, eh?'

Now it was his turn to show off some knowledge.

'Accepted wisdom in science is a peculiar thing,' he continued, warming to his subject. 'For instance, by the middle of your twentieth century there were two alternative theories of the origin of the Universe. These were called the "Big Bang" and "Steady State" theories. The latter fell out of favour later in the century. For a long time afterwards almost all scientists spoke as if the "Big Bang" was the only possibility.

'Then, about eight or nine years ago – eight or nine years ago by my reckoning, that is - Professor Erich Schmidt pointed out the fallacy in the mathematics associated with the "Big Bang". Now all scientists speak as if the "Steady State" is the only way. Oddly enough, it was earlier investigations in Switzerland using something called the "Hadron Collider" in Switzerland that pointed the way for Schmidt's research. The investigations with the "Hadron Collider" had been intended to underline the "Big Bang" theory. Anyway, do you see the parallel I'm drawing?'

For some reason, probably because of Jet's enthusiasm and sureness in what he was saying, I felt deflated by the airy way he announced this. 'I see,' was all I could say.

'Take the example you gave just now, of me killing you, for instance,' he went on breezily. 'It's true; if it happened I couldn't be the same person, but someone very much like me would still be living in the twenty-first century. And, don't forget, you're only one of my thirty-two great-great-great grandparents. All of us have that number, except where there are marriages between cousins of some degree. There are more marriages of distant cousins than you'd think. You and I happen to have the same surname, that's all. I

could be having this conversation with any one of my other fifteen great-great-great grandfathers'.

'So why aren't you, then?' I demanded. The way I was feeling at that moment certainly made me wish he'd visited one of the others.

'Because you were the perfect choice,' he said. 'You're absolutely spot-on. My father and I made the selection without hesitation. Anyway, the robustness of time would ensure that any alternative version of me would do much the same things. Except, that is, if someone were able unknowingly to alter a time-node.'

I couldn't bring myself to ask him what a "*time node*" was.

'I'm sorry,' he said, when he saw my downcast appearance. 'There I go again, letting it all spill out. But there's so little time, and I've still got so much to tell you. My visit last Thursday was a wasted thirty minutes. Today, I've been trying to make that time up.'

'You should know I'm no mathematician,' I said.

'Neither am I. It's not mathematics I'm here to tell you about. But I'd planned to talk about three more important things on this visit. If I still have time do it, that is,' he said.

He rolled back the left sleeve of his jacket, to reveal a watch. This wasn't the normal kind of fob-watch, but one more like those that became popular in the war against the Boer farmers in southern Africa. At least, I call the instrument a watch, but it was like no timepiece I'd ever seen. It was a black shiny object, with red glowing figures in place of hour and minute hands. I was able to read the numerals clearly. They said '14:11' in large numerals. Underneath this, smaller, though still easy to read, was 'FRI 25-05-46'. In distinct contrast to the slick-looking timepiece, on the middle finger of his left hand was the ornate ring I'd seen before. It looked even more elaborate today than when I'd first seen it.

'We still have twenty minutes. It should be enough time. I hope you don't mind if I hurry. The first is-'

'One more thing, first of all,' I interrupted him. He wasn't always going to be allowed to dictate the pace. 'You're not going to tell me the ring is from the twenty-first century? It looks a lot older than that.'

'In a way it is; well, the pattern of it is at least. It's one of the three things I wanted to tell you about. This is a copy of a Turkish ring from the mid-sixteenth century. The original is priceless. You won't be surprised to learn it'll be your most treasured possession.'

I looked at him in astonishment. What did he mean, '*my* most treasured possession'?

'But I couldn't allow you to give me such a treasure!' I protested.

'It'll be *you* who'll be giving it to *me*. I couldn't give this ring to you even if that was what I wanted; it's one of the things about time-travel. Nor will you be giving it to me directly. It will be a family heirloom passed down the generations.'

His extravagant claims were perplexing me.

'Actually, the ring I'm wearing *is* from the twenty-first century. This is no more than a gold-plated replica my grandfather had made about forty years ago. The original is safely locked up in a security vault. It's far too valuable to wear about the place.'

'I haven't got a ring like that. My father certainly never had one, either.'

Jet smiled. 'No, but you very soon will have. It'll be yours early on Saturday morning, to be precise.'

Jet could see I was looking at him with puzzlement. He was enjoying this moment.

'Go on, then,' I said. 'Tell your story.'

'I have to tell this quickly, Tommy. We don't have enough time.'

Then he paused for a moment. When he resumed speaking, he did so slowly, emphasising every detail of what he was saying.

'You'll find the ring when you go out for your morning walk on Saturday, the eleventh of July. It'll be buried precisely six feet due west of the footbridge across Coston's Brook. That would be in the direction of Coston's Lane. I've studied the map very carefully.'

There was only one footbridge across the brook. It was the same one where Mazod and I had taken our embarrassing tumble yesterday. I looked at him again.

'How can you possibly know a thing like that,' I said. 'Even if you're *really* a visitor from one hundred and thirty-two years in the future?'

'You'll tell me and earlier generations of our family exactly where you found the ring. That's how I know. You'll record everything about this month in writing. The notebooks you use will come down to us, together with the rest of your writings. That's the second thing I wanted to tell you about. Make sure you start the written record without delay. Record everything important you see this month. And write down all of your thoughts, too. It'll be easy enough for you.'

I looked at him, dumbfounded. "*The rest of my writings*"? I hadn't picked up a pen with serious intent in the seven years since I'd had to resign from the staff of *The Independent Record*. But I could see he wanted to say something else.

'So what's the third thing you wanted to say?' I asked him.

'Well, the third thing is something for me, to be honest. Do you remember the sketch you made in 1907 of the Communists? The one you were drawing when I saw you in London that time? Did you finish it? It never came down to your descendants. Do you still have it?'

'The Anarchists you mean? Those Russians I drew in Fulborne Street, just off the Whitechapel Road? I finished the drawing and still have it. They were going to use it in the paper but decided not to bother in the end.'

I remembered the incident only too well. Not only was this the last occasion in the past when I had encountered Jet,

but I could still feel the keening disappointment I knew when the Editor had decided not to use the illustration because of space limitations. He preferred to squeeze in another advertisement for damned *Eno's Salts*. I never drew anything else for them in the remaining weeks I worked there.

'Can I see it? Can you bring it with you next time?' Jet asked.

'You can have it with pleasure. When will be the next time I see you, anyway?'

'No, I can't physically take anything back with me, in the same way as I can't leave anything here. And I also told you my visits have been pre-programmed. I won't be able to be here again until Monday of next week. I've given you quite enough to think about as it is, I'd say.'

I liked Jet, but not his air of superiority. Besides, I didn't care to be bossed about from the twenty-first century.

'If I do find the ring I'm going to have to give it straight back to its legal owner.'

'You can't do that!' he said, alarmed. 'It's got to be passed down through our family. Besides, I told you it's from the sixteenth century.'

'You'll be telling me next it belongs to the Ottoman Empire,' I said.

'If it belongs to anybody, it does belong to the descendants of the Ottomans. We've researched this aspect of history very carefully. There was an exact duplicate of the ring made by Suleiman the Magnificent, or the Law-giver as they sometimes called him. The one known about to your history is still in Turkey.'

Turkey? Greenford? It sounded too fantastic.

'Then what was this one doing here in Greenford?'

'Nobody knows. Perhaps some traveller found it, and then lost it here when he returned home. Quite probably this all happened as far back as the sixteenth century.'

'Then the ring should be classed as Treasure Trove,' I said. 'I should really hand it to the Crown Agents.'

'Perhaps, but you're never going to do that, are you? You're not exactly the greatest supporter Royalty's ever had.'

'Or maybe I should take it back to Constantinople,' I persisted doggedly. I'd hardly do such a thing, but I wasn't going to let him get away with such a comment so easily.

'*You can't go back to Constantinople.*' He sang this as if these were the words of a music-hall song.

'What?'

'Constantinople is going to change its name to "Istanbul" in twenty-odd years.'

'Now, why should the Turks ever dream of doing such a thing?' I protested. The capital city of the Ottoman Empire has been called Constantinople for centuries.'

'*Why they changed it I can't say. People liked it better that way.*' He was singing again.

'Have you gone mad?' I asked.

Jet became serious in an instant.

'I'm sorry. I couldn't resist it. Those are lines from a song popular in the middle of the twentieth century. Then it was revived early in the twenty-first. Now it's become a favourite once more in our own time. I saw Elanic images of both the old versions through my Linker a few hours before I left home. I'm sure the new version will make it into the Sleb Libraries. It's everyone's ambition to make it into those. That's why the song is buzzing around my head. Everyone is talking about it.

'Anyway, as I was saying, Constantinople won't always be the Turkish capital. And the Ottoman Empire will disappear altogether in a little over four - goodness me!'

He glanced at the strange device on his wrist.

'What's wrong?' I said.

'I've run out of time. I've got to go!'

Even as he said this he was fading from my view like some latter-day Cheshire Cat. On his lips, as he disappeared finally from my sight, I could barely make out his mouthed

words. I guessed two of them to be "ring" and "book". He hadn't even begun to explain what an 'Elanic Image' was.

Then I was intensely aware I was once again alone on the hill. It was deathly quiet. Not even the sound of bird song could be heard.

*

On the way home, as I was crossing the Black Horse Bridge, I made up my mind to show my defiance. The idea gave me a thrill of pleasure when I thought of it. It was the same kind of feeling I'd known years before, when I scribbled something rude on my slate in the Betham School, or pinched the girl sitting in front of me when the schoolmaster turned his back.

I'd write up a record of this strange month of July as Jet had asked. There were two large blank notebooks at home. They'd belonged to my father, who'd had some notion of writing a record of King Edward's Coronation. The Coronation − \I ask you! Needless to say, he hadn't even started the project. Now, those notebooks would be perfect for the job of writing my notes of this fantastic month. I wouldn't be content to make the record merely in note form; I'd write in as much detail as I could.

I'd also go digging for the Turkish ring by the Coston's Brook, precisely where he'd told me I'd find it. Nobody could fail to have his curiosity aroused by Jet's words and the sight of the ring. But I'd do it on *Friday* morning rather than on Saturday. I'd put what he'd called 'the elasticity of time' to the test.

Tuesday, 7th July, 1914

Vicky looked to be in the pink of health as she opened the side door of the forge. I mean this quite literally. Her complexion was even more florid than usual and her ample frame was adorned with a pinafore of a vivid rose colour.

'Tommy!' she said. 'We haven't seen you since May at least. It may even have been April when you last turned up on our doorstep. Why have you been avoiding your old friends?'

'Don't be daft, girl. I've been up to my eyes in work, that's all.' This was hardly true. I'd been busy enough for the last few days, but for months past my business had been in the doldrums.

A small figure peeked out from behind the vastness of Vicky. 'That's young Hannah hiding there, isn't it?' I said, motioning as if to seize the three-year-old. She disappeared into her maternal bolt-hole with an excited squeal.

The truth was I hadn't been around to see John and Vicky Jakes so often lately. They'd both been my good friends since our days in Betham School. Vicky had been a year younger, but she and John had become childhood sweethearts on the day they'd met. They'd married the day after John's twenty-first birthday. Their first child, a boy, had died at less than a year old. Now, both parents doted on Hannah.

'Well, come on in then. John will be with us shortly. He's washing in the back yard. Getting the stink of the smithy off himself, he likes to say. I always tell him; that smell is our food on the table, and don't you forget it.'

Vicky smiled and led the way to their kitchen. Hannah followed, skipping. She recognised me with confidence now, and her mother's words and manner had put her at ease. She

kept glancing at me over her shoulder, daring me to say something else to her. I didn't, but pursed my lips at her and crossed my eyes. As usual, this made the little girl collapse in a fit of giggles.

'You'll stay like that if you're not careful, Tommy Green,' said Vicky, looking back at me with mock-seriousness. 'And as for you, Hannah Jakes, you shouldn't tease your Uncle Tommy all the time'. Hannah, with her back to her mother, tried to imitate my face-pulling to comic effect.

The kitchen was unbearably hot. An enormous fire roared in the grate. The day had been cooler than normal for the time of year, with steady rain falling until an hour ago, but this was July. Still, it was Vicky's way: too much heat; too many big meals; too much fussing around the cottage after her family. Too much of most things, really. But there was always plenty of love for her husband and daughter. You couldn't say there was too much of this.

'Tommy. I thought I heard your voice.' John poked his broad head around the back door. 'Be in shortly.'

John Jakes was the village blacksmith, and you'd have guessed as much from a glance at him. He was brawny and wide-shouldered; you could imagine the rippling muscles underneath the shirts always seeming to be one size too small for his frame. During his working day he didn't even wear a shirt; satisfying himself with a loose singlet under his leather apron. Not even that on the hottest days of summer; he preferred then to be bare-chested for his trials of strength against the horses and the forge. His good-natured, ruddy face was fringed by a luxuriant black beard. You'd swear he'd been born with this fierce growth. Now, it was impossible to imagine him without facial hair, though in fact he'd only been letting the beard grow freely for a year or so.

Yet John hadn't always been the archetypal village blacksmith. When he'd come to Betham School, during my

last year as a pupil, he'd certainly been tall, but was a nervous, scrawny youth who wouldn't have said 'boo' to a goose. His underfed appearance in those days was the result of the meagre meals he'd been fed at the 'Cuckoo School', the institution for orphan and destitute boys in Hanwell. John would doubtless have spent the rest of his childhood there before being shuffled off to some grim indenture designed for pauper children as soon as Cuckoo School could get rid of him. Then, in the nick of time, his Uncle Eddie had come to the rescue.

Eddie Page had died only a few years ago. He was still working well into his seventies as Greenford's blacksmith. This was before John had taken over. Mr Page had put meat and potatoes into his belly and a blacksmith's hammer in his hand. John had taken to both as if born to them. People travelled from miles around to the smithy, even though many of them had a blacksmith in their own villages. John's appetite for work and food had been prodigious ever since he'd come to Greenford.

My friend was never happier than when hammering away in his forge. Except, that is, when he was in the bar of his favourite public house, *The Hare and Hounds*, nursing a pot of ale in his hand. Ale was the reason I didn't see John so often these days. I didn't have his head for drink. His thirst for beer was getting stronger as the years went by. My own, never intense even in my youth, was getting weaker.

*

'Your Vicky looks in fine health,' I said to John, as we set off westward along the Ruislip Road.

'Aye, that'll be little Tommy,' he said.

'Little Tommy?'

'Little Tommy Jakes. Hannah Jakes' young brother. Going to be the next village blacksmith, I shouldn't wonder.' John grinned broadly.

'You mean...?'

'Of course it's what I mean. Vicky's seen the midwife today. Next January our Tommy will be coming, so the woman tells us. I'll give him a few years at school – you know, to learn to read and write and all that nonsense – before he has to get down to the real world of anvils and horseshoes. A good father, I'll be.'

John grinned at me, cocking one eyebrow in that characteristic way of his and hoping I'd rise to his teasing. Despite what he'd said, John had proved to be a fine scholar in his short time at the Clock School, and well appreciated the value of education. In fact, both of us might have gone on into the rarefied strata of college education, if our circumstances had been different. Not that either of us complained. John had always been keener to get to work in the smithy, whilst I was happier to find my own education through reading. All my life, I'd been an avid reader.

Nowadays, John may have liked to portray himself as the bluff strongman of the village, but beneath this he was a thoughtful and intelligent man. It was one of the reasons why I wanted to talk to him tonight. The more important one was the strong friendship we'd enjoyed for so many years.

'Who's your son going to take his name from?' I asked. I knew the answer to this before I spoke, naturally. What I really wanted to ask John was how he could know the baby would be a little Tommy. I'd already guessed the answer to this question. He didn't know whether the baby was going to be a boy or girl. A son was what John wanted, so he'd made up his mind a son was what he was going to get.

'You're slow tonight, my old mate,' he said. 'I thought you were supposed to be the brainy one of the two of us? Of course I'm going to call the lad after my best friend.'

'That's good. I'm really honoured, John. I thought you'd want to be calling your son after your Uncle Eddie, or one of Vicky's brothers, or even after yourself.'

'Vicky would only get the two of us mixed up if we called the lad "John". You know how she can be. She's got seven brothers: we wouldn't want them all fighting about the baby's name. There are enough "Eddies" in the World already.'

I didn't say there were even more "Tommys" in the World.

'To tell you the truth, we were nearly going to call my son and heir "Charlie". We had to think hard before deciding,' said John, grinning at me. I knew he didn't mean this. 'Especially since I got a letter from Charlie the other day. Took three months to reach me, the letter did. I don't know if it's the fault of the General Post Office or the US Mail. This Pony Express must run into trouble with shooting parties.

'I'll tell you what he said in his letter when we get to the *Hare and Hounds*. You'll be amazed. We can't stay in the pub too long tonight, though. I've promised Vicky I'll be back by nine o'clock. I'm out skittling on Thursday. You know what those boys on the team are like for their demon drink.'

I was relieved to find that tonight I wouldn't be playing the supporting role in one of John's marathon drinking sessions. At the same time I was disappointed to learn I'd be pressed to get the chance to talk about what was on my mind. A letter from Charlie meant that, not only would John want to go over every detail of it, but he'd also want to recount endless stories about his friend's doings in America.

He was a music-hall comedian, this Charlie - Charlie Chaplin. A couple of years ago he had gone to make his

name in something the Americans called "vaudeville". It sounded exactly like music hall was supposed to be to me. John was very proud of Charlie, who'd been with him in the 'Cuckoo School'. Both of them had improved their lot since those hard times.

Normally I'd have been happy to sit and be entertained by John. Tonight, though, I really wanted to hear what John would have to say about the cross-roads at which my life had arrived. I knew I wouldn't get the chance to air my own thoughts and feelings now. But what can you do when your best friend has just told you he plans to name his son after you?

*

There'd been heavy rain earlier in the day. As usual, most of it seemed to have stayed on the surface of Ruislip Road. It always got me down when it was wet like this. Still, I tried to keep up a light banter with John, who was in an even better humour than usual. It was a relief to me when we crossed Muddy Lane and the *Hare and Hounds* came into view.

Further along, on the other side of Ruislip Road, outside 'Harrow View', a wagon was being loaded up with produce from the market garden. Tigwell and two of his men were hard at work, later than usual because of the rain. They were working to ensure the load would be ready to go out first thing in the morning. The three of them knew John and myself – probably they knew John very well – and waved a greeting in our direction.

Although we were looking upon a familiar scene in the village, I felt acutely at that moment I wasn't part of its life. John was my friend, my very good friend. I knew both of Tigwell's men. Even Tigwell himself respected me well enough. But over this last week I'd started to feel I didn't really belong in Greenford. As I watched, this feeling

suddenly intensified. I felt like an observer, almost a foreigner, walking by John's side.

Why should this be? Greenford was the place of my birth. I'd lived in the village for most of my years. It surely wasn't because I was having ideas above my station now that Mazod was offering me friendship. My hopes for something more between us in the future were strong but I knew I'd have to keep reminding myself it might all come to nothing.

Mazod's interest was incredible enough, but I was also becoming surer that my unworldly feeling could only be because of the other, far stranger encounter I'd known in the last week: my meetings with Jet. It was as if the road ahead suddenly branched in two opposite directions. In one way the sign pointed to the life of respectable village craftsman, although with a woman beyond his wildest dreams at that craftsman's side. As for the other direction – well, I didn't really know where that might lead.

John was keeping up a stream of excited chatter about Charlie as he walked by my side. Most of it I'd heard before. At the Cuckoo School he'd, at first, been friendlier with Charlie's older brother, Syd. This brother was about the same age as John and they had a number of other things in common. Both of them had been born in Lambeth to mothers who were struggling music-hall artistes. Both of their mainly absent father – a stepfather in Syd's Case – laid claim to some sort of French descent. Chaplin was supposed to be a French name, John had told me, and so was 'Jakes', spelled as 'Jacques' at one time. And both had shown determination to improve their hard lives.

John had never properly explained why he'd maintained the friendship with Charlie, rather than Syd. I found this strange, especially since John had told me the Chaplin brothers often worked together in their new life on the stage. I resolved that tonight I'd ask him about this. If I might not have the chance to talk about my own future, I'd at

least look for the answer to a puzzle that had vaguely troubled me over the years.

*

'Two pints of porter, Ken.' John said.

Ken was the mournful son of the even more mournful landlord of the *Hare and Hounds*. For some reason Mr Weedon senior wasn't here tonight. There were few enough people in the bar and we were able to find a seat without any trouble. This was unusual for this public house. Despite its isolated position on the edge of Greenford, practically in Northolt in fact, it was normally crowded.

It would certainly be even busier when they finally got around to finishing the new Ravenor Park Estate on the other side of Ruislip Road. The builders had begun to mark out the roads. We knew they were going to be given fancy names like 'Roland's Dene'; 'Eastmead'; and 'Crossmead'. The developer had even started to plant trees to justify the epithet of 'Avenue', although few houses as yet had so much as foundations. John said new developments like these would alter the face of Greenford.

I wasn't so sure. The arrival of the Great Western Railway ten or eleven years ago hadn't made a great deal of difference to the life of the village. People had probably been making similar predictions about the future more than a century ago, when the Grand Junction Canal to Paddington was excavated. Anyway, I thought the face of Greenford could do with some changing, or at least that some of the sleepiness should be rubbed from its tired eyes. The two of us would often have lively arguments on this subject. Not tonight, though.

'Charlie tells me he's left Fred Karno's company altogether, now,' said John, almost before we'd sat down with our pints. 'He's signed a new contract with an American called Mack Sennett. This man Sennett saw him on the stage

a couple of years ago in New York, when he was still with Fred Karno's troupe. Charlie was in *A Night in an English Music Hall*, with William Morris's outfit. Sennett decided there and then Charlie was one for the future. At that time, Sennett himself was earning only five dollars a day in DW Griffith's Biograph Company. Goes to show, eh?'

I never ceased to be amazed at John's encyclopaedic knowledge of Charlie's doings, so I merely nodded to him and sat back.

'What I was thinking, Tommy, is that you and I should go to one of the new picture-houses to see one of Charlie's films. He's made two or three films already. They're being shown over here, he tells me.'

'Why don't you and Vicky go? You should take your wife.'

'You know very well Vicky wouldn't be interested in things like that,' John said. 'There's *The New Paragon Palace*, the cinematograph theatre in Southall. Or there's the new bigger one at the junction of Northfield Avenue and Uxbridge Road in West Ealing. *The Kinema*, they call it. Come on, Tommy; liven up. What do you say?'

'I don't know, John. I've never been to a picture-house. Isn't the cinematograph supposed to be bad for your eyes?'

'You don't want to believe that nonsense. Films are the coming thing. They're going to wipe music-hall right off the map. The music-hall bosses are probably the ones putting around this story about people's eyes. Tommy, be a sport.'

John looked so keen for me to say "yes". I was intrigued by what I'd heard about the cinematograph. As far as I could make out, it was a series of moving pictures of music-hall acts shown on the wall. Besides, this story about damage to your eyesight probably was nonsense, as John was saying. And I'd see at last what this Charlie looked like.

'All right, John,' I said. 'You find out when one of the Charlie Chaplin films is on. We'll go together to see this music hall-on-the-wall.'

'Great. I'd better tell you there's no sound, though. Someone plays a piano. And you won't be seeing any colour, come to that.'

'No sound? A music hall with no sound? No colour? This I must see. You find out when it's on and we'll go.'

'I've already found out,' said John, looking sheepish. 'Mr Weller, the Manager of *The New Paragon Palace*, tells me that *Kid Auto Races in Venice* is being shown in his cinematograph house early next month.'

John sat quietly for a moment. Then he drained his glass at one gulp. I knew his silence would give me the chance to talk about the things on my mind. But I could also see now was not the time. John's imagination was firmly in California. John could see himself in America, being on the stage or, now, making music-hall films with this Charlie Chaplin rather than being a blacksmith in Greenford.

'Another pint, John?' There was no point in asking, as John's beaming features told me.

*

'Tell, me John,' I said, putting down the foaming glass of porter in front of my friend. 'How come you've kept in touch with Charlie rather than Syd for all these years? Did you have some sort of falling out with big brother?'

'No, nothing like that. Syd's no letter-writer, that's all. Charlie keeps me in touch with what Syd's up to. The two of them are going to work for Mack Sennett.'

John took a sip of his beer, and absently wiped his beard with the back of his hand. I knew there was more to it.

'And?'

'What do you mean by "and"? Give a man a break.' he said.

'Come on John. I'm supposed to be your best friend'

'You are my best friend.'

'Well, then.'

'There's nothing shameful about it, if that's what you're thinking. Charlie sees me as a special friend. That's all there is to it. He doesn't forget old favours. Not Charlie.'

'I never said there was anything shameful about it,' I protested. 'What old favour are you talking about? Something when you were both in the Cuckoo School?

John took another sip of his pint. He always drank slowly when he was thinking hard. He gazed into the distance. I'd reminded him of an episode from a past he wanted to forget.

'Who are you playing skittles against on Thursday?' I asked, although I couldn't have cared less. I knew I'd touched on a painful subject and was sorry I'd mentioned it. Now I wanted to talk about something else. Anything would do, even a game of skittles.

He ignored what I was saying and looked down at his pint. Some moments passed before he started to speak. His words were voiced slowly and uncertainly at first, but as his story unfolded, he spoke quickly, with animation.

'I've told you Syd was my friend when we were in the Cuckoo School? Well, Charlie was no more than his kid brother at first, so far as I was concerned. I liked the boy well enough, but he was only about eight years old. I was nearly four years older.

'Anyway, the day came when Syd left the school. He joined the Navy to go on board the training ship *Endeavour*. It was where I might have gone myself. The last thing he said

to me before he left Cuckoo was, "*John, do me a favour. Look out for Charlie. Keep a close eye on my brother for me.*" Well, you had to keep a close eye on that kid, I can tell you. Always getting into scrapes, he was.

'Still, I managed OK as Mother Hen. Kept him out of trouble, most of the time. Then one day, as luck would have it, Charlie and I were the two boys picked to represent the School at one of Queen Victoria's Diamond Jubilee Parades. In June, 1897 this was; not so long before I left the orphanage and came to live with my Uncle Eddie. We were meant to wave a silly little flag and cheer as the old Queen drove past in her carriage. That kind of nonsense. We were given a sausage roll for our troubles, though. Not so bad.

'Of course, Charlie wouldn't leave it there. Not our Charlie. He waits till the carriage draws right alongside us and then, oh yes, he waves his flag right enough. But then he pulls a face at Queenie. He pulls a face at Queen Victoria! As luck would have it, she turns to look in our direction at that very moment. Well!

'I could see how angry she was. She turned and whispered something to the man riding behind her carriage. The postilion, he's called. Or is that the one who rides at the front? I don't know. Anyway, this man - he had a very long nose and looked even older than the Queen - joins her in looking daggers at us. I swear if Queen Victoria had been fifty years younger she'd have jumped down from the carriage, caught hold of Charlie by the throat, and shouted "*off with his head*" like in the story. Stunned by it all, I was. Not Charlie, though. He fell about laughing as if he'd made the best joke in the world.'

John reached for his tankard and took a big gulp. He smiled, reliving the moment. If Charlie's boyhood deeds weren't the best jokes in the world, I could see they were strong contenders for the title in John's mind. Then his expression grew more serious.

'There's more to this story,' I prompted.

'I was sure we'd be for it when we got back to the Cuckoo School, even though the Master hadn't been near enough to see Charlie's antics,' John continued. 'But nothing did happen. Neither did anything happen on the next day, or on the day after. But then, on the Thursday of the following week, there was a bugle sounding in the yard. As usual Captain Hindrum read through his old megaphone the names of the boys who were to be punished on the day after. Friday was always punishment day. And, this week, Charlie's was the only name on the list. Hearing his name read by itself made things seem all the worse. I couldn't sleep that night.

'Those Fridays were always terrible, but this was the worst I remember. We used to be lined up in the big hall, so as to make three sides of a square. On the fourth side they'd put a long school desk where the boys to be beaten had to stand in a row. Eight-year-old Charlie was there by himself. He was white and trembling. They didn't usually punish boys of that age, not in that way, but I could see old Captain Hindrum was itching to let fly.

'On the right, in front of the desk, was an easel with wrist-straps dangling from it. You could see the straps had worn from being used so much. From the frame of the easel they'd got a splintered birch rod hanging. When I looked at it I suddenly thought, "Jesus; they're going to birch Charlie instead of using the short cane. It'll kill the poor kid." So I broke away from the line – you wouldn't normally dare to do such a thing – and shouted, "*It was me, Sir. I pinched Charlie and made him pull a face at the Queen. I'm sorry, Sir.*"

John was reliving the moment.

'You could see Captain Hindrum didn't believe a word. He looked at me in that sneering way of his. Didn't say anything at all. Then he got one of the Sergeants – a big bugger, he was – to lay me face down across the desk and hold me tightly so I couldn't move.

'The other Sergeant pulled my shirt out of my trousers and over my head - they always did that - and clamped his big fat hands around my ankles. It was a long time – it seemed like a long time, anyway – before anything else happened. Then I felt it. The first stroke across my back. It really hurt. You know how skinny I was when I was a kid. Captain Hindrum was sixteen stones if he was a pound. Bastard.

'There were five more strokes. I don't mind admitting I was blubbing like a baby by the time they'd finished. Then, when I stood up, I realised they'd only used the cane after all. I looked again at Captain Hindrum. For a moment I thought he was going to use the short cane *and* the birch on me.

'He must have seen the question in my eyes, because then he said in that booming voice of his, "Jakes, I haven't used the birch today although this crime warrants it. This is because you showed some decency in speaking up". That was all he said directly to me. Then he turned around to the other boys and said in his booming voice, "Let this be a moral lesson to you all. Always be prepared to speak up when it is the honourable thing to do. Dismissed!" Notice that he didn't say anything about "the truth". To go by the look the man gave Charlie on his way out I'd say the captain knew the truth all along.'

John's ruddy face had become white while he was telling this story. It was as if he'd become a scrawny twelve-year-old again, rather than the powerful man I knew who tipped the scales at seventeen stones. Nowadays, he could lift the heavy anvil in his smithy more easily than I could a cooking-pot. I didn't know what to say.

'I'll get you another pint, John,' was what I did say. It was as good as anything.

*

The bar was busier now. It was a few minutes before I could come back with the two tankards. This time, I'd decided I needed a drink myself. I was relieved to see some of the colour had returned to John's cheeks. It was good to see the ghost of his usual smile playing around his lips.

'All I was telling you about happened seventeen years ago, Tommy. I've never told anyone, not even Vicky. Charlie's remembered it though, for all these years. That's why he still keeps in touch. And he's doing a lot more.'

'Oh?' I said.

'I wasn't going to say anything yet, but he wants me to go to California to work in the films with him. I've sent him a photograph and he says I'd be exactly right as the villain. I'm going to go, Tommy. I'm going to go. I've sent him a letter and his reply should come any day now.' He saw me raise my eyebrows. 'A bit of make-up works wonders, Charlie says. And I can pull a few fierce faces. Like this-'

Here he made a face. To me, it looked more comic than fierce. Maybe a bit of make-up would help.

'Well, yes, I suppose so.'

'To tell you the truth, that's why I'm so keen to go and see *Kid Auto Races in Venice* next month. Then I can practise my acting to get it right.'

So, my old friend John might be going to California, then. I could hardly imagine such a thing. Still less could I imagine Vicky in America. She hardly ever left her domain behind the smithy. And what of the baby?

'What does Vicky say, John? You know, with the baby coming next year and all?'

'We've talked about it. It'll be a wrench for her to leave her brothers and sister behind, but she's going to do it. We've decided it would be a good idea for us to get a boat in October. Tommy Jakes will be born an American. He won't

be Greenford's blacksmith after all. I wasn't telling you the whole truth a while back. I'd have told you of my plans in September. But you've got the story now and I did promise Vicky I'd be home by nine. It's a quarter-to already.'

I reached for my hat. Tonight I'd hoped to speak of my own future. John had spoken of other things. But I did still want to talk myself.

'John, I want to say something about my own plans. Well, not exactly *plans*. More thoughts and ideas, you'd have to say. Not tonight, I know we haven't got time. When can we do it?'

'You're the one with the ideas, old friend. I'm only the village blacksmith. Until October I will be, anyway.' He winked at me. 'But I've promised Vicky I'd only be out on one more evening this week. I'm skittling on Thursday, like I told you. We're playing the team from the *Load of Hay*. Tell you what – we're one short on our side. How about you standing in?'

Playing skittles was the last thing I wanted to do. I'd hardly ever played the game. John had seen me on an alley one evening years ago when I'd had a few lucky rolls. Ever since then he had it fixed in his mind that I liked the game and was good at it. So, on Thursday evening I would be playing skittles for the *Hare and Hounds* against *The Load of Hay*. There was nothing else for it.

Wednesday, 8th July, 1914

Do other men experience quite the same thing? I'd never dared to ask anyone, at least not directly. When I'd questioned John in a roundabout way a few years ago, he'd laughed uproariously, thinking I was making a joke.

Every ten days or so, I was possessed by an overwhelming surge in my libido. It was as if some madman within was straining at his manacles. After a few more days it would be so all-consuming that I knew a physical pressure behind my eyes. I grew edgy, clumsy, and couldn't sleep two hours together in the night. Although I tried to keep myself in check, I knew I became short-tempered, too. It was like finding yourself chained to a lunatic.

This had been something I'd lived with from the age of eighteen, or even younger. It wasn't that I wanted for female company in my youth. At first, the village girls found me amusing and good company. I suppose they found me physically attractive, too.

A few days before my nineteenth birthday one of them, Felicity Dunham, had shown a willingness to let me indulge my fancies. The difficulty came when straight afterwards she assumed proprietary rights over me. I was mightily relieved when a few months later she moved away to Brighton with her family. Otherwise I could now have been a married man like so many of my contemporaries.

Of course, now I can appreciate the way Felicity had been looking at our friendship. A woman of any class would have done exactly the same. With more mature reflection, I realise this only too well. Women in our society have so little on their side: it's no wonder they place such value on the one thing they do possess.

Soon after Felicity Dunham moved to Brighton, there was the awful scandal with Priscilla Clarke. From that day

forward the village girls shied away from me. Who could blame them, when this disreputable episode had been embroidered and passed into village legend? More than once I became aware of one or the other of the village girls looking at me, while her friend – the village girls usually went around in pairs; to protect their honour, I suppose – would shake her head and mouth something like '*strange*'.

The solution was provided by Rosie. She knew how to loosen the madman's chains for a few days.

I'd been going to Acris Street for ten years. For seven shillings and sixpence, I could ease my tensions for an uncomplicated fifty minutes. By now, there was more than a purely commercial liaison between us. A genuine affection had grown up. Unless I was deluding myself, she looked forward to these fortnightly visits almost as much as I did, though perhaps not in exactly the same way.

There wasn't one fortnight I'd missed in the last ten years. Even during my newspaper interlude, when I'd lodged near Whitechapel Road on the other side of London, I'd still make the trip across the city to see Rosie in Hanwell. And for all of that time I'd never been with any other woman, even though there were plenty of common doxies around who'd have charged a lot less than Rosie for their favours.

*

Early closing on a Wednesday had been laid down by Parliament a few years ago. To tell you the truth, I was never sure if the new law applied to me because, like my father and grandfather before me, I'd never been able to afford to employ a shop worker anyway. Henry Trevithick's easy talk of 'a pretty girl or two to front the shop' had been both exciting and vaguely alarming for me.

People like the Ravens might complain about greedy shop assistants and the activities of their trade union, the NAUSAW&C, but for me the Shops Act helped justify a

welcome break in my wearisome routine. A comfortable pattern to my weeks developed. Whenever the demands of trade allowed it, I would spend alternate Wednesday afternoons in happy idling.

I liked those lazy afternoons, but the Wednesdays of alternate weeks were precious to me. Today was one of those days, and the avalanche of emotions I'd known this month had made me anticipate the day even more keenly. I needed to call into the Pressings and Stampings Company in West Ealing to place an order and pick up some brass plates. Also, because there was too much money - too much money! - on my premises I knew I should also make a call at the London and County Bank in Ealing Broadway.

But the plain fact was that I wanted to go to Hanwell. It was with feelings far beyond my normal fortnightly quiver of excitement I found myself turning the key in the heavy key to lock the street door of the shop.

Thank goodness for Rosie!

*

There was an extra spring in my step as I passed the Red Lion inn and followed the Ruislip Road eastwards alongside the Brent. The river itself looked deceptively handsome in the afternoon sunlight. At least, it looked attractive until I crossed Greenford Bridge and got closer to the unclean water. Still, before long everything was right with the world and I was making the steady ascent up Cuckoo Lane towards Hanwell.

At first I saw no-one else on the road. Then, coming down the hill from some way off, near the Cuckoo School, I saw a couple walking arm-in-arm. Before too long the sight of them was unmistakable: Mrs Raven, whose beaming face I could imagine long before it became near enough to make out, and Mr Raven with his slightly awkward gait. He was

wearing his usual grey suit. It was far too small for him, especially in the trouser-legs.

You know how it can be when you recognise people coming towards you from a long way off? There are awkward stares for what seems to be forever, but neither party is sure when it would be polite to call a verbal greeting. Both are too conscious that it would never do to yell like louts from too far up the road. This time it was I who spoke first; Mrs Raven was smiling at me as if she were fit to burst, and I felt obliged to ease her discomfort.

'Hello, Mr and Mrs Raven,' I called. When they drew respectably nearer I continued. 'I don't usually see you walking down the lane on a Wednesday afternoon. You're both well, I trust? The new shop's doing well, so I hear, Mr Raven.'

Like so many of his generation, Mr Raven was a man of very few words. When we drew level he favoured me with no more than a good-natured grunt before looking to his wife to speak.

'We're both very well, Mr Green,' she said. 'Today was such a beautiful day that I asked Minnie if she'd mind closing up the shop in Greenford for me. Then I walked up here so that Raven and I could stroll home together for a change. It's far too nice an afternoon for us to be cooped up indoors slaving over our cash-books. So I turned to Raven, "Raven, I said, 'Mr Green never misses his fortnightly walk. Why should we always have to do our cash books on a Wednesday afternoon?" So here we are, on our way down Cuckoo Hill.'

'Good for you', I said. 'Well, I mustn't keep you from your constitutional. Good day to you both.' I was keen to be on my way.

Mrs Raven clearly wanted to say more. She took one step nearer.

'Well, now we're all here there was one important matter we wanted to discuss with you. As a matter of fact we were going to call around to your shop this evening. Weren't we, Raven?' she said, turning to her husband. Mr Raven nodded gravely. At that moment I wondered if the shopkeeper even possessed a first name. At least his wife wasn't addressing him as "Old Raven".

'Really?' I said, surprised. They'd never called around, at least not the pair of them together, for as long as we'd been neighbours. 'That'd be very pleasant. But I haven't got much spare time at the moment. And the last thing I'd want is to interrupt your walk. So, if you'll excuse me until this evening...'

'It won't take us long,' said Mrs Raven. Then, without waiting for assent from me, she turned to her husband. 'Shall I tell him, or would you like to, Raven?' Mr Raven waved vaguely with his right hand for his wife to continue. I'd have been amazed if he'd done anything different.

'What are you doing on the evening of Tuesday, the fourth of August, Mr Green?'

'Nothing, as far as I know.' This seemed to me a strange question. 'Why do you ask?'

'It's the date of the next meeting of HADS. We always meet on the first Tuesday of each month. We've never missed a meeting in ten or more years.'

'But I don't go to the meetings.'

'Ah, but we want you to go to the August meeting. And we'd like you to come with us every month after that. We're going to propose a new member.'

'You surely can't mean me?'

Mrs Raven looked towards her husband and then at me. She was enjoying this moment.

'It should be no surprise to you, Mr Green. You're doing such a good trade all at once. I always knew you had it in you to be one of the leading traders in our village. And an engraver's business adds a bit of class, too. I've always thought so. So, will you come along with us?

'Yes, I suppose so.' I didn't intend to sound so grudging, but I was anxious to get to Ealing, and more especially to get on to Hanwell. 'Yes, I'll be pleased to be there. Good day to you both.'

*

The disappointment written on the faces of the Ravens! Being asked to go along to HADS, as Hanwell and District Shopkeepers' and Traders' Association was known, was like being invited to pass between the Gates of Paradise as far as the Ravens were concerned. Actually, the group was no more than a small organisation of local traders. Hanwell and Southall didn't have nearly as many shops as Ealing. Greenford possessed even fewer. There were no more than two or three members of HADS hailing from Northolt, and they were innkeepers rather than shopkeepers.

My diary, if I'd possessed one, would have been filling up rapidly: Henry Trevithick was calling to see me on the thirtieth of July to discuss his business proposition and John wanted us to go *The New Paragon Palace* in Southall on the following Monday. Now the Ravens wanted me to go to HADS on the day after that. I felt that, with some reluctance I have to say, I was being drawn into the life of the village.

When I reached the busy Uxbridge Road, I was tempted to turn right toward Acris Street rather than left toward Ealing. But I knew this would be pointless. Rosie wouldn't be expecting me before four o'clock and, besides, I did have genuine business to conduct in Ealing. It made me uncomfortable to have so much money about my person.

As I always did, I counted the motor-cars speeding by as I walked from Hanwell to West Ealing. There were thirty-seven of them, plus two motor-cycles and a few lorries. This was two or three times the number I'd have seen as recently as five years ago. If anything was going to bring more people to Greenford, it was vehicles like these, rather than the Great Western Railway. You often saw a few motor-cars passing along Ruislip Road or the Old Field Lane. Still, machines like these were the preserve of the monied classes, so perhaps they wouldn't change life much, either.

It suited me when I passed only acquaintances as I progressed along the Uxbridge Road, and so could limit contact to a polite doff of my hat and a "good afternoon". And it was a good afternoon, not least weather-wise. The sun was shining from a cloudless blue sky and I had plenty of time in hand, so I strolled at a leisurely pace as I continued through West Ealing. I suppose I could've got the tram at least in one direction along the Uxbridge Road, but I'd never before done that.

Only when I reached Lamb's second-hand book shop at the extremity of West Ealing did I think of interrupting my walk. Mr Lamb seemed at liberty to ignore the early-closing laws with impunity. But I knew that, if I did go in his shop, I'd be likely to buy more books than I could easily carry. Not only that, but I had far too much money with me, and I'd be sure to spend more of it than I should. I could imagine the scene: the old but fit and eager Mr Lamb scurrying away on one mountaineering trip after another among the huge piles of dusty books as he went in search of one title after another for me.

No; that would never do. I was glad that the bookseller was not to be seen as I passed his shop, and resolved to walk on the other side of the road on my return trip from the London and County Bank. Bookish temptation wouldn't then come my way. When I reached the bank, my plan was to pay in the whole of the considerable sum I had

with me, save for the three half-crowns I'd been keeping aside. And I didn't plan to spend this money on books. I had another use for those coins in mind.

*

He must have seen me in the moment before I saw him.

As I rounded the corner into Acris Street, picking the tiny specks of fluff from the jacket of my suit – I always tried to dress smartly when I came to Hanwell – I all at once felt a pair of eyes upon my person and looked up. Although Acris Street is fairly long, I could see the person who met my gaze as I looked up was unmistakably Archie Perkin. He'd been walking on the same side of the street as me, but when he saw I'd recognised him, he'd averted his eyes and quickly crossed the road. But for an instant before he'd done that, he stared very hard at me.

What could I read in his expression? Surprise at seeing me here? Disapproval, as if he knew where I was going and exactly what I'd be doing there? Or was it guilt when I'd guessed where *he* had been? The more I thought of it, the more likely it seemed Perkin was on exactly the same mission as me. Not his usual look of condescending amusement, that much was sure. Before I knew it, he'd passed quickly by me on the other side of the street. There was nothing for me to do but hurry on to Rosie's front door. Archie had seen me. Whatever else, I was sure he knew exactly why I was in Acris Street.

*

'Why are you bringing them brass plates to me, Tommy? You should fetch a girl a bunch of flowers, not old metal sheets.'

'I'm sorry, Rosie. These are for my work. I didn't think you'd mind if I brought them to your house. I need these four sheets to complete my overdue orders. I'll bring

you flowers next time.' Even as I said it I knew I could never have carried a bunch of flowers out of Greenford. There would have been far too many questions and whisperings. What would Mrs Raven have said? Ten years had passed, and I still hadn't quite lived down the scandals of my youth.

Mr Vincent at the Pressings and Stampings Company in West Ealing had been surprised when I'd ordered and given him a cheque for sixty-four plates. I really could have done with more than the four I'd collected today, but I wasn't going to bring a stack with me into Rosie's house.

'Course I don't want your flowers, Tommy,' she laughed. 'Your seven-and-sixpence is all I need. And your special attention; let's not forget that. You know you're the one I like best. You're one of a kind, my lad. Get your coat off, then.' She helped me off with my jacket, at the same time giving me a big wet kiss full on the lips. I knew, or at least this was what Rosie told me, that I was the only one of her customers she greeted so affectionately.

'Who was the man here before me?' I asked.

'Now, come on Tommy. You know I'd never say anything to you about any of my other gentlemen. Nor would I breathe a word about you to any of them. Anyway, why should you think there's been anyone else in this afternoon? A girl needs her rest, you know.'

'I'm sorry, Rosie. I wasn't thinking.' What she said was true. It was a matter of pride with her, this business of confidentiality. I didn't even know her own surname. Come to that, I wasn't really sure if her real name was "Rosie". This didn't matter; when I was in the bedroom with her, there was no-one else in the world. Except today there would be: Mazod Betham.

For the first time in ten years, I'd wondered whether I should be coming to Acris Street. But the aching desire within me was even more powerful than usual. Mazod was

the reason for this. When I'd sprawled across her on the wet footbridge last Sunday at first I, like her, had only seen the funny side of things. Then I'd become – well, I'd have admit to arousal of the most base, male kind. And my lust hadn't really passed off since that day.

Mazod had become aware of my excitement. A look had clouded her eyes. It was one I couldn't quite read. It was more than mere shock or dismay at my animal desires. If anything, there was for a moment a kind of faraway dreaminess about her. But this quickly passed, to be replaced by a steely determination to push me away. By then, I'd regained enough control to scramble up myself and help her to her feet. After that, I stupidly tried to act as though nothing untoward had happened.

Mazod and I had scarcely spoken on the walk back to her home in Greenford Green. The unsavoury episode on the bridge hung in the air between us as if it had substance. She told me it wouldn't be wise if I were to accompany her all the way home to Betham House; it would be sensible to let her explain her drenched appearance to her Aunt and Uncle by herself, she said. I was glad of this, but felt uneasy as to how she'd act towards me on Friday. But at least she'd promised I'd be seeing her then.

*

'Wake up, Tommy! You've gone off into one of your trances again!' Rosie looked up at me, smiling. 'Most days you'd have had me in the bedroom by now. We haven't got all day you know. Once is never enough for my Tommy.'

She turned smartly and went into the bedroom, closing the door behind her. After the normal wait of two minutes, I followed her, remembering to deposit my three half-crowns on the sideboard as I passed.

*

Rosie was sitting on the side of the bed as usual, looking at me with those big eyes of hers. She was naked, with her white housecoat discarded carelessly on the bed beside her. Oh, Rosie! She gloried in her nakedness. This was one of the things I liked most about her. Her unashamed nudity was a sight that always took my breath away, and she knew it. No-one would have called her especially attractive in the normal way. She couldn't be called 'pretty' and carried a little too much weight around her middle. Recently, too, I had noticed the beginnings of greying in her mane of brown hair. Her breasts were not large and they were curiously flattish. None of this mattered.

She knew what I wanted, and exactly how she should give it to me. But first, in a kind of ritual that had grown up between us over the years, there was something she so much enjoyed. I discarded my street clothes and, trying not to hurry, gently fastened my mouth to each of her nipples in turn. I moved my tongue and lips in the small movements that gave her so much delight.

'Oh, Tommy! I do love you so!' She always said the same thing. I was sure that she meant it, too, at least for that instant. I often wondered what Mr Rosie – I felt sure there had to be a Mr Rosie somewhere – would have made of it.

She tried to hold me to her breasts for longer but my need was too urgent. More roughly than I'd intended, I pushed myself inside her. Today, the first time was over in seconds.

*

'Wow, Tommy. That wasn't like you. Not to start with, anyway. Someone must have been feeding you oysters. Dozens of them.'

I reached over to her as she lay beside me in the bed.

'No, Tommy. No more. I've got to go. So have you. You've had more than your fifty minutes' worth already.

You were here ten minutes ahead of your time as it was.' In one easy movement, she swung her legs to the floor, and retrieved her housecoat. I knew better than to try to get her to stay with me on the bed for even five more minutes, and so I eased myself from the mattress with a lot less elegance than she'd shown.

'See you in a fortnight. Same time?' I said. Should I even be saying this? Mazod was now in my life. She was my future…

'Can't see you then. I'm sorry, Lover. Next week I'm going to my sister's place in Hammersmith. Her old man's upped and left her for some tart who works in the fruit market. Would you credit it? I'll be staying with her for a fortnight. But I'll have a real treat for you three weeks today, if you can come to see me then.'

'A real treat?' I hardly heard what she was saying. I was in a curious dilemma: on the one hand I knew I shouldn't come to see Rosie again at all; on the other I wondered how I was going to survive for three weeks. Two weeks would have been difficult enough.

'Yes. Don't you realise you've been coming to me for all of ten years? So I said to myself, "Rosie, you ought to do something really special for that boy. He's far and away your favourite gent". So that's exactly what I'm going to do.' She paused in the task of buttoning up her housecoat. 'You can bring me those flowers you were on about just now, if you like. Mmmm, that's a lovely idea. Don't you think so?'

'Yes.' But I knew I couldn't bring her a bouquet. I thought quickly. 'What if I spent the whole afternoon with you? I'll bring another half-crown instead of flowers. Like the idea?'

Rosie looked incredulous. 'The whole afternoon for ten bob? A girl's got to eat, you know. How about you bringing fifteen shillings? Then you can stay for the whole

afternoon, from one o'clock until six. What's more, you'll know you won't be robbing the food from my table.

'Well then, it's settled,' she said. She stood up, very pleased with herself, and smoothed down the housecoat. 'So don't forget to put it in your diary: Wednesday the twenty-ninth: spending all afternoon with Rosie.'

So, there was another date for my non-existent diary. Somehow, I'd managed to talk myself into paying twice as much as usual. But I knew I couldn't come here on the twenty-ninth of July. Nor could I come on any other date in the future. Not if my hopes for Mazod were to be realised.

Thursday, 9th July, 1914

I felt a fraud walking at John's side. Here I was, on my way to be a member of the *Hare and Hounds* skittle team against the formidable bunch from *The Load of Hay*. I knew I'd be hopeless on an alley. Worse, only ten minutes ago John had told me it was a crucial match we'd be playing. The visiting team was top of the West Middlesex league. This was the chance for 'our boys', as John liked to call them, to knock the visitors off their perch and become King-pins in their place.

John had laughed off my half-expressed reservations. He'd even insisted I should roll as anchor-man in our team of twelve. If only he realised what a flimsy anchor I'd be. We were passing Knapp's Cottages before I plucked up the courage to speak about what had really brought me out tonight.

'John, I want to ask you about something. It's important.'

'You know all there is to know about skittles. I've seen you roll.' He knew I didn't want to talk about our game, but was teasing me as usual. 'Each of the teams has twelve players,' he said. 'There are five rounds of rolls for both sides, with every one of us of rolling three balls in each round. There are nine pins in the diamond. All you have to do is knock down all of them with each roll. Nothing to it. I expect my anchor-man Tommy Green to score a full twenty-seven in every round.'

John laughed. I'd never seen anyone score twenty-seven in a single roll. I wasn't sure he had, either.

'No, I'm not talking about skittles,' I said, ignoring the banter. 'You know that's not what I want to say. Tonight,

I want to ask you about my future. In the same way as you and your plans for going to California to work with Charlie, you might say.'

'Now that's something I was going to tell you the news about,' John said. 'This morning I had a short letter from Charlie. We'll definitely be off to America and much sooner than we'd planned. We'll be sailing not later than the end of next month. It's going to be earlier still if Charlie can make the arrangements. He'll be writing to me again in a few days with more details. We've been dead lucky – I think we've got a buyer for the forge already, and he wants it as soon as he can move in. Even Vicky's becoming excited at the prospect of catching the boat to America now, although she's as nervous as you'd expect. So, Tommy Jakes will definitely be born in California.'

Then Greenford would need a new blacksmith. Much more importantly from my own point of view, I'd be losing my only real friend in the village. This made it all the more vital for me to speak now. But how could I begin to explain, even to John, that I'd had a visit from my own descendant? He'd hardly be able to believe a word I was saying if I told him my hopes for Mazod weren't entirely forlorn. How could I expect him to accept my sanity if I tried to tell him I'd had a visitor from the future as well?

'So, you're definitely going to a life in the New World, John?' I said. 'And I wish you and Vicky well for it. Myself, I feel as though I've wasted the last seven years. But now it might be all about to change for me.'

John looked at me sideways, smiling knowingly.

'I know what it is you're going to tell me. I've heard some whispers about Mazod Betham. She's been paying you a lot of attention lately. You know Vicky's sister Nellie is a maidservant at Betham House? Well, she's heard Mr and Mrs Hartson saying things to their niece like "are you sure about this, Mazod?" But Nellie tells us the Hartsons are a fine

couple, not a bit like some of the other stuffed shirts in the village. I should go for it, my son.'

This was news to me. So Mazod's thoughts about me might be as serious as I'd dared to hope? They must be, if she'd gone as far as talking to her Aunt and Uncle.

'Does Nellie know anything else?' I asked. I heard my voice rising by an octave in excitement.

'Nothing besides the time when she overheard the family conference,' said John. 'She couldn't even be entirely sure they *were* talking about you, so maybe you shouldn't get too excited yet. Servants can only catch snippets of conversations, you know. They're not allowed to join in with the discussion and say their piece. But Nellie also heard in the village you went walking out with Mazod Betham after Church on Sunday. And I know myself the girl's been quietly asking about you here and there.

'If you ask me, it all sounds like she's very interested. So, go for it, Tommy. Go for it. Never mind a bit she's who she is and you're only a shopkeeper in the village. Anyway, you're not an ordinary shopkeeper, are you? You're an engraver, like you keep telling me. You don't get many of those in a village like Greenford.'

'A calligrapher and engraver,' I corrected him.

'Whatever you say,' said John, chuckling. 'How did things go on your walk with your dream girl on Sunday, anyway?'

I thought for a moment. How had they gone?

'Well enough, at first at least,' I said. 'But then it rained – it was like a tropical storm if you remember. We were both drenched.' John might be my good friend, but I wasn't going to tell him about the embarrassing episode on Coston's Brook footbridge.

'You can't control the weather, old son. It wouldn't surprise me if this isn't something you'll be laughing about together in twenty years' time. You'll be telling the kids the story, I shouldn't wonder.'

'Bertie, Trevor and Mary.' I couldn't help blurting this out.

'You've got *names* for them already?' John laughed incredulously. 'Well, there's nothing like confidence, I suppose. But take one step at a time, eh, Tommy? First of all, are you going to see her again?'

'Yes. Tomorrow evening.'

'Well, there you are then. I shouldn't say anything about the kid's names yet if I were you. It might frighten her off.'

I had to laugh at the way John said this. Soon, the pair of us was falling about hysterically, exactly as we regularly used to do when we were younger. It was as well this was a quiet part of Ruislip Road. But, despite this moment of hilarity, I did want to talk seriously to my friend John.

'Trade has been looking up for me as well,' I said, when we'd both calmed down a little. 'Six months, or even a week, ago, the shop was barely keeping afloat. I was hardly making enough money to feed myself, let alone a wife. And the three kids,' I added, jokingly. 'But lately, I've been rushed off my feet. I've got no end of customers and orders are piling up on the books. Yesterday the Ravens even asked me to join HADS.'

'You've got it made, Tommy. I can see it now. That little plate outside your shop, you know, "Thos. Green & Son, High Class Calligrapher and Engraver". You'll have to correct it, you know. You'll need to change the "Son" to "Sons". It's high time you had a new sign, anyway. Didn't someone tell me your grandfather put the old one up?'

'There's something else, John. A businessman, Henry Trevithick, you know, wants me to take new shop premises on the Uxbridge Road in Ealing. He's even said he'll pay the rent for the first few years. Trevithick wants us to be partners.'

'Henry Trevithick, the Cornishman? His driver is often in the smithy. Life is really taking off for the two of us, isn't it? I shouldn't be at all surprised to find Mr Trevithick is behind this rush of trade you're having. He's a shrewd businessman, by all accounts.'

I hadn't thought of it, but John was probably right. The amazing increase in business couldn't have happened all by itself. Henry Trevithick had to be at the root of it somewhere. What was it he'd said about "the power of advertising"? The leap in trade might be Trevithick's way of giving me a demonstration of this power. For now, he'd probably have limited himself to verbal recommendations to his own acquaintances. A shrewd man like him would no doubt have thought the press and other more costly public advertising could follow later.

The direction sign pointing in the way of the respectable village community and - dare I even think of it? – marriage to Mazod Betham – was coming into sharper focus. But I also wanted to talk to John about the blurred sign pointing in the less well defined direction. As we were about to cross Muddy Lane, I put my hand on his arm to stop him walking on and turned to face him.

'John, there's another thing.'

'There's more? You're telling me we won't be seeing your *Ealing* business for dust. Then you're saying you plan to marry a high-class girl from the local social set – and one of the prettiest, I might add. You've already decided that you're going to have three kids. You've already chosen names for them, for Goodness' sake. Now you're telling me

there's more? What's got into you all of a sudden, old friend?'

When John put it like that, it did sound ridiculous. Especially when I didn't really know what I wanted to say to him. But I had to try.

'Your blacksmith's shop is successful, wouldn't you say? It's part of the business community of Greenford, in a way.'

'Don't be so patronising, Tommy. It's not like you. The Greenford Forge *is* a part of the business community. A successful part, too. The Ravens asked me to join HADS three years ago, I'll have you know. But I wasn't going to waste good drinking time on nonsense like that.'

'Sorry John. I didn't mean to sound so pompous. But now you're going to throw all your past efforts up for – well, art, you'd have to say.'

'Art? I'd never thought of acting in films as art,' he said. 'The stuff you're so keen on yourself is the bee's knees, so far as most people are concerned.'

'Your film-making in California will be art, take it from me. Anyway, the same sort of choice might be coming to me.'

'Tell me more. You've got me interested.'

And now, what should I tell him? Not that I'd had a visitor from the future, for heaven's sake. I breathed deeply and took the plunge.

'You've known Charlie since you were a boy, right? And now he wants to do something for you to really change your life. It's the way things are, wouldn't you say?

'Go on,' said John. 'I'm listening.'

'Well, there's someone I've known for a long time, too. Since I was a kid of six. And now I'm sure he's going to do something to change my own life.'

'You've never mentioned anyone like that before,' said John, dubiously. 'Where does he live? You've got no other close friends in Greenford, so far as I know. What's this man's name?'

'He lives in London. His name's Jet. I only see him now and again.'

'Jet? That's a peculiar name.'

'He's... foreign.' This sounded unconvincing, even to me.

'Well, what's this mysterious foreigner with the funny name going to do for you?'

'You know how I've always liked to draw? And how much I've missed writing since I left the *Independent Record*? I've always wanted to create something.'

'So you've told me many times before. And this... Jet... is in the newspaper business, is he? Or does he own an art gallery? Something of that sort?'

'Not exactly, no.'

'So what is he going to do, then?' John creased his brow. He was genuinely puzzled. And who could blame him? It was hardly clear to me.

'I don't know yet.' This sounded so lame. 'But I know the choice will be between me settling with Mazod in a life as a respectable craftsman; in Greenford or Ealing, it doesn't matter which and... and... something else.'

That "something else" sounded so pathetic. I knew this as I said it. Goodness knew what John made of what I was asking. I expected him to laugh in my face. But no, he

threw one of his big arms around my shoulders and lowered his voice.

'Look, old chum, he said. 'You listen to your mate John Jakes. Your engraving business is zooming away; Henry Trevithick is making you his special protégé; and the best-looking girl in the village – someone you've thought of yourself as a kind of Princess in the Tower for years, don't forget – turns out to be sweet on you. What more could any man want? Don't waste any more time thinking about this Jet nonsense, whatever it may be – it sounds like you haven't got much of a clue yourself – and count your blessings.'

'I suppose you're right, John.'

'Of course I'm right. Now, come on. We're supposed to be playing skittles, remember? And I've already told you; we want five rolls of twenty-seven from you.'

*

The bar of the *Hare and Hounds* was full when we walked in. When we arrived it was already ten minutes after the due starting time for the game. Jack Dean, the captain of our team, came up to John as soon as he saw us.

'*There* the two of you are. Hello Tommy. Where've you *been*, John? I was getting nervous.' Without waiting for a reply, Jack called over his shoulder to Keith Randall. Keith was propping up the bar. He was the jovial captain of the team from *The Load of Hay*.

'Oh, so you two have decided to turn up at last,' said Keith, walking over to us, pint in his hand. 'We thought you'd lost your nerve and weren't going to show your faces at all. Some of the boys wanted you to be scratched from the team but, generous to a fault; I agreed with Jack you could have a quarter-of-an-hour's grace. Still, it's won't make any difference to the result. You boys are playing for a team that's heading for a thrashing tonight.'

Keith Randall winked at me and took a swallow from his tankard. He waited for John's response.

'Not unless some of your boys have got their mothers playing as ringers for them.'

Randall laughed good naturedly. 'No, we've got all the usual boys. Best players in West Middlesex. Except Little Jimmy Verulam couldn't come. Got a fork stuck in his foot or something. Careless boy. So, we've got a lad called Arnie Stannard to stand in for him. Arnie's from Southall. You probably wouldn't know him. The lad's not lived there for long.' He turned around and called to the throng at the bar. 'Arnie!'

'Sounds like they *have* got a ringer playing for them,' John whispered in my ear.

A short man with a weasel face and rheumy, darting eyes stepped forward.

'Arnie, meet John and Tommy,' said Keith Randall. 'You'll be rolling against Tommy. Seems right, since neither of you are regular players.

Arnie Stannard wrinkled his nose rather than offering his hand.

'Well, what are we waiting for?' said Randall genially, to no-one in particular. 'Come on, Jack. Your team ready?' Randall strolled over to our captain, who was already wandering away in the direction of the bar.

'You're waiting for me to get a pint, that's what,' said John directly to Stannard, who remained standing next to us, smirking irritatingly. 'Tommy. What's yours?'

'He keeps us waiting half the night for him to show up and then he wants us to wait while he gets a drink,' said Stannard, unsmilingly.

If Keith Randall had said this John would have laughed it off, or more likely made a wittier crack in return. But Arnie Stannard had only met John a few minutes before and was a midget beside him. He must have been very brave or very stupid. John looked at him as if ready to tear him apart. Looks could deceive: John was a gentle man and would only strike out in self-defence or under extreme provocation. Stannard had made his jest, if jest it was, without a trace of humour in his voice or on his face. Only when John stared very hard at him did the corners of Stannard's mouth twitch upwards in something approximating a smile.

'We'll do our talking on the skittle alley, sunshine,' said John. 'My mate Tommy will show you a thing or two.'

Arnie Stannard turned to me and smirked again. I wished John hadn't said anything.

*

The teams were dead level on points as the first round neared its end. Now only we two anchor-men had our turns to come. Arnie Stannard took his place at the line, looking cool and confident. He made his first roll, the wooden ball gliding gently and noiselessly down the alley.

'Six! Well done Arnie!' Keith Randall's voice echoed above the general hubbub in the skittle alley. The side-room was packed with our two teams of twelve and another dozen or so onlookers who'd drifted in from the bar.

Arnie's rolled his second ball, if anything more slowly than the first. Two of the pins were knocked over, one of them spiralling around to make slight contact with the remaining pin. This rocked with comical slowness then it too went down.

'A spare! Nice one, Arnie. Set them up, Jack, so our man can knock them all down again, will you?'

Arnie didn't knock all nine pins over with his third roll, but he still managed five. That made a score of fourteen I'd have to top. Arnie looked at me and made a mock bow, ushering me towards the line.

What was I doing here? I was no skittle player. I picked up the wooden ball. It felt heavy and awkward in my hand.

'You're getting your feet wet, mate,' Arnie called out.

'What?' I said. I didn't know what he meant.

'Feet over the line,' called John. 'You're standing too far forward.'

I stepped back and clumsily rolled the ball. It completely missed all the skittles and rumbled harmlessly down the side of the alley. My second ball managed to clip just one skittle in its innocuous journey. The third ball did better, toppling three skittles. I'd scored four. Four against fourteen.

'Never mind, Tommy. You're a bit out of practice, that's all,' said John.

'Of course I'm out of practice,' I whispered to him. 'I haven't played in the last nine years. I tried to tell you.'

John winced, but patted my shoulder in commiseration.

On the second roll Arnie scored another spare and ended up with a score of twelve to my five. I think the third roll may have been closer, but couldn't be sure by that time of the evening. The alley, the skittles, the wooden ball, and the players on both teams were becoming an alcoholic blur. John kept bringing fresh pints from the bar. Like a fool I kept on drinking.

I don't remember anything about the fourth and fifth rolls. Nor do I remember the evening's end, nor much about

my erratic progress along the Ruislip Road with John playing shepherd and doing his best to keep me vertical. I recall seeing the road coming up to meet me a couple of times and vomiting noisily outside Knapp's Cottages. Two candles were lit in the houses, but John dragged me away before the tenants could recognise us.

I knew a minute or two of lucidity as John unlocked the street door of the shop with my key and struggled to get me, rubber-legged, up the stairs and on to my bed.

'Tell... Jack... sorry for letting you all down,' I said, thinking gratefully that my words had a slight degree of coherence. 'I'm sorry I let you down, John.'

For some reason, John found this to be hilarious. He was chortling away as he pulled my boots off and let them fall noisily to the floor.

'You didn't let anyone down, my old mate. Don't you know you're very funny when you're had a bevy? I haven't laughed so much in ages.'

'Yes... but... skittles,' I managed to say.

'Well, I doubt if Jack will be looking for you to replace me in the team when I go to California,' he said. 'Your first couple of rolls were bloody awful. But you weren't as bad all night. You weren't a bad skittler at all later on. It was as if the drunker you got, the better the player you became. And your last roll was the winning roll for our side. That can't be so bad.'

'Winning?' I struggled to say.

'Their team was one point in front when Arnie Stannard had his last go. But he only managed six with his last three balls. Then you came on and got seven with your first two. The place was in uproar when you got one of the others down with the last ball. We'd won!'

'Arnie Stannard?' My intention was to ask John how this unpleasant man had reacted, but I was far too drunk to put the words together. John seemed to guess what I wanted to say.

'Little rat-faced git,' said John. 'I thought he was going to cry when you made your last roll.'

And then I must have passed out.

Friday, 10th July, 1914

Did the furry creature nestling behind my teeth belong to me? Like the other dismembered parts of my mouth, it tasted foul. It was at least twice the size of a normal tongue. For a moment, I had no clue as to where I was. I had fleeting visions of myself lying at the side of the Ruislip Road looking up at stars in a sky much closer than it should have been. Slowly, I realised I was lying on top of my own bed, blinking stupidly towards the bright sunlight streaming through the undrawn curtains.

Shivering despite the warmth of the day, I pulled the pillow over my face. Slowly, the events of the previous night began to cobble themselves together in my mind. The last time I'd been as badly hung over was more than seven years ago, on the night before my departure for London. This morning, my bedroom spun gracefully on its axis. I knew there'd be no point in trying to make a connection between my feet and the floor yet.

Then I must have dozed off for a few minutes, because when I next forced my eyelids open I felt ever-so-slightly better. The clock by my bedside ticked loudly, and I coaxed my head around to see its face.

Twenty-five minutes past nine. I hadn't set the alarm. There was no way I was going to be walking out to Coston's Brook to dig for the Turkish ring in broad daylight. Besides, because of all the customers I'd been having lately, I'd formed the habit of opening up the shop before nine-thirty. Well, I wasn't going to be doing *that* this morning.

I lay on the bed, allowing my bleared senses to ease themselves into this Friday morning. Vaguely, I wondered if instead I'd go looking for the ring under cover of darkness tonight. But I was going to see Mazod earlier in the evening, and to go digging near the Coston's Brook at dead of night

seemed vaguely criminal. So I resigned myself to digging for it tomorrow morning, exactly as Jet had said I would. There'd surely be some other way of putting his father's grand theory of "the elasticity of time" to the test.

*

Reluctantly, I opened my shop at twenty minutes past ten. I wouldn't have unlocked the door even by that time, but for an impatient customer, a Mr Harris who told me he'd travelled from Ealing. He was hammering on the street door as I crept downstairs. I couldn't have faced breakfast this morning, anyway. Making a superhuman effort, I was polite in the face of Harris's demanding and rather vague order specifications. I thought I'd managed to send him away more or less happy.

He was the first of five customers who called that morning. I could see myself working late into Saturday night in an effort to clear the backlog of orders I was accumulating. As noon drew near, I managed to chew my way through less than half of a cheese sandwich. The pangs of hunger barely outweighed the waves of nausea coursing through my body as I ate.

At four-fifteen I closed up the shop for the day. I knew this was at least three hours early, but I'd arranged to meet Mazod at a quarter-to-eight and I needed to rest my aching limbs and pounding head for a while before then.

*

She looked beautiful. Beautiful. I could see she was totally in control of herself and the world about her. There could be no other way to describe it. Mazod wore a simple navy-blue outfit, set off by an unfussy bonnet of a cream hue. As I approached, she was gazing casually in the opposite direction from me, to the north. I was able to look at her undisturbed for at least half a minute. The experience was like a balm to my aching eyes.

Yet again I found myself wondering at my good fortune. I couldn't believe how lucky I had been to find this wonderful girl had an interest in me. John was absolutely right when he'd said, "*Don't waste any more time thinking about this Jet business and take your chances*". Of course it was what I should do. How could I think, even for a moment, of doing anything different? Mazod had more than looks going for her. She was independent-minded and bright: no other girl of her class would have defied social convention to walk out with someone like me. A lower-middle-class tradesman with a damaged reputation is what I was.

I was only a dozen yards away from where she stood when she turned in my direction. She smiled when she saw me. It was a warm, engulfing smile that sent a thrill through me.

'Tommy! I'm so glad you came early. I was here ten minutes before time myself; I was thinking for a minute I might have to wait for longer. You should've bitten the bullet and called for me at Betham House.'

When we'd parted on Sunday, Mazod said she'd really wanted me call for her at home this evening. But it seemed to me that a young man who'd returned their niece home in a half-drowned state could hardly expect a warm welcome from Mr and Mrs Hartson. When Mazod saw me quailing at the prospect of calling at Betham House, she'd instead agreed to wait for me underneath the elm tree down the lane.

'*Perhaps next time.*' Those simple words had sent a shiver through me. That I could even think of a *next time* was incredible. And tomorrow or the day after would be that next time, so long as I didn't make a fool of myself again this evening.

'Were your Aunt and Uncle cross to see you so wet?' I managed to say. 'I felt awful about bringing you back in a state like that.'

'They knew I'd been walking out with Tommy Green, not King Canute. You could hardly have been expected to command the rain-clouds to turn back, could you? We were both caught out by that cloudburst. Anyway, enough of that nonsense. Where shall we go?'

I smiled at my memory of John saying a similar thing about King Canute yesterday.

'We haven't got much time, have we?'

'It's a quarter-to-eight now,' she said. 'I should be home by nine o'clock at the latest this evening. My Aunt and Uncle wouldn't forgive you if you kept me out later. Bringing a girl home wet through would be one thing; keeping her out after dark would be quite another.'

'Let's have a short stroll along the lane towards Sudbury,' I said. 'It'll be easier for us to time ourselves if we don't go too far.'

'Well, if that's what you want. There's not much to see that way, but I suppose we don't have long this evening.'

My heart leaped when she caught hold of my elbow so naturally. It was true the road leading to Sudbury was dull and featureless. But it also had one distinct advantage: few people used it in the evening. We should be undisturbed.

Arm in arm, we strolled along the lane, saying very little. This time, my usual tongue-tied state in Mazod's presence wasn't the only reason for our comparative silence. I was content simply to be in her company. On this glorious evening she was also happy to say little. It was me who made the first real attempt at conversation.

'Mazod, I'm sorry I can't take you to tennis parties or anything grand in that way.'

'Tennis parties?' She laughed gently. 'Tennis is a silly waste of time. I don't like it at all. I only play the game

because it's so popular in the village. One doesn't want altogether to be a social outcast.'

'What I'm trying to say is, I'm sorry I can't be one of the local set. You might become a social outcast if you walk out with me.'

Mazod stopped and turned to face me.

'Look, Tommy. I'll walk out with whomsoever I please. The "local set", as you call them, means nothing to me. They're just some of the young people in the area. Don't think about it for a minute.'

'Sometimes I think it would be good not to be tied to the shop all day. I wish I was one of the moneyed people of Greenford.'

'You're doing your best to paint an unattractive picture of yourself, aren't you? Let me say you have an entirely wrong idea of Greenford. There aren't so many "moneyed people" in the village as you might think. There are a few wealthy ones – like your friend Archie Perkin.' Here she paused and cast a teasing eye on me. I smiled, somewhat ruefully. 'But most people aren't exactly rolling in wealth.'

'You can't tell me, for instance, that the Hanson family hasn't got much money,' I said. 'Not when they're living in a fine house like Stanhope Villa.'

'It's not good form to discuss the wealth of other people, and we really shouldn't do it, but you've picked a fine example there. Everybody knows the Stanhope Hansons are as poor as church mice in that big house of theirs. Why, the sacrifices they must all make to keep up the pretence. They won't be able to stay there for much longer, from what I hear. For all I know –'

Mazod didn't finish her sentence. From behind us a mechanical noise cut through the stillness of the July

evening. We turned around to see the approach of a gleaming silver motor-car. The vehicle came to a halt as it drew level with us, the driver pulling ostentatiously on its brake. It was a machine unlike any I'd seen before, long-bodied and shapely. In appearance it was striking, but what really impressed me was the quietness of its engine. Every one of the motor-cars I'd previously encountered had been noisy, chug-chugging monsters

'Hello, Mazod,' the driver said, pushing his goggles up over his forehead to be recognised. It was Archie Perkin. 'Like my new car? It's far better than the old one. It cost the Earth, but it's worth every penny.'

'Yes, it's nice. It's stylish. So you've got it at last then?'

'I picked it up this morning. And it's more than stylish: it can get up to around eighty miles an hour on the flat. It's a very special car; a Rolls-Royce Silver Ghost. It'll make me the envy of all the chaps for miles around.'

Archie Perkin was entirely ignoring my presence. I wanted to say something to assert myself.

'If an athlete made a noise like that engine he'd need to go to see his doctor without delay,' I said. This wasn't the most sparkling example of wit I could have mustered, especially since the car was so quiet in running. Neither did my remarks sound as light and jovial as I'd intended. The truth was, they made me sound like a petulant child. Mazod looked at me and arched her eyebrows.

'Yes, well,' said Archie, and turned his gaze quickly back to Mazod. 'Fancy a spin? I'm going as far as Harrow-on-the-Hill and back.'

'I'm with Tommy,' said Mazod. I had visions of myself being relegated to the back seat, an unwanted passenger.

'We'll go some other time, then.' Archie pulled down his goggles and fiddled with the controls before rolling off silently. It was clear he didn't share those visions of me riding in the back seat.

'Tell you what, though,' he shouted, bringing the car to another halt after a few yards. 'There was a matter I wanted to discuss with you, Mazod. Perhaps I'll call for you at ten o'clock tomorrow? We could go for a quick spin in my new car. How does that sound?'

'You'd have to call for me before ten o'clock. I'm making a trip to see my Aunt in Sudbury.'

'What, her again?' Archie smoothly released the brake. 'You're always going off to see your Aunt. Right-ho, I'll be at Betham House by nine-thirty. Perhaps I'll be able to give you a lift to Sudbury. By-ee!' Then he showily spun the steering-wheel and was soon gliding off down the narrow lane. When the motor-car was twenty yards distant, the note of the engine suddenly increased in pitch and volume. Archie sped off alarmingly quickly and was soon out of our sight.

'You were rude then,' said Mazod, turning to me.

'I didn't mean to be. It was just –'

'Just that you were jealous?'

'No, it's not that,' I started to protest. 'It's –'

'Oh, so you weren't jealous, then? Your deadliest rival was going to whisk me away on his gallant silver charger and you're telling me you'd have been quite unmoved?'

I couldn't tell if she was teasing me or not. It was true I knew the bite of jealousy at that moment, although I was feeling even more apprehensive when I thought what Archie Perkin might tell Mazod about me when he saw her tomorrow. After all, he'd seen me on Wednesday in Hanwell on my way to see Rosie. For certain he'd have known why I

was going there: he'd probably been to see her for the same reason himself. Perhaps I should make a clean breast of it to Mazod? But how could I tell her such a thing? She'd surely storm away and never want to look at me again.

'Come on Tommy!' said Mazod, punching my upper arm quite hard. 'You don't have to take everything so seriously! It'll take us no more than a quarter-of-an-hour to drive to Sudbury. I'm not about to run away with Archie.' She lowered her voice, and spoke to me more gently. 'And I've told you before: you've no reason to be jealous of him, or of anyone else. Now, what were we talking about before Archie came along in his new motor-car?'

'You were talking about the people of Greenford. How some of the better people aren't as rich as I might think. You were starting to tell me something about the Stanhope Hansons.'

'Oh, yes, so I was. But I really don't think we should be talking about other people. What I said about the Hanson family was in confidence. I shouldn't have said anything at all. Promise me you'll not repeat it?'

'I promise.' This was easy enough for me to say: I'd never been remotely interested in gossip.

'But I'll tell you what: I'll talk about myself,' said Mazod.

'Please don't do that.'

'Why ever not? Don't you want to know about me?'

My face reddened. 'You know I do.'

'Well, then. Now, do you think of me as being a member of the moneyed classes of Greenford?' She saw my embarrassment at being asked such a direct question. 'Don't be shy, Tommy. Answer me honestly.'

'Everyone knows about your famous ancestor, Edward Betham.'

'Yes, everyone in Greenford has heard of my great-great-uncle. He opened the Clock School with his own money. Nobody would say anything bad about him. Quite right, too. He was a good man, a real philanthropist. And, yes, he did have some family money. Though I have to say there never was a vast Betham fortune; nothing to match against the wealth of some of the richer merchants who live around here today. Or your friend Archie Perkin,' she added teasingly.

'But, don't forget, this was much more than a century ago. By my parents' day, there was precious little family money left. When they died, Betham House was already in mortgage. If my mother's sister, my Aunt Theresa and her husband, my Uncle Roger, hadn't stepped in and taken over the house, I don't know what would have become of me as an orphan.'

'When did you lose your parents, Mazod?' I asked. She'd lived with her Aunt and Uncle for as long as I could remember, though now she mentioned it I did vaguely recall other people living in Betham House before the Hartsons.

'It was fourteen years ago, during the typhoid outbreak we had in the village.' She held up her hand to stop me when I tried to mumble some words of sympathy. 'It was a long time ago and I was no more than a little girl. My Aunt Theresa and Uncle Roger have been like a mother and father to me.'

So she'd lost not only her mother, but her father, too. This was the year before the death of my own mother. And, as she'd said herself, Mazod would have been much younger than I was when my mother was taken from us.

'And don't you start thinking my Aunt and Uncle have pots of money, either. We live simply and without

extravagance. We have only one maid and a cook as live-in staff. Betham House is not a big house, after all, and my uncle's only expense is his wine and his postage stamp-collection. As for me, all I can really call my own is a small annuity of fifty pounds.'

'I won't tell anyone what you've told me.' I was amazed at Mazod's forthrightness. No-one else in the village, of any class, would have told me as much as she'd done.

Mazod smiled. 'No, of course you won't Tommy. I'm sure of that. That's one of the two reasons why I gave you that confidence.'

'What's the other reason?'

'So I can be sure you're not simply after my money.'

I made to protest, but she smiled brightly and waved my words away.

'Now, come on. It's time we were headed back. It's half-past-eight already.'

On the way back she dismissed my words with a wave when I tried to raise any further question of money or social class. The light way in which she did this gave me a warm feeling. And she promised to walk out with me again after Church on Sunday.

Saturday, 11th July, 1914

I'd set my alarm clock for half-past four in the morning, but still I was awake ten minutes before its bell sounded. Even so, I lay there in the gloom for a while feeling like a cat-burglar about to embark on a criminal escapade.

After a speedy wash and shave, I looked again at the prize I'd unearthed from the back of my workshop. It was a double-pronged metal implement, two feet or more in length. This robust object dated from the middle of the last century, but was still in good condition. My grandfather had used it during his days as a labourer on Waxlow Farm, so I remembered my father telling me. I assumed he'd used it for digging up weeds in the days when our family was still close to the land. There was no spade or shovel in the shop, but this wicked-looking tool should do the job equally well.

*

It was a windless morning. The sun had already risen by the time I stepped outside. At first, I feared I might see farm-workers out for the hay-harvest, but soon realised gratefully this hadn't yet started. It was probably too early in the month for haymaking, Greenford's major agricultural event of the year. I was glad of the silence and solitude, because, wielding this heavy weapon, I had the vague feeling of being about to do something illegal.

There was no-one abroad in the village. Neither did I see anyone as I walked past the eight poor tenants' cottages to the east of the centre. Nor even did I encounter anyone as I walked the short distance along Coston's Lane to join the footpath leading to the brook. The only living creatures I did see close at hand were a few squabbling crows, who took little notice of this morning interloper. Their harsh cries rent the morning air and made me feel like an intruder upon their early-morning realm. There was no good reason for this: I

was doing nothing against the law of man, bird or beast, But couldn't rid myself of my unease; of the feeling I was about to steal something rightly belonging to the Ottoman Empire.

Only when I reached the footpath itself did I see someone coming towards me from the opposite direction. It was a smartly-dressed man out for a walk, his two dogs at heel. These animals bounded around him, chasing each other with enthusiasm. As soon as the dogs ceased their boisterous game, they started to stalk phantoms visible only to canine eyes. How I wished my own life could be as simple as that of a dog.

My heart sank as the early-morning stroller approached near enough to be recognised. It was Archie Perkin yet again. I guessed he'd taken a morning hike to his precious Greenford *Parva-Vale*. Worse, I could see that, at the rates the two of us were walking, we'd reach the footbridge over Coston's Brook at about the same time. I deliberately slowed my step, so we'd meet instead on this side of the bridge.

The dogs, two young Irish Setters I'd have said they were, saw me as soon as they'd tired of their game of wraith-stalking. I could tell this by the twitch of their ears and the stiff pose they suddenly assumed. Then they were off, running at a fast pace in my direction. Perkin called their names after them, ineffectually. These sounded to me like 'Rip' and 'Tear'. To my ear, these were ridiculous names for such playful animals.

Now, I do like dogs. I'd often thought I should get one myself. In more normal times, it would have made an ideal companion for my dawn forays to Horsington - *Horsenden* - Hill. But the last thing I wanted this morning was an encounter with Archie Perkin and these frolicsome animals. They were a recent acquisition of his, to judge by what I guessed to be their age – they didn't seem to be much above puppies – and his lack of control over them.

Soon they were with me, leaping up and wagging their tails furiously. I lifted the digging-tool above my head so there'd be no danger of causing injury to the dogs. From where he stood, Archie Perkin could not fail to have seen me brandishing it above my head as if it were weapon. I wish I'd had the sense to wrap it in a piece of cloth: it was an unusual-looking object, and he'd be likely to enquire as to what it was. And even he might want to say a word of apology for the dogs' behaviour. I didn't want him to say *anything* to me, all the more so since I knew he'd be in Mazod's presence in a few hours. Then I had another disturbing thought: he might want to say something about seeing me in Hanwell on Wednesday.

The dogs soon tired of their gambolling around me and went racing off in another direction across the field. As Archie Perkin approached within twenty yards of me, I put on a sudden burst of pace, resolving to stride past him, giving the slightest greeting that courtesy allowed. That was my intention, but those last twenty yards seemed interminable to me.

Despite the chill of the early-morning air, I knew I was red-faced. For one alarming moment, I feared I'd burst into hysterical laughter as I put my plan into action. My intended "Good Morning Mr Perkin" sounded more like "Guperkin", even to me, and I barely turned my head towards him as we passed each other. I was quite sure now he *was* going to say something to me and registered that he was looking at the old farm implement enquiringly. But then he called to his dogs again – their names were indeed "Rip" and "Tear" – and the moment thankfully passed.

I slowed my pace as I neared the footbridge. Six feet due west of it was where I'd been told I'd find the buried ring. This was supposed to be just ahead of me and I felt so nervous. First glancing over my shoulder to make sure Archie Perkin and his dogs were safely on their way, a quick survey of the ground told me this guideline meant I'd have to

dig in a patch of ground measuring not more than four feet by a foot or so. The ground was clay at this spot, and wet and boggy into the bargain. But my grandfather's digging-tool, despite its half-century of age, was sharp and formidable. I felt confident it would stand up to the sticky task ahead of it.

I dug. The ground was as unpleasantly heavy and wet as it looked. Still, the metal implement could have been designed for its task, and cut through the earth with minimal effort on my part. I didn't know how deeply I should dig, and first of all excavated to a depth of only three inches, with no result. Then, struggling a little more, I dug down another six inches, but still could see nothing unusual. After the muddy labours of a foot I found the ring. There could be no mistaking its hard outline in the earth, despite the jewel's burial under the soil for three or four centuries. To find my prize in this way after seeing it, or at least what I'd been told was a facsimile, on Jet's finger only days before, was an eerily thrilling experience.

Enough of the dirt of centuries came away easily enough for me to try the ring on my now-slimy finger. It fitted snugly, almost if I'd visited a jeweller's shop in Hatton Garden that morning. Despite the coating of earth, I could imagine the ring as more lustrous than the one on Jet's finger. I don't think this was simply because I knew what he'd worn only a gold-plated copy. I looked at the ring admiringly. It could have been made for me. In a sense, I suppose it had been.

Suddenly, I became aware of the eyes of another on the back of my neck. I looked around and saw Archie Perkin coming back this way. Fortunately, he was still some distance away with his dogs. I leaped to my feet, thrust the ring into the breast-pocket of my jacket, and strode from the scene as quickly as I could.

I'd taken no more than a half-dozen steps across the bridge when I realised I'd left my grandfather's digging-tool

across the brook behind me. What should I do? I couldn't turn back; if I did I'd be forced to acknowledge Archie Perkin. The only reason he'd have returned was to put questions to me. They'd be questions I didn't want to answer. I resolved to leave the implement where it lay on the ground behind me. It had served its purpose and was unlikely to be called into service again. All the same, I didn't like to abandon it; this morning it had taken on the quality of a family heirloom.

My original intention had been to retrace my steps to the village. Now my plans would have to alter, so I continued briskly along the path until it joined up with Cow Lane. With a nervous glance behind me – I had the notion Perkin might have followed – I walked along the lane to Greenford Green. Several times, I felt with my fingers for the shape of the ring in my breast-pocket, though did not dare to draw it out.

From Greenford Green I followed the path of the Old Field lane, intending to walk along its length to the village centre and the security of my shop. But then, as I was passing Coston House, I saw Archie Perkin once more. This time, his two dogs saw me immediately. They looked ready to bound over to greet me as an old friend, but for some reason they didn't. Just as he had on Wednesday in Hanwell, Archie had seen me a second before I saw him. There'd be no avoiding him this time. He stopped, unmistakably waiting for me.

'Good morning again, Mr Perkin,' I said when I reached him. I enunciated this as clearly as I could; I didn't want to embarrass myself with a "Guperkin" again.

'Morning. Timmy isn't it?' he said, smiling. I couldn't be sure if he'd mis-remembered my name as a deliberate affront. 'We've done a circuit of the village between us. You made a peculiar mess by the footbridge, I must say.' He looked at me with a question in his eyes, but I held my silence. What could I say?

'Anyway,' he continued, 'I can't stop now; but you were in such a hurry back there that you left this fine piece of ironwork on the ground. Always look after your weapon in a battle, my man.'

With a flourish, he whipped from behind his back my grandfather's farm tool, and thrust it into my hands. Then, without saying anything further, he marched off in the direction of Greenford Green, whistling happily, his dogs running around him excitedly as if their master had performed a conjuring trick. Exactly what did Perkin mean, "*Always look after your weapon in a battle?*" Were he and I embroiled in an undeclared war? Was Mazod Betham our disputed territory?

*

I'd meant to employ the time before I had to open my shop in the writing of a few more pages of my journal. I was satisfied with the way it was coming along: I'd thought to write it not as a simple diary-record, nor yet in the style of the newspaper reports I'd been familiar with in the past. Instead, I'd write in an honest way, trying to describe the way I felt about the curious things happening to me in this, the strangest month of my life.

Some inner voice told me I should make a full and careful record, even though I couldn't help but be aware this would always not show me in a favourable light. If I were to believe what Jet had told me, my only readership would be far in the future, anyway.

Although by now I was deeply engrossed in the task of recording, I'd decided that this morning, I wouldn't continue with it. Today, I wanted to turn my attention to writing a *Haiku*. Tomorrow I'd be seeing Mazod, and would show it to her. Archie Perkin might have a pile of money; investments all over the world; two new dogs; and even a shiny 'Silver Ghost' as he'd called it, but this time it would

be me who'd choose the weapons; I couldn't imagine Perkin penning a poem.

An image had flitted across my mind since Mazod had first spoken about the *Haiku*. As often as I could when I was in London, I liked to stand by the pond in The Green Park, watching the large carp laze close to the surface. On my last evening in the city, before my return to Greenford the next morning, I'd paid a farewell visit to the park. Although the days were long at that time of year, I'd arrived late in the evening and already it was getting dark. No one else was around.

The moon, emerging to take over the sun's sentry duty, was full in the sky and the large shoal of fish was especially close to the surface sheen. They were a living extension of the water. They showed no movement, except in the tail fins. Some optical illusion made it look as if these were gently rotating. Fish, lake, twilit sky and I were held in silent tableau for a good ten minutes. Then, quite suddenly, a dark cloud passed in front of the moon. This startled the carp, and with a flick of their tails they disappeared into the depths.

This image, which I suppose had lain quietly in a forgotten corner of my memory for seven years, had grown intense over the last week. This was surely my own *moment of communion with nature*. But how could I express it with force and elegance to impress Mazod as well as satisfying myself? And how could I do this in a short poem of only seventeen syllables, and in a way that spoke of the seasons? I supposed I might achieve the latter by moving the whole incident from its actual late June to a fictional autumn. The departure of the fish might then represent the end of summer. That June evening had indeed marked the end of my own short summer...

*

'Good heavens. I was told you opened your shop at nine-thirty? It was twenty minutes to ten and you still had me

rattling the door in the road outside. What if I were a customer? And the double-door system you employ is enough to deter anybody. It's ridiculous, plain ridiculous!'

The speaker was a tall, bony lady of about sixty. She was dressed in a dark-brown, featureless but expensive-looking two-piece costume. On her head she wore a flowered hat of prodigious proportions, and from beneath its rim and over a gleaming pince-nez two pale grey eyes were blinking furiously at me. I wanted to ask her what, if she wasn't a potential customer, was she doing in my shop? But so belligerent was she and so formidable her appearance that my nerve failed me.

'I'm sorry,' I said, sweeping my clumsy drafts of the *Haiku* under the counter. 'I was doing my accounts.'

'Well, I had only the briefest glance at what you are calling your accounts. They looked a complete mess. I couldn't even see any figures!'

Who was she? Her impertinence was breath-taking.

'Well, what can I do for you?' I said. 'Would you mind telling me who you are?' I added nervously, almost as an afterthought.

'Who am I? Why, I'm Mrs Henry Trevithick, of course. My husband had arranged for me to call in this morning. Why were you not ready to receive me?'

'I didn't know you were coming. Your husband hadn't said anything about it. I wasn't expecting to see him until after his return from Cornwall. He told me he was coming on the thirtieth of July.'

She sighed when I said this, but didn't evidence an ounce of contrition. Her haughtiness now seemed to be directed at her absent husband as well as at me.

'That's typical of my husband. He's a good businessman, but he does suffer these ridiculous memory

lapses. At least I *thought* he was a good businessman. I'm not altogether sure he has it right this time,' she added, glancing around my shop. 'Sentimentality about his grandfather would seem to have got the better of his financial judgement on this occasion.'

'I hope that's not true.' I tried to say this calmly. Inside I was seething and wanted to protest vehemently. But this overbearing woman was the wife of Henry Trevithick, the man who held the key to my future in the business world. And so, indirectly, to a possible future with Mazod.

'I say it because it looks to me to be very much the case,' she said. 'I say it also because Mr Harris from Ealing, one of our friends and neighbours, told me you were late opening the shop yesterday. He had to hammer on the shop doorway, in exactly the same way as I found myself having to do this morning. What's more, he complained that the way you took his order was unprofessional. It was almost as if you were in a trance. This was the word he used to describe his experience. You're not trying to tell me those things are good business practice, I trust?'

A trance? I couldn't argue. It had been induced by all the porter I'd consumed during the skittles match at the *Hare and Hounds* the night before. I wasn't going to tell Mrs Henry Trevithick about that.

'And I should mention another matter of concern,' she continued, scarcely pausing for breath. 'At least four of the people to whom we recommended your services are still waiting for completion of their orders. This is no way to conduct trade that Mr Henry Trevithick seeks to promote. You should give a realistic estimate of when you can complete the work and stick to it, even if doing so means you have to put in additional hard work.'

'I have been doing in a lot of extra work,' I protested. 'I've worked late into the night most evenings this week.' This was true. The early-morning rising and the late-night

working was telling on me. But she ignored me, and carried on with her lecture.

'…And, as I said, the double-door entry system you have is enough to deter anyone. I think my husband has already mentioned to you that a specialist business like this is in the wrong location?'

'Yes,' I said, flatly.

'Well, I entirely agree with him. Now, show me your books.'

I was reluctant to show her my accounts. Even Mr Trevithick had not asked for this. We'd made no formal agreement as yet. Besides, although late last night I'd brought my books more or less up to date, I was sure they wouldn't be up to the standard this domineering woman would expect.

But when the Cornishman and I had spoken my hopes of a life with Mazod had been no more than a wild dream. If I was hoping to make it more than fantasy I was left with no alternative but to show his wife my business records.

'I'm waiting,' she said.

Without another word I drew out the three books from under the counter: the day-book; the materials-and-orders book; and the main accounts book. I handed them to her and she adjusted her pince-nez and bent over them to begin her examination.

'Is this all?' she said. 'Good Gracious. Your handwriting is minuscule. But, never fear, I will know exactly what I'm looking for. In the days before my marriage I used to be an accounts clerk. The male employees of the firm looked at me askance until I demonstrated I could work faster and work more accurately than any of them.'

She then looked through each of the books, flipping through the pages rapidly, stopping now and again to pore

over an entry, giving here and there a thoughtful "hmmm", or more often a grunt of disapproval. She didn't ask me one question during her impromptu audit, though she did indeed appear to know precisely for what she was looking. Despite my bruised pride, I was impressed, and anxiously awaited her verdict. After no more than fifteen minutes she closed the final book with a theatrical snap.

'I suppose,' she said. 'That most of the information is there. But it's in an absolute mess. I shall tell my husband he must to hire a reliable bookkeeper to get your accounts into order.

'Now,' she said, removing her pince-nez with a flourish. 'You have seven orders that should have been completed by yesterday. Can you get them done by Monday?'

'Six or seven,' I said.

'Take my word for it, young man. You have seven orders to complete. Unless you're trying to tell me these books are not accurate? Now, can you get those orders done?'

'I should be able to finish them.'

'There is to be no "should" about it. "Can you" is what I asked.'

'Yes, 'I said. 'I'll finish them.'

'Good. Do you want me to send a boy to help you?'

'No, thank you,' I said, as politely as I could. Someone else in the shop was the last thing I wanted.

'Then I'll leave you now. You have a lot of work ahead of you today.'

She turned her back and marched out of the shop without so much as a "thank you" or even a "goodbye". And

she hadn't even asked to see a sample of my engraving or calligraphy.

Sunday, 12th July, 1914

Last night I didn't finish working until after one o'clock, so I'd been grateful for the chance to relax this Sunday morning. I'd given the alarm a rest for once, and lazed in my bed until ten o'clock. I surely needed the extra sleep: the combination of early rising and late working was wearing me down. Today, I'd made a leisurely breakfast. I'd treated myself to two eggs and bacon before strolling down the Old Field lane to Holy Cross Church. There I'd wait for Mazod to come out after the service.

I should have been content at the prospect of seeing Mazod this morning but two things were preying on my mind as I waited for the congregation to emerge. Would she have wondered why I didn't attend Church this morning? I knew I skipped attendance as often as I dared, but that was in the days before I was walking out with her. But the thing really worrying me was that Archie Perkin may already have told her where he'd seen me on Wednesday. Perhaps he'd said more about Rosie.

Mazod, followed by her aunt and uncle, was one of the first people to step out of the Church porch. How perfect she looked. For the Sunday Service she was wearing a dress of the palest lilac and the simple flowing elegance of it suited her to the ground. For the hundredth time this month, I thought how fortunate I was to be getting closer to her.

It seemed to me I could read a question in her eyes. I feared the worse as she said a word or two to her Guardians before walking briskly over to join me. Her usual smile was absent.

She did at least put her hand on my arm when she reached me, though I noticed she did not link it with her own

as before. I mumbled a greeting, but Mazod didn't reply directly.

'Where shall we go?' was all she said.

'I thought we could walk up to the site of the old windmill,' I said. 'Unless you think it's too far?'

'No,' she said. 'We've plenty of time today.' Again, I thought she spoke a little shortly.

'At least I don't think we'll be caught in a cloudburst today.'

I tried to say this lightly, making a joke of it as best I could, but she didn't respond. We'd walked all the way up the Old Field lane, along Ruislip Road, and had even taken the turning up to Windmill Lane before she spoke more than a few words to me. Until then, I found myself leading the conversation, something I was always clumsy at trying to do, especially with Mazod.

'Archie mentioned yesterday that he'd seen you earlier in the morning,' she suddenly said. 'It was the second time recently he'd seen you in unusual circumstances, he said. You turn up in the most unexpected places: those were his words. By the way he was speaking; it all seemed to be some coded joke of his. At all events, he was very amused.' She looked at me. I thought I could read an unspoken question playing across her lips. It was good she'd decided to talk in something like her normal fashion at last, although I could hardly be comfortable with the topic of conversation she'd chosen.

'Yes, I was walking very early yesterday. I saw Mr Perkin out with his dogs.' I waited anxiously to see what else Mazod might say.

'It was strange. He said he didn't know you were such a keen gardener, or that you were so fond of butterfly-collecting. What do you think he meant?'

'Oh? I expect he was jesting.' I waited tensely to hear how she'd continue with her questions. The 'gardening' must be a sly reference to my digging at Coston's Bridge. But butterfly-collecting? It sounded as if Archie Perkin was hinting at my visit to Rosie on Wednesday. Had he told her more?

'Archie was most amused by the whole thing. He kept chuckling all the time he was talking. As I said, it sounded like some private joke shared by the two of you. At any rate, he didn't mean me to understand. You men are like naughty boys sometimes.

'One thing he did eventually tell me was that you'd made an awful mess of the ground next to the footbridge over the brook,' Mazod said, with a quizzical look. 'Why ever should you do that?'

'I was looking for something,' I said, hoping she wouldn't pursue the matter. 'Did he say what he meant by his remark about "butterfly collecting" by any chance?' I tried to make my enquiry sound casual, although this wasn't easy. I was only too sure what Archie Perkin had meant by "butterfly-collecting".

Mazod didn't answer my question. Instead, she walked away from me and ostentatiously examined some flowers in the hedgerow. They were common dog-roses. It seemed to me she only did this to avoid answering my question.

Coincidentally, a real butterfly landed close to her hand. It wasn't a Red Admiral, just an ordinary Speckled Brown, but at least it gave me a chance to change the subject.

'That reminds me. I've written a *Haiku* for you,' I said. 'I've got it here in my pocket. Would you like to see it?'

'Is it about wild flowers or butterflies?'

'No, it's about fish.'

'Fish?' She looked blank. 'Go on then.'

I read the Haiku:

> *'Moonlight on water*
> *hidden by cloud. Carp flick tails*
> *and summer is gone.'*

Yesterday, I'd been pleased with the poem. I thought it had captured my thoughts on that evening in The Green Park and expressed them through nature. Today, the result seemed lumpish and forced. And the way I'd read had made the lines sound all the more wooden.

'It's not too bad,' said Mazod. 'There are perhaps some points where it could be tightened up. But my Aunt Hattie in Sudbury says longer poetry about the English countryside is going to be the next big thing in verse. She's in correspondence with Abercrombie, who knows these things. Have you heard of the work of The Dymock Poets?'

'The Dymock Poets?'

'Dymock is the name of a village near Ledbury in Gloucestershire. Abercrombie and some of the new young poets have made it their base.'

I knew the name of Abercrombie. But the last thing I wanted to do today was discuss them and their work. And I'd never heard of any place called Dymock. All I wanted to do was tell Mazod of my hopes for our future. I cast my eyes downwards. I must have looked sullen.

'Cheer up, Tommy,' she said, her voice taking on some of its normally bright tones. 'Life's never that bad. Look, I can see very well you don't want to talk about the Dymock Poets. I don't want to discuss poetry, either.'

'Then what do you want to discuss?' The way this came out made me sound like a petulant child.

'Ourselves, Tommy. I want us to talk about ourselves.'

I looked at her, puzzled. It was all I really wanted to talk about, too. But how was I to even begin? And exactly what did she herself have in mind? Today I found it so difficult to judge her mood.

'Look, Tommy,' she said. 'We don't have to go all the way up Windmill Lane. We can cut across on the footpath further up on the right – hardly anyone ever uses that - and come back down Muddy Lane from there. We need to talk.'

We hadn't seen anyone else all the way along Windmill Lane, for that matter, but the footpath she was talking about was splendidly isolated. It was crossed by another that led back more directly to the village of Greenford. To go that way would save us walking down the dull Muddy Lane, but Mazod didn't seem to know about the path.

Her knowledge of local geography must have been a bit hazy, too. I knew we still had a fair way to trek up Windmill Lane before we reached the footpath. Still, I was more than content to walk by her side in silence, especially since she'd at last linked her arm firmly with mine. Despite what she'd said about the two of us needing to talk, Mazod seemed content to remain quiet. Only there wasn't really a silence: it was a delight to listen to the choral repertoire of the thrush and the contralto of the blackbird from high in the branches. Once, we heard two chaffinches exchanging their peculiar lemonade 'pops' from the trees above us on either side of the road.

We had turned off to our right and followed the footpath for some distance, before Mazod spoke.

'We'll sit here for a while, shall we?'

She indicated a log by the side of the path. It looked remarkably like my morning seat on the Hill, save that this

was shorter and more gnarled. I sat down beside her, wondering whether it would be right for me to try to kiss her. What would she be expecting? I decided it would be too forward of me.

'Now we're going to talk have a proper conversation,' she said, as if in response to my unspoken question. 'Both of us are going to talk. I want us to be really honest with each other. No pretence.'

All I could do was nod. I wondered what she was going to say, and exactly what she'd be asking me.

'You shouldn't get any wrong ideas about my place in society,' she said.

She looked at me, clearly expecting me to say something. 'I haven't got any wrong ideas,' I said. 'I've hardly thought about that sort of thing,' I added. The latter was hardly true, but the question had not been uppermost in my mind. The last thing I wanted her to think was that I was a treasure-hunter, or some sort of social climber. 'I know your family isn't sitting on a fortune. You've told me as much yourself.' It sounded indelicate to put it so bluntly, but I felt sure she wanted me to say something. Exactly what was she expecting from me?

'Yes, it's true. But it's only part of the story. I also told you my mother and father died when I was a little girl of five, and that my Aunt Theresa and Uncle Roger brought me up. Remember?'

'Yes, you've told me all about that, too' I said. I wondered where this was leading.

'Well, now I'm going to tell you more. My mother, Vera was her name, was the youngest of the three sisters. She married William Betham. If my parents had lived to bring me up, I suppose I would have been conventional and conservative, exactly as you still believe I am. My mother

was by far the most timid of the three sisters, so my Aunts have told me.'

The last thing I could imagine was a "conventional and conservative" Mazod but I didn't attempt to interrupt her. I wondered why she was telling me so much.

'My Aunt Theresa was the eldest of the three. She used to be what I suppose you'd call "arty" in her younger days, back when she lived with her family in Hampstead. There were a few eyebrows raised at some of the things she did, I can tell you.

'But, after she married my Uncle Roger, she became village-respectable. All the more so after my mother and father died and the two of them came to live in Betham House to look after me. All the neighbours think she is and always has been exactly like them. She's not really; at least she's still not like the local people in the way she looks at life. Can you imagine the reaction of some of the others if I'd told them I wanted to walk out with a shopkeeper? But my Aunt Theresa - and my Uncle Roger, to be fair - simply talked to me in an adult way about you. I'm really lucky with them, Tommy. I'd never do anything to upset them.'

Again I was amazed at how honest and forthright Mazod could be. No other girl would have been half as open about such private matters. I knew I could never have been anywhere near as direct myself. At that moment, I wanted more than anything to hold her, but something told me now was not the time to do it. Besides, I could see she wanted to say something else.

'I didn't know the middle sister, my Aunt Hattie, until I was twelve or thirteen,' she continued, after a thoughtful pause. It was if she was giving voice to thoughts that had lain quietly in her mind for a long time. 'Now, Aunt Hattie really was something. So she still is, in lots of ways. My father gets very annoyed every time he sees her with a copy of Mrs

Pankhurst's journal, the *Women's Dreadnought*. I'm sure she carries it purely to tease him most of the time.'

Here she stifled a laugh, but grew serious as she continued.

'You'd have to say my Aunt Hattie was a Bohemian in both senses of the word. She caused an absolute scandal in Hampstead when she eloped to Prague – that's in Austria-Hungary, as I expect you know – with a concert pianist called Zítko.

'Eventually they split up – Zítko turned out to be something of a philanderer – and later on my Aunt Hattie came to Sudbury to live near to her sisters. It was only then she discovered her younger sister had died. She didn't even know of my existence until she came back from the Continent. Aunt Hattie made such a fuss of me when she found she had a niece. And for me, it was like suddenly finding a wayward big sister.' She smiled to herself. It was clear Mazod thought the world of her Aunt Hattie.

'Wayward?' I prompted her when she fell silent again.

'Well, not wayward in the way she was in her younger days, of course. But you'd still have to say she's unconventional. It's a good job the people of Greenford and Sudbury aren't aware of some of the old stories about her. She lives in what she calls her "studio", though really it's nothing more than a few rooms above a shop. These days, my aunt is mainly interested in poetry and art galleries, but she's still very attractive and has plenty of admirers. Most of them she keeps at a safe distance, but some very respectable family men have propositioned her. I could give you a list of names that might surprise you. But I'm not going to! Now, what about you?'

'Me?'

'Yes. Well, I've told you a great deal about my family. Aren't you going to tell me anything of yours?'

'There's not much to tell.'

'Of course there is! There must be, Tommy. I know your father died around the time my Aunt Hattie came back from Prague. That was when you came back from London to run the shop. It was then I first began to notice you, even though I was still a young girl. You used to work for a newspaper in London, didn't you? But I don't know much else about your past. It's as if there's a big dark veil over it in the village.'

What should I say? I drew a deep breath before speaking.

'I was born and brought up in Greenford. I went to the Betham School. Soon after I left the school, my mother died. This would have been a few years after you'd lost your own parents, I suppose. A short time later, I went to work in a print shop in Ealing for several years. Then I had a lucky break by landing a job as a junior journalist with the *Independent Record*, a newspaper in London. I loved working in the newspaper trade. But I'd been there only six months before my father died and I came back to Greenford to run the family business.'

It sounded to me as if I were talking about somebody else; it was almost as if I were running through a draft of the first part of an obituary for the *Record*. And I was only twenty-nine years old. What might be in the second part? For a moment I became profoundly sad, and said nothing further.

'Is that all you're going to tell me?' asked Mazod. 'What things do you like? What about the future? What hopes, plans and dreams do you have?'

'*You*!' I wanted to shout this at her, and to anybody else who'd listen. '*You're my hope and dream for the future!*' But my inhibitions got the better of me. Instead, I answered in a bland, matter-of-fact, way.

'To tell you the truth, I feel I've wasted the last seven years,' I said. 'I suppose I'd always kept alive the vague notion of getting back into the newspaper business. It was probably for that reason I'd been content to let things tick along quietly in the shop. Right from my days as a child I'd seen it as the business of my father and grandfather, rather than thinking someday it would be my own, if I'm honest. All my life I've read a lot and I used to do some drawing. But, these days I'm really working hard at my business.' I thought for a moment before adding: 'I'm going to go into partnership with Henry Trevithick before long. I'll be moving into new premises in Ealing, soon.'

'Henry Trevithick? Well, there's a man who really knows what he's doing. He's a friend of my Uncle Roger. Your work must be going well.'

'There are a few contractual points to iron out yet. Business matters, you know. Don't say anything to your Uncle just yet, please.'

So, not only had I prematurely told Mazod about Henry Trevithick, but I'd committed myself to following the signpost direction marked "respectable member of the business community". But, if Mazod were to be my companion this would be the only path to take, anyway. I remembered what John had said to me on Thursday. "Go for it", he'd said. It was good advice.

But tomorrow morning, I'd promised to see Jet on the Hill again. What would he have to reveal about the other, more uncertain, path? Or was this thought merely something I'd built up in my mind upon no solid foundation? Now, more than ever, this was exactly what it seemed to be.

'And what about your friends?' asked Mazod, interrupting my reverie. 'You don't have too many in the village, from what I can gather.'

'John Jakes, the blacksmith, has been my good friend for years.'

'Now,' said Mazod. 'You might think this is very forward of me, but I do want us to be completely honest with each other. And you are a man of twenty-nine years of age, after all. What about girls?'

'None of those in the village interests me,' I said. 'Except you,' I added, trying belatedly to be gallant.

She studied my face intently. For a moment, I was convinced she must know about Rosie and was ready to say something. I quickly spoke again.

'And what about you? What are your own "hopes and dreams", as you put it? Do any of the young men in the village interest you?'

She laughed lightly. 'I'm not going to say "only you" if that's what you're hoping. There isn't much to tell you about young men. I've walked out with a few, but there's never been anything serious.' She paused for a long time before continuing. It was clear that what she was about to say was important to her.

'My Aunt Hattie was my heroine for a long time. I had some idle notion of modelling myself on her when I became twenty-one. Going off to the Continent to find art, you know. It was my dream. But over the last few months I've come to realise that, after all, I'm too conventional for such a life. I do like art of all kinds, but I've got to admit I've no especial artistic talent. So, I suppose when the time is ripe, I hope to meet the right kind of young man.'

'What is the right kind of young man? One with lots of money?'

'No,' she said, firmly and more than a little crossly. 'I'm not one little bit interested in material things. I've told you as much before. I'd be happier with someone who is

prepared to work for his living. He won't be a stuffed shirt, like so many of the young men in Greenford. Nor will he be even a bit stodgy, like my Uncle Roger. That doesn't mean I want a wild philanderer, like my Aunt Hattie's Zítko. He'd have to be sympathetic to art, and above all he'd have to be prepared to let his wife *breathe*. Then he'll be the one for me.'

'Sounds like me,' I heard myself saying. I realised it was a stupid thing to say as soon as I'd said it.

'*You*, Tommy Green? Well, if and when you think you measure up to the job you can apply for it. But it will have to be when I know you a whole lot better. You've hardly allowed me to see yourself at all, yet. Now, come on. We can't sit here all day.'

Saying this, she jumped up and started to walk briskly along the footpath. Again she looked lovely; lovelier even than when I'd seen her coming out of the church earlier today. After a while she did take my arm, but held it less tightly than before. I couldn't help thinking I'd missed a golden opportunity. It was as if I hadn't said enough, or that I'd said the wrong things about myself. Did she now regret telling me so much about her own life?

We walked along, talking of inconsequential matters. I had the distinct impression we were drifting apart as we walked. When we came to the right fork in the path, the one that led back to Greenford, I pointed out Waxlow Farm and told her this was where my grandfather had worked as a labourer years before I was born, but she didn't seem to be particularly interested. We'd almost reached the village before I could work up the courage to ask if I'd see her again.

'If you like,' she replied. 'Tomorrow, I'll be busy, but I've got to go into the village for something on Tuesday, so I'll call for you in your shop when it closes at seven-thirty.'

That laconic "if you like" held out a glimmer of hope for me. I had to try to hold on to the thought. Mazod was certainly perplexing; more so than any girl I'd ever known. At one moment she'd been telling me far, far more about herself than I'd ever expected. The next she was berating me for not being equally as forthcoming and becoming remote from me. Did she now regret telling me too much, too soon? Was the way she behaved no more than a reflection of her youth? She was probably not yet twenty, after all, ten or so years younger than me.

Although I was tired, that night I kept on turning events over in my mind. It was at least three hours before I could get to sleep, and when at last I did manage to close my eyes, I slept fitfully.

Monday, 13th July, 1914

Lucky thirteen? The morning didn't promise anything of that nature. The sky was iron-grey; it looked as if the clouds were ready to tumble from the Heavens. I didn't own a proper Macintosh; all I possessed was an old sheet of canvas. This I kept at the ready as all the time I kept glancing nervously above.

I'd considered not coming to meet Jet today, discourteous as this would have been. My absence wouldn't have been because of the threatening storm. It was because I'd already decided where my priorities should lie. They weren't in the vague direction to which I'd imagined Jet to be pointing. Still, something drew me back to the Hill, despite my misgivings. I suppose I wanted to hear what this young man would tell me about the future. And especially I wanted to learn what he had to tell me about the future of Mazod and myself.

Precisely at seven o'clock, he materialised in the exact same spot as a week ago. It was almost a replay of the last appearance. Only not exactly: on the previous occasion his grin had told of his pleasure with himself and his conjuring trick; this time I'd have said he was plainly worried about whatever he'd come to say.

He tried to fasten a friendly smile on his face as he walked up to greet me, but I could see his unease.

'Hi, Tommy. Good to see you again. You've had some week since I saw you last.'

'Yes Jet. You could say I have. Tell me, how do you know?'

'You've written it all down, remember? My father told me about the sticky bits of your courtship. Don't worry about Mazod. Yesterday would have been no more than a

minor hiccough. Women were always impossible to understand, eh?'

Immediately, I was furious at his easy knowledge of my most intimate feelings and the way he dismissed them so lightly. Besides, I'd done some serious thinking since yesterday: Mazod was right to have acted as she did. I knew I'd been guilty of over-calculation, of planning my every move to win her without genuinely trying to make her aware of my true feelings. My attempts at courtship had been inept in the extreme; I'd have to come out of the long grass.

But when, after debate with myself, I'd decided to climb the hill this morning, I'd resolved that today Jet and I shouldn't argue pointlessly again, so I tried to suppress my feelings of anger and changed the subject.

'You didn't look exactly happy yourself when you first appeared,' I said. 'You can't have had such a wonderful seven days yourself in Future-land.'

'From my point of view, a week hasn't passed since I last saw you. In fact my first visit, when you were still a young boy, was at about eleven o'clock this morning by my reckoning. The clocks might have been ticking away normally for you since I was last on the hill, but I've spent a bare half-hour in what you call Future-land. All I could manage to do was rest briefly and to try to compose myself for the next stage of our discussions. This was why I was looking so serious when I appeared; we've now arrived at the stage where I've got to tell you some grim things. I'm not looking forward to it.'

'Grim things? Do you really have to? I could do with lighter conversation.'

Jet didn't answer this directly. Perhaps he thought it was no more than a weak attempt at levity on my part, although I really could have done with some cheering up after Mazod's coolness toward me yesterday.

'Well, I'll be staying with you for longer this morning. There are some more pleasant things I'd like to do first, if you'd let me. Did you remember to bring the sketch I saw seven years ago - seven years by your reckoning, that is?'

'Yes. Here it is,' I said, pulling out the drawing I'd done so long before for the *Independent Record* from underneath the folded canvas sheet. 'I'm not sure it was a good idea to bring it out with all these rain clouds about, though. Aren't you even going to sit down this morning? The things you have to tell me can't be all that bad, surely?'

Jet forced a grin and sat down beside me on the log, taking the picture I offered to him in a grasp I noted to be perfectly solid. He was no kind of phantom, nor indeed had did I ever form the impression this was what he was. I'd myself have described the picture as a fully worked-out drawing rather than a sketch. The pen-and-ink highlights I'd used to complete it and the few touches of grey wash here and there were among the best I'd ever achieved. Still, he held the picture respectfully enough, almost reverentially in point of fact. He studied it for a long time before saying anything further.

'It's really fine. You can't guess how much I wish I could take it back with me. It would be of historical as well as artistic interest in the twenty-first century. It's a shame this drawing doesn't survive over the years.'

I remembered he'd said he couldn't take back – or should I say forward? – any material object. 'Historical and artistic interest?' I said. 'It's was only ever intended as a newspaper drawing of the Russian Anarchists when they came to London. My editor didn't even publish this illustration with my piece.'

No, I thought, he didn't use it after all my effort. The man preferred the revenue from an advert for Eno's salts.

'More fool him, then,' said Jet. 'Do you know who these three men were?'

'I only really had a chance to study the man I've drawn there,' I said, pointing to the man of youngest appearance. 'This one, standing behind the other two in the picture. And I saw him on no more than three or four occasions in all. He was lodging next-door to me in Fulborne Street, off the Whitechapel Road. The Polish Socialist Club found the lodgings for him, so a little investigation told me. My sources told me his name was "Vasily from Baku", but I heard the other Anarchists calling him "Soso". Anyway, he seemed to be a crafty customer, always slyly looking about the place. You could see his devious mind ticking away. But the other two were more important, so far as I understood.'

'So they were in the early years of the Russian Bolshevik Party,' said Jet. 'But this neighbour of yours became one of the monsters of the twentieth century. The proper name of this "Soso" was Joseph Djugashvili. Later, he took the name of "Stalin", the "Man of Steel". I'll tell you more of him later. Do you know the names of the other two?'

'This one,' I said, pointing to the white-haired, intellectual looking man wearing spectacles, 'was Lev-something. I can't remember what the other one was called, but the others always used three names when they spoke of him. At the time I remember thinking that, together, they sounded like a chant or incantation.'

'The name of the one with glasses was Lev Bronstein,' said Jet. 'The name you heard as a chant was probably Vladimir Ilyich Ulyanov. The two of them afterwards took the names of "Trotsky" and "Lenin". To see a picture of these three characters drawn from life at such an early date is really something.'

'They came to London in May, 1907 for some sort of Anarchists' Conference.' I remembered the time very clearly. All the other papers covered the story in a so much livelier

way than ours. The *Daily Mirror* used the headline "*History is being made in London!*" Some of the others ran stories about women anarchists practising with guns in front of a mirror. The *Daily Express* headlined with "*Russian Revolutionists Afraid of Camera!*" Our editor was afraid of using my picture and losing advertising space. So much for history, then. We only ever carried half a story. It was one of the reasons why the newspaper failed a few years afterward.

'I once managed to get some translated quotations from Monsieur Severeff, one of Imperial Russia's secret policemen,' I continued, remembering the episode with mixed pride and bitterness. 'The editor didn't use one of them. The Imperial Government sent Severeff over to keep an eye on the Anarchists. No wonder the *Independent Record* went broke. It was a big story at the time. We'd have been first with the feature, but we may as well have missed the story altogether.'

Jet looked at me. He was going to say something else about the Revolutionists, but I could see he was changing his mind.

'I promised to show you my Idee Card,' he said, reaching into his pocket and producing a small object. It wasn't a card at all, but a thin sheet of white shiny material. The sheet bore a portrait of Jet, together with rows of numbers and symbols. The picture was like a photograph, but I was amazed to see it had real depth. It was as if it were three-dimensional, with a tiny Jet trapped inside what he'd called his card.

'This is amazing,' I said.

'Amazing? Some people have used other words for them. But it's no good to say anything. It's been compulsory for everyone to carry these for about twenty years. The Idee Cards we use today are much more sophisticated, technically, than the early ones.'

'So what do all these letters and numbers mean?' I asked. They were in twelve or fifteen tiny rows, in a column on the right-hand side, opposite the curious image of Jet.

'They're the standard citizenship measures,' he said. 'The one at the top, for instance – you see where it says "BMI"? Well, that stands for "Body Mass Index". You can see mine was 20.9 the last time it was calculated; that's well within the maximum 22 stipulated by the Government for my age group. I've probably gained a little weight since the last statutory measure, though I'd hope not too much. My next assessment is due in three weeks, so I'll have to spend a little more than the statutory minimum time at the gym to be on the safe side.'

I tried to ignore the many questions framing in my mind about this strange society of the future. 'What about all those other numbers and codes?' I asked him.

'They record things like IQ, Conformity Factor and General Citizenship knowledge. But we haven't time to go through every line. I want you to see my Linker. Then I'm afraid I'll have to give you a history lesson.'

He'd put what he'd called a card away in his pocket and was holding up his wrist to show me the instrument he referred to as his "Linker" before I could ask him anything further. "The Linker" was the strange watch-like object I'd found so fascinating when I'd first seen it earlier in the month. On its face were displayed figures, boldly lit as before. This time they read '14:46'. The smaller characters underneath, exactly as they'd done a week ago, read 'FRI 25-5-46'. But, as I was puzzling over this paradox and remembering what Jet had said about relative time, the figures became obliterated by a pattern of lines.

For a second or two, the lines were monochrome and fairly static. But very quickly they became multi-coloured and arced in graceful geometric patterns. Their movement across the small screen was variable in speed, but always

fascinating and a joy to watch. Sometimes, the lines left behind them a shimmering outline showing their path across the small screen. The hue of the lines changed slowly as I watched. I couldn't tear my eyes away for even a second. All the time Jet was saying something to me but I couldn't distinguish his individual words: for the moment my world had become the one enclosed by the tiny screen. I didn't know whether I'd been lost in this world for seconds, minutes, or hours.

'Tommy?' At last, Jet's voice penetrated my consciousness. The pattern of lines was replaced by the glowing symbols '14:49' and 'FRI 25-5-46'.

'What was it I've been looking at?' I said, coming out of my trance. 'It was extraordinarily beautiful.'

'Nothing more than a Linker graphic,' said Jet. 'I thought you might be interested in seeing the program. I installed it – well, my Father did, to tell you the truth – shortly before I left home. Here, in 1914, we're out of range of any of the broadcast programs, and I thought you'd like a short demonstration of what a Linker can do.

'It's a shame I can't show you any Elanic Images. Most people think these show a Linker at its best.

'Broadcast programs? Linkers? Elanic Images?' I said. He was too fond of dropping these odd expressions into our conversations.

'Sorry, he said, when he heard my question. 'I should tell you that nearly all the publicly-available programs are cast from the central network: weather forecasts; spread-calcs; slebtok; entertainments; databases; comms-links; tabulators; and so forth. I'd really like to show you a few Elanic Images if I could'.

'Elanic images? Come on Jet. Talk some sense'

'Within range of the central databases, a Linker can generate a life-sized, animated image of a person from history or the Sleb Libraries. I've sat and spoken to your own image a dozen times. Of course, it's not as good as talking to the real you. They didn't get the colouring quite right. I suppose they were working from a few inadequate colour prints from the sixties and seventies after all.'

My brain felt as if it were frying with all these new ideas bombarding it. All I could do was sit there, stunned. Jet allowed me a few quiet moments. Then he was off again.

'Sorry, I may be going too fast. But there's so little time. Everyone has to carry a Linker and an Idee. It's the law. I think the word 'linker' explains its purpose: the instrument is meant to act as a link between the individual members of society and our Government. I don't know where the other word came from.'

'You may as well be talking a foreign language,' I said. 'What, for instance, are tabulators?'

'No more than devices for keeping track of us for regulation safety purposes. They're the reason my visits to 1914 should be of no more than 55 minutes duration. We're out of range of the tabulator programs here in your time. An alarm would be sounded in one of the security stations if I were out of contact for more than an hour.'

I couldn't believe what I was hearing. 'What happens at night when you go to bed, then? The alarms you're talking about must be going off all the time.'

'We're not allowed to take our Linkers off for more than an hour at a time,' he said, simply. 'Even when we're asleep at night.'

'How can you live like that?'

He regarded me as if I'd said something outrageous and fixed me with a surprised stare. For what seemed a long

time he didn't speak. When he did it was in a low voice, and he spoke carefully as if reciting lines he'd learned somewhere.

'Remember, your society seems equally strange to me. But I remind myself that your values are not better or worse, only different. As LP Hartley said, "the past is a foreign country: they do things differently there". I have to keep reminding myself not to look at that country through darkly-shaded lenses any more than I should rose-tinted glasses.'

'That sounds like something you've learned off by heart. You aren't the first one to say this, are you?'

I hadn't a clue as to who this Hartley character was. But Jet had been assertive enough about this saying about the spectacles. At first, he tried to look offended. Then, slowly his face creased into a wry smile.

'No, I have to admit it was my father who wrote down the addition to the epigram some years ago. It's not my invention.'

Then his expression became serious again. He stood up from the seat to face me.

'I shouldn't procrastinate any longer. My main purpose today is to tell you about the history of the twentieth century. But, although I've thought of scarcely anything else, I don't know where to begin. I've used up more than half of my fifty-five minutes already.'

My impulse was to make some sarcastic comment, but at that moment young Jet seemed to be carrying the weight of the world on his shoulders.

'It's usually best to begin at the beginning,' I said, trying to encourage him.

'In less than three weeks,' he suddenly blurted out. 'There will be a war.'

'Sadly,' I said, as sympathetically as I could. 'The whole of human history is littered with wars. There was a war against the Boer farmers in South Africa at the turn of the century. My father's cousin lost a leg in that conflict. Only last year there was yet another war in the Balkans. One thing we can be very sure of is that there'll be more wars to come in the future.'

'You don't understand,' Jet said. 'This will be a war like no other in history. It will be world-wide in scale. Can I even begin to make you aware of how terrible it will be? There will be nine million soldiers killed, for a start. They will fight in hellish conditions. The lasting symbol of that time was the mud-filled trenches the soldiers fought from. Half of the sixty-seven million men mobilised across the world will be casualties of one sort or another. Nearly a million British soldiers will be killed.'

In the rapid way he spoke, those figures were overwhelming. They would have been too much for me to take in, however I'd heard them.

'Nine *million* dead? A million Britons?' I said. '*Sixty-seven* million soldiers? The population of our country is fewer than forty million people. How can such a thing ever be?'

'It's beyond the understanding of people in my time.' He shook his head slowly. 'They called the conflict the "Great War" for a while. It was supposed to be "the war to end wars". Only it wasn't. Not much more than twenty years after this one ends, there'll be another, even bigger in scale. More than sixty million people, soldiers and civilians, will die across the world.

'Why? Why?' I couldn't believe what I was hearing.

'That war, the later one, will come to be called the Second World War. It will be a direct result of the one starting less than a month from today. Your war will end with

an unworkable treaty. A person who was a lowly corporal in the first war, Adolf Hitler by name, will exploit the resentment of the German people. He'll be the catalyst for the second war. Hitler was the most evil of the monsters of the twentieth century. He did unbelievable damage to the world in pursuit of his insane vision. But this won't be the only legacy of the Great War.

'In Imperial Russia, thanks to the incompetence of their Generals and the antiquated state of their armaments, the Bolshevik Communists, under their leader Lenin - one of the men in your drawing – will seize power in 1917. None of this would have happened if not for the First World War. Imperial Russia would have dragged itself into the twentieth century eventually. Already when you drew your picture of the three revolutionaries in London the influence of the "Anarchists", as you call them, was on the wane. Seven years after the Communist Revolution, Stalin – your next-door neighbour in Fulborne Street – will succeed Lenin as leader. Stalin will be responsible for millions of deaths during his thirty-year reign.'

This was insane. Jet was talking about the fate of so many people. I could not begin to comprehend the numbers. He continued, even though by this time I was too stunned to listen properly to what he was saying.

'People say the effect of the Oil Wars earlier in my own century, and even of our present Cyber-wars, would have been quite different if we'd been working from a saner base. As it is, the future of our civilisation itself is under threat. It's this that's prompted my father's unorthodox action now.'

I made no reply. What could I possibly say? Jet seemed to realise he'd said too much, too quickly, and also held his peace.

'I have to go in a moment. My time is nearly up,' he said after a long silence.

'Yes, you'd better go.'

'But I'll be back on the day after tomorrow. I have to tell you more. Not very many of them are good things; I'm sorry.'

'What can tell me that could be worse than the terrible things you've already said?'

'I've got to tell you about your family history. *Our* family history. It's *people* that fight in wars and shape the path and pattern of the future.'

I bowed my head down and didn't look up. There could be nothing for me to say. My eyes were still downcast when I became aware of, rather than saw, Jet fading away again. His departure left me more alone than I'd ever felt before, even as a boy on the day my mother died.

Tuesday, 14th July, 1914

Ever since yesterday morning I'd been haunted by the nightmare future Jet had seared into my mind. He said he was going to tell me even worse things tomorrow.

On Sunday evening, after I'd returned to the shop, I'd thought everything, or what I then thought was everything, through. The way ahead seemed so clear. I'd show proper respect for Mazod and myself by being more honest about my hopes and feelings. And I knew I'd need to work hard in my business to make it a success. Henry Trevithick had shown me what might be possible if I put my mind to it. But, after listening to Jet's dark words, everything seemed so pointless: he'd told me the world I knew was going to be torn to shreds in three weeks.

The orders I'd promised Mrs Trevithick to complete were still unfinished. There'd been another steady stream of customers all today, but I could hardly blame my lassitude on them. No, the only thing I'd really felt equal to was the writing of my journal. Now this seemed to be so much more important than before. I'd nearly filled the pages of one notebook already; soon it would be time to start the second.

Mazod had promised she'd call in the shop less than an hour from now. At first, I hardly felt like seeing her tonight. On Sunday evening my heart was filled with new boldness and resolution; after what Jet had told me I could only wonder bleakly what our future would hold. How could I convince Mazod there was hope for our life together when I had no hope myself?

It was when I'd reached my nadir that I realised there might still be a glimmer of light in the darkness. Hadn't one of the first things Jet had told me been that Mazod would become my wife? Hadn't he said she and I would have three children together? Their names still rang around my head:

Bertie, Trevor, and Mary. This could only mean that, somehow, I'd struggle through the horrors of a world at war. I had to keep tight hold of the knowledge that Mazod would become my wife and we'd have children together after the war.

As I was wrestling with these contradictory ideas for the thousandth time, the muffled bell above the inner door strained. Through the door pushed not an early Mazod, nor a late customer, but John Jakes. He was smiling broadly.

Now, John very rarely stepped into my shop. I saw him sometimes about the village, or more often when I called to see the family at the forge. Today, it looked as if there was some news he was bursting to impart and couldn't bear to wait until he saw me in the normal course of things. I could see he was bringing some news. And, as he waved the piece of paper he carried in triumph, I guessed what that news would be.

'Love a duck, Tommy.' he said. 'You're looking so serious tonight. This boom in trade can't be up to all that much if makes you act so solemn. And here's me, coming to give out the news of my lifetime. I was expecting at least a smile from my old mate.'

'You've had the letter from Charlie?' I said this as if it were a plain statement of fact, rather than a question I was asking. How I wished hadn't made my response so unenthusiastically.

'Yes,' said John, matching my flatness of tone. 'I had the letter this morning. We're sailing from Liverpool early next month. Charlie's arranged everything. We're sailing on Wednesday, the fifth of August. We'll be aboard the *Magnetic*, a ship of the White Star Line. It docks in New York and afterwards we've got this fantastic journey lined up from east to west coasts across America. I was going to ask you to come around for a farewell meal with me and Vicky

on Saturday night. Unless it's too much trouble for you to come, that is?'

The fifth of August. That was more than three weeks away; it was in three weeks Jet had told me the world we knew would be torn apart. What exactly did this mean? I still could not imagine the scale of death and destruction. How would the world change for John and Vicky? And what dark future lay ahead for young Hannah and the unborn baby Tommy? I tried to push these thoughts to the back of my mind and hoped I'd managed some sort of smile for John as I answered.

'Sorry, John. I've been a bit distracted. Had some bad news.'

'Business?'

'Yes, in a way.' I couldn't prevent what hardly qualified as a half-truth from passing my lips. I couldn't tell John what was coming our way.

'Listen, Old Son. Don't let the bastards get to you so much. Everything will work out fine in the end. Who'd have thought I'd be off to California next month, eh?'

'You think so, John? You really think everything will be all right?'

For a moment, John looked puzzled at the way I asked this question, but then he quickly answered. It was good to hear what he had to say, even though we had different ideas on our minds.

'I know so. Now, come around on Saturday straight after you shut up shop. Hang the closed sign on your door half-an-hour early. Vicky'll be looking forward to seeing you. So will young Hannah. She thinks the world of her Uncle Tommy.'

'And little Tommy?' I don't know what prompted me to ask that.

'Give the lad a chance. He hasn't even arrived yet. But yes, when you come to see him in California, we'll be able to tell him that this is his Big Uncle Tommy, who came to see him off before he was even born.'

*

John's quick visit had cheered me a great deal. His bluff good humour and down-to-earth common sense usually had that effect. And why shouldn't I be optimistic, despite the terrible things I'd heard? Jet himself had told me that Mazod would become my wife. I'd do it; somehow I'd survive the terrible "Great War" he'd talked about.

By the time Mazod came into the shop, I was almost smiling.

'You're in a good mood tonight, Tommy,' she said.

I couldn't help chuckling at the irony. If only she'd arrived twenty minutes before...

'I was thinking how lucky I was.' I was thinking I was especially lucky that her manner was not distant in the way it had been on Sunday. Perhaps, as Jet had said, this day had been no more than a hiccough.

'We *are* both lucky, Tommy. We have good lives. Think of all the poor people in some of the African colonies. Think of some of those in Asia and South America.'

'Do you read the international reports in the newspapers, Mazod?'

'Hardly. Anyway, I don't need to. My Uncle Roger insists on giving me a summary of the news every day. What do you want to know? Don't expect me to give you chapter and verse, mind.'

'What's happening in Europe?'

'Europe? Well, Europe hasn't had many mentions because the papers are full of the business in Ulster this week.'

'What about the killing in Austria-Hungary? Sarajevo?'

'Oh, there was something a couple of weeks ago,' Mazod said. 'We talked about it, remember? The Royal Family, the Habsburgs, weren't very happy about it. You could hardly expect them to be, would you? But what could they do when it came down to it? Anyway, I think the fuss has quietened down by now.'

'There's nothing happening? Are you sure? I've heard that part of the world is a tinder-box. There were Balkan wars in 1912 and 1913. And the Germans sent a gunboat to Agadir in Morocco the year before. The German Emperor will be looking for any excuse to support his friends in Austria-Hungary.'

I did remember the front page of the *Daily Mirror* two weeks ago. They'd made quite a thing about the killing in Sarajevo. I'd thought then the assassination might even give rise to another Balkan War. And now Jet had talked about his "Great War". I was looking for bad news everywhere.

'Well, it sounds as if you know much more about what's happening in the world than I do. Now, are we going to go out for a stroll, or what? I haven't got much time tonight, you know.'

*

We'd decided to walk down the Ruislip Road, towards the *Hare and Hounds* and Northolt, just as John and I had done on the Tuesday and Thursday of last week. I wasn't going to tell Mazod about this, naturally, especially about my drunken exploits after the skittles game. We'd been talking easily and pleasantly, perhaps more easily than we'd ever done before. But then I thought, 'I *should* tell Mazod

about that night. I've promised myself to be more honest with her. Isn't this a chance for me to tell the truth?'

We were about to cross over Muddy Lane. I put my hand on Mazod's arm exactly as I'd done last week with John.

'Mazod, I have to tell you something.'

'Yes. What is it?' She turned to me, grey eyes widening.

'I walked down this way last week. To play skittles in the *Hare and Hounds* it was.'

'And?' Mazod looked puzzled.

'I'm afraid I had too much to drink. Far too much.'

'Why are you telling me this?'

'I thought you wanted me to tell you *everything*?'

'I didn't exactly mean a thing like *that*. You're not the first young man who's had more to drink than is good for him.'

Then she started to laugh, gently at first, but then in an unrestrained manner.

'Why are you laughing?' I asked. But her laughter was infectious, and I found myself joining in with her.

Mazod put her hand over her mouth. It was some moments before she could collect herself sufficiently to answer me.

'Oh, Tommy, you are a one. Most young men wouldn't have dreamed about telling a young lady anything about such an exploit, but you did it with a perfectly straight face. I can imagine you telling the story to my Aunt and Uncle in exactly the same way.' Here her smiling stopped for a moment. 'You won't do it when you see them on Thursday, will you?'

'Thursday?'

'I was going to ask you if you'd be free on Thursday evening. If you are then I'd like you to call for me at Betham House. I've had enough of this hole-and-corner; meet here-and-there business. If we're going to be properly walking out-'

'Properly walking out? You and I?'

I'd only dared to half-believe what Jet had said about Mazod before now. Strangely, I'd been more ready to accept what he'd told me about the coming "Great War". Any thoughts of Mazod had been tinged with wild fantasy. But now I was really beginning to dare Jet's words were true. On Sunday evening I was even unsure I'd be seeing Mazod for much longer. Then, on Monday, I'd had that frightening conversation with Jet. Now, Mazod herself had spoken about the two of us walking out properly. How much the world had changed over these few days!

'Well, we have been seeing each other quite a lot of late, Tommy,' said Mazod. 'We're becoming quite a topic of conversation among the village gossips. But I only said "walking out", mind you. I've got to know far more about you before it becomes anything more serious.'

'I'll tell you everything you want to know!' I almost shouted.

'Yes, I do believe you would, now.' She smiled. 'But let's take it slowly, shall we? Don't try to do everything all in one go, will you? Promise me that. Try to take things as they come.'

I saw now she did regret telling me so much about her own life on Sunday. But this weakness of hers, if it could be called a weakness, only made my feelings for her all the stronger.

'I promise,' I said, even though I wasn't wholly sure what I was promising.

'Let's cross over the road and walk on to the Ealing Lane, shall we?' she said brightly. 'We can look down at the canal from the bridge. On a fine evening like this the sunlight, right at this moment when dusk is beginning to fall, shimmers so wonderfully on the water.'

She took my arm again and we crossed the Ruislip Road. As we neared Harrow View, we saw Mr Tigwell outside the house on his wooden rocking-chair, enjoying a smoke on this superb evening. He raised his pipe as we passed, smiling at both of us in recognition. How natural it all seemed. I was so happy.

We turned right to walk the short distance down Ealing Lane to reach the canal bridge. Mazod was right; something about the summer light did lend a magical quality to the evening. The water was calm, moving almost imperceptibly under the merest breath of wind. The reflection of the cloud outlines on the surface, darkened by the depths of the canal and the lateness of the hour, was of the hue of burnished gold. A swarm of gnats hovered in the air at a respectful distance of six feet in front of us. Somehow, I don't know how or why, we were sure the insects wouldn't come nearer to bother us.

We stayed like this, gazing silently at the reflection on the water, for at least ten or fifteen minutes. Both of us seemed to be lost in our own thoughts. I know I was, and that hope as well as darkness lay ahead. Then, a gentle sound reached us, and slowly we became aware this was made by the hooves of a horse on the towpath. The path was rough and stony at this point, and the steady *clop-clopping* made a rhythmic, almost musical sound.

The narrow boat the horse was towing drifted into view, and, although the light was going, I recognised the colours of the Northolt Tile Works on the boat's side. It was

carrying a full load of bricks, and so was lying low in the water. The bargee, leading the horse in its contented plod, looked up, and he and I recognised each other. It was the same man I'd last seen a fortnight ago. He would have then been, as he was tonight, on his way to Paddington. A lot had happened to me in the intervening two weeks.

Perhaps because he hadn't expected to see me, or anyone else, peering down at him from the bridge, he greeted me as if I were an old friend rather than a nodding acquaintance. He doffed his cap, waving it in an extravagant manner. I'd never before seen him bare-headed, and was surprised to see his bald pate gleaming through the twilight shadows. He was a handsome old man, and his smile revealed a row of surprisingly even teeth.

Mazod returned his wave, making him smile all the more. She kept waving until the narrow boat rounded the bend in the canal. Then she turned to me.

'What a nice old man. The two of you must know each other well.'

'Not really. We only know each other by sight. I think I've always seen him on his boat. I do tend to see him fairly often in the summer, though.'

'It must be wonderful to know people from so many walks of life,' said Mazod. She spoke a little wistfully, I thought.

Her enthusiasm gave me an idea. 'Mazod, how would you like to meet the village blacksmith? He's my best friend, John Jakes. I've told you about him. I'm going to the forge on Saturday evening to have a meal with John and his wife Vicky. Vicky's sister Nelly is a maid in your own house. How about you coming along to join us?'

Mazod looked regretful. 'Tommy, I can't. I'm sorry. I've already arranged to go to my Aunt Hattie's in Sudbury

on Friday. I won't be back until sometime on Monday evening.'

'That's all right,' I said. 'Never mind.' But my disappointment must have been written on my face.

'I really am so very sorry, Tommy. Perhaps we could go to have a meal with John and Vicky on another evening? You and I will be seeing each other on Thursday, anyway, won't we?'

'That might not be so easy,' I said. 'This is by way of being a farewell meal. They're going to America very soon.'

'America? Maybe I'll get the chance to meet them before they go anyway, even if not for a meal? Look, I feel awful about this. I'll be at home most of next week, and from now on I won't make any social arrangements without checking with you first. And the same must go for you, too, Tommy. After all, you and I are walking out together properly now.'

'Yes, we're walking out properly now.'

It gave me a shiver of pleasure to be able to say those words.

Wednesday, 15th July, 1914

On this perfect morning it was impossible to imagine war-clouds casting their shadows over the peaceful scene below. The hayfields of Perivale beneath the Hill stood out fresh and clear against the brightness of the coming day. I was reminded of my fancy at the beginning of the month. Then I'd imagined Hanwell and Ealing as model villages seen through the limpid air. Today, even London, far to the south-east, looked less smoky than usual in the morning sunlight. But now I could think only of the mailed hand of the coming war balling into a fist ready to smash down on the model villages and city.

Precisely at seven o'clock, in exactly the same spot as before, Jet materialised into view. He turned to look at me, and I tried to read his expression. There wasn't quite the disconsolate look I'd seen on Monday; rather his knotted features told of a determination to say things that had to be said. I wasn't looking forward to our encounter, but resolved to help the young man in his difficult task. Despite my heaviness of spirit, I tried my best to give a smile of welcome. As he joined me, he responded by wrinkling his own features, and shook my hand warmly. But this was a parody of a normal social meeting and we both knew it.

'Hello, Tommy. It's good to see you.'

I couldn't bring myself to the hypocrisy of responding in kind.

'So, you've come to bring me the bad news, have you Jet?' I said, instead.

'Not all of it is bad news. After all, you do know your family survives until 2046. For many years longer, I hope: my partner Zilla is expecting a baby in three months. We

haven't picked a name for her yet, but she'll be your great-great-great-great-granddaughter. I think I've counted the right number of "greats" there.'

'Great-whatever granddaughter? How can you even be sure she's going to be a girl? You're as bad as my friend John Jakes with his son and heir.'

For a moment I thought I saw Jet wince at this remark, but he quickly composed himself.

'Sorry, I was forgetting; you wouldn't be aware of a thing like that. People have been able to know the sex of their unborn babies for more than half-a-century, if it's what they want. Zilla and I chose to be told.'

'Congratulations to you both, then.' It felt odd to be wishing my remote descendant well in this way, but Jet was clearly so pleased to be telling me his news that I felt it would only human be of me to reach forward and shake his hand once again.

I didn't think now would be right time for me to comment on yet another odd name from the future, "Zilla", nor the odd term they used for "wife". "Partner" indeed! My hope was that Henry Trevithick would soon become my partner in business. I hardly entertained any notion of making him my wife! Despite the situation, I smiled to myself at this odd thought.

'Thanks, Tommy. I'm glad to see you in a good mood, because I have a confession to make. One that won't please you at all.'

I wouldn't have said my mood was a sunny one, exactly, but I was relieved that I hadn't displayed the full depths of despair I was feeling.

'I'm listening,' I said.

'My father, Ollie, and I discussed what we were going to do for a long time. But there was only one conclusion we could have reached.'

'And what was that?' I could see Jet was uncomfortable, and tried to reassure him. 'Come on Jet, I may as well have the whole story. Sit down, why don't you?'

Jet took his place beside me. He sighed a little. It was a few moments before he spoke.

'We decided it would be unfair to place so much knowledge of the future in the hands of any one man. Especially since we planned to tell him about the way things were going to work out for him and his own family. You can see why, can't you?'

'Yes, I understand. Goodness knows how I'm going to live with what you've already told me. But I don't see what you can do about it now.'

Jet looked a little more relieved, though clearly still apprehensive. 'I've already done it, Tommy. Do you recall examining my Linker on Monday? Do you remember the pattern of lines you were watching?'

'Yes, of course I do. What are trying to tell me now? Out with it. Stop beating about the bush.'

'Before I came to visit you my father loaded the Linker with a Psi-program. It's not a strictly legal program. I'm afraid.'

'Go on,' I said, in as neutral a tone as I could manage.

Despite my urging, Jet remained silent for a short but painful interlude. I could imagine him steeling himself to speak and waited for him.

'By midnight on the last day of this month,' he said, drawing a heavy breath. 'You'll have completed the notebooks you're writing and then you'll seal them up. You

won't know why you're doing it. The books won't be opened again in your lifetime. You'll forget you even wrote the account of this month.

'Nor will you even remember meeting me, except as a stranger in your boyhood and youth. Nor will you remember any of the things, good and bad, I've told you. From the beginning of August and for the rest of your life you'll live normally - as normally as anyone can with all that's going to happen to the world. But you'll have to carry the burden of the things I've told you – and what I've still to tell you – until the thirty-first of July.'

'What you're saying is that your "Psi-program", as you call it, has somehow mesmerised me. It's what you're trying to say to me, isn't it?' I tried to laugh, but the sound came as a half-strangled choke.

'Yes. You can think of it in that way, although a Psi-program can do far more than any human hypnotist.' He looked at me imploringly, and put his hand on my arm. 'I'm sorry Tommy. It was the only way.'

I fell silent, and Jet did not do anything to disturb the peace. I could hardly be pleased that Jet and his father had felt at liberty to play their devious tricks with my mind, but could understand what Jet meant when he spoke about giving me this terrible foreknowledge of the times ahead of us.

It had been difficult enough for me to listen to the awful facts he'd given to me already. But why, anyway, should he have told me all those things? The more I thought of it, the less it made sense. Why had he even chosen to visit me from the future in the first place, come to that? I turned these questions over and over in my mind, but could come up with no answer. It was a long time before I spoke.

'I can't say that I'm happy with your deception – "deception" is the only word I can use – with your so-smart "Psi-program", although I can understand what you're saying

about the impossible weight I'd have to carry. Already I can feel it pressing down on me. But why did you want to tell me all those things in the first place? What are you even doing in 1914 at all? Answer those questions for me and I might begin to understand a little.'

For a moment, I doubted my own sanity. What if all this was, after all, some waywardness of my own mind? Yet Jet, and the things he'd said, had seemed real enough from the day I'd first seen him. I grasped his arm. It felt solid. He rocked in response to the shake I gave him.

'Yes Tommy, I'm real enough. And all of what I've recounted is the truth. My father told me that today would be our most difficult interview. It's every bit of that. I can see this is going to be so hard for you to take in. The things I've said would be near to impossible for anyone to accept, I know that. But, please believe me; I'm doing all of this for a reason; the most important reason there could ever be. It would be wrong today for me to try telling you exactly why I'm here in 1914; I still have other things to make you understand. But I promise I'll tell you all the rest next time I'm here.'

'For Goodness' sake, give me some space to think! You're already talking about "next time". I'm still trying to come to terms with what you told me on your last visit!'

I shouted this at him. Then I rose from the log and paced forward and back like some sort of fool.

Then, as if such a thing could shut out this visitor from an unwelcome future and everything he represented, I turned my back on him. Looking towards the peaceful scene below me once more, I could imagine again the countryside I overlooked was my own peaceful Kingdom laid out before me. I resented the harsh vision lodged in my mind. Why couldn't this unhappy lot have fallen to someone else?

'Ready, Tommy?' Jet said gently after several minutes. 'Come and sit down.'

I did this, although the irony of *him* telling *me* to sit down on *my* seat was not lost on me. 'I simply don't understand. It's all too much.' I shook my head.

'You can hardly be expected to see what it's all about,' Jet said, sympathetically. Then his expression changed. 'Look, do you want to continue? If you don't, just say the word. I'll disappear at the end of our fifty-five minutes and you'll never see me again. The Psi-program will do its stuff at the end of the month. It'll be as if I'd never been here at all.'

'But you told me your visit here was very important.'

'It is. It's more vital than you could begin to imagine. But I'm worried that we're asking too much of one man. Before I started, I hadn't imagined how difficult for the both of us this was going to be. If it's too hard for you to bear, then it'll be too much for me.'

'If we did go through with whatever it is you've planned, what exactly would you be telling me?'

'As I said, today I'd be speaking to you today about our family history. I've already told you briefly about the events to come in this century, but you can't have one without the other. I meant exactly what I said on Monday: it's people and families who have to fight in wars and make history. Families like ours. Then, when I come to see you next, I promise I'll say exactly why I'm here and why I have to tell you about these terrible things.'

Obviously it was people who fight in wars and make history. Everyone knew that. But Jet said it with such force and feeling that the words took on a new meaning for me. And these were *our* people that he was talking about. His people as well as my own. Our family. With a new resolve, I decided what I should do.

'All right. Today you must give me the history of our family.'

'Are you sure? If we decide to go forward, we'll have to see this through. It will be anything but easy for either of us. Especially for you.'

'Tell me this. Do I really marry Mazod Betham? Do we really have three children together? Do they grow up to be adults?'

'Yes. I can assure you of all of those things. But the story's not all so wonderful.'

'And if I marry Mazod and we have a family it can't be all so bad, either. I want to hear what you have to say, Jet.'

He smiled thinly when I said this, but then looked very sad. Now, it was as if he was the one who seemed reluctant to speak.

'You're not having second thoughts yourself now about what we're doing, are you?' I prompted him.

'No, I can't afford the luxury of second thoughts. So much depends on us – on you and me, but especially on you. I only hope my father has worked everything out properly.' This was the first time I'd seen Jet express the slightest doubt about his father's judgement. 'It's only now I truly understand how big this all is,' he added.

'I've already told you, Jet; I'm listening to what you have to say. And from what I know about your father, I'm inclined to believe in his good faith for what he's trying to do for the world.' Did I? I still wasn't wholly sure, but at this moment it seemed necessary above all else to reassure Jet.

My words restored Jet's confidence to some extent, though the young man was in a more chastened mood than I'd seen before when he started to speak.

*

Jet insisted on telling me our family history in full. He even told me about myself and my father. I had some knowledge of my grandfather, Thomas Green, even though his birth in the year 1819 sounded so long in the past. I suppose it was.

'How have you come by all this information?' I interrupted him.

'Family history is one of my hobbies,' he said. 'All this information is there on the public databases.'

He spoke as if this was a sufficient explanation.

'Shall I continue? he said. I nodded, and he went on with his story. He seemed to be very confident in his memory of all the details. 'The father of Thomas Green was Percival Green. He was born in 1792, on Waxlow Farm. His mother was Mary Green. With them, I'm afraid our family history rather fizzles out.'

'And why should that be, if your *databases* are so clever?'

Jet sighed. 'Because Percival Green was born illegitimate. The Parish register – I've studied a copy of it on screen dozens of times – records that Mary Green was a vagrant girl passing through Waxlow Farm. She gave birth in a cow-shed. Greenford must have been a more normal agricultural area in those days, not simply one of London's hay-ricks.

'Personally, I have a theory her name wasn't really Green at all,' he continued. 'My notion is that she took the surname from the village name. Certainly I've never been able to find her birth or death recorded in any of the neighbouring parish registers.'

What was he telling me now? That I was descended from a line of bastards who didn't even know their names? He must have read the look on my face.

'Don't be offended, Tommy. Remember Mary Green is my ancestor, too. Anyway, don't you think it's romantic to be descended from Green of Greenford in this way? Especially so when Percy Green was born in a cow-shed. Quite biblical, wouldn't you say?'

I didn't see it like that. 'Go on,' was all I said.

'Really speaking, I was only telling you about our forebears out of interest; I suppose because it's a subject that fascinates me. The more important thing is that you should know about those who lived in the years between you and me. Now, I think I've told you enough about myself. My father Ollie was born in 1994.'

'It's good to hear our English line continues up to the middle of the twenty-first century, I suppose,' I said. 'Even if it made such an inauspicious start in some barn on Waxlow Farm.'

'Not exactly "English". My mother, Kathleen, is from Aberdeen, and my grandmother, Gwyneth Vaughan, is from Llanelli. Zilla Jagan, my own partner, is from Guyana.'

'Guyana?' I'd never even heard of a place by that name, even though I prided myself on my knowledge of geography.

'You'd know it as British Guiana,' he said.

I didn't know what to say about all these family revelations. In their small way they were almost as alarming as the horrific account Jet had given me about future world history. But I thought I should keep this observation to myself, so simply nodded to him to continue.

'It's my grandfather, and your great-grandson, Wayne Green, who provides a living link between us. You'll still be alive when he is born, and he's living now – in 2046, I mean. He's very fit and healthy. You'll know my great-grandfather – your grandson, John, better. He lived until several years

ago; a few years ago by my reckoning, that is. We both knew him, even if to me he was a very old man and to you he was a young one.'

Jet's face showed it was almost as difficult for him to grasp these vast time spans across the generations as I did.

'It's good to know that I'm going to live long enough to see my great-grandson, this "Wain", even if he managed to get himself such an odd name.' The story of our family didn't sound at all bad to me. What had Jet been talking about? At least I was going to live to be an old man.

'Well, you'll hardly be young when Wayne arrives. And he doesn't remember you at all. He was only a baby when you - when you –'

'And when will *that* be, exactly?'

'I'm not going to tell you that,' he said. 'Call it superstition on my part, if you like, because the Psi-program will wipe all this from your mind at the end of the month. Every life carries within it a death sentence. Our blessing is we don't know when the sentence will be carried out. I'm not going to rob you of that blessing, even for a couple of weeks.'

Jet looked at me to see my reaction. I wondered if these were really his own words, or did he borrow them from someone else. It didn't sound like his way of speaking. But I said nothing, and after a moment he continued.

'I will tell you that you'll be around for years and years yet. You'll see the first manned landing on the Moon, on the TV at least. Mazod will be watching it with you. It's one of my grandfather's favourite stories. His own father, who was there at the time, told him about it.'

'First men on the Moon?' I looked carefully at his face to see if he was teasing me, but his expression seemed to be wholly in earnest. 'On TV? Now, what's TV?'

'Sorry; it was a thing like a radio – wireless I mean – only with pictures.' I'd never even seen one of these "wirelesses", even though Jet casually presumed I had.

'We both – well, our whole family, I should say – owe a great deal to my grandfather,' Jet continued. 'He borrowed a lot of money to finance my father's special education when he recognised his genius. And he also paid to have your book published. The best thing is, it was because of you he was able to borrow so much money. It was thanks to the financial security given by the Turkish ring you'll be passing down the generations without anyone knowing what it was. If they noticed it at all, our family thought it was a small, anonymous, paper packet until the day my grandfather investigated further.

'That's why the ring's so important to our family. You never used it yourself. In fact you seem to have hidden it away and forgotten about it. I expect it was something to do with the Psi-program. Anyway, my grandfather got all the money he borrowed back a thousand times or more over. The book was a best seller.'

'My book?' Our family's story seemed to be wonderful, not the grim epistle promised by Jet. Or were there darker tales still to be told? As if in answer to my unspoken question, Jet's expression clouded over. He dropped his voice until it wasn't much above a whisper.

'Your book will be called *A Soldier's Story*. It won't be published for more than eighty years after you've written it, but it will come to be seen as a classic – a British *All Quiet on the Western Front*, the critics called it.'

'I've never even heard of a book of that title. Western Front? Where's that?'

'The German book hasn't been written yet, either. The events it portrays are in your future. It won't be published for another fifteen years.'

'I suppose you're going to say both books are about the "Great War" you've been telling me about?'

Jet didn't answer. He looked down and didn't even try to speak.

'Well? I'm waiting,' I said, after nearly a minute of silence. 'I'm the one who'll be living through the damned war, not you.'

'Yes, you are,' he whispered hoarsely. 'Oh, I'm so sorry, Tommy. I'm so sorry. My father is a very clever man but he may have taken on too much this time. He's asking one man to shoulder an almighty responsibility.'

'You're talking about me, I suppose. I'm the one who'll have to shoulder the burden, naturally.' I had never seen Jet acting in quite this way. Before he'd always seemed in control of the situation, often more so than I'd have liked.

'Then I suggest you tell me what you're here to say and let me be the judge,' I said, abruptly. His dilatory ways were annoying me. 'Didn't you tell me your visit is limited to fifty-five minutes? That means you have less than fifteen minutes left. It's clear to me that you haven't even started to tell me the really important things.'

He visibly tried to compose himself. Then he started to speak. This time his voice was quiet but clear.

'I'm sorry,' he said. 'In a few weeks, on the fourth of August, this country will declare war on Germany. France, Russia, Turkey, Austria-Hungary, and many other Empires will be involved. As the war goes on – it will last for over four years – even more countries of the world will be drawn in. It will be a terrible war, as I've been trying to tell you.

'In less than a month,' he continued. 'You and your two friends in Greenford will be in The First Battalion of the Middlesex Regiment. They called it the "Duke of Cambridge's Own Light Infantry" for some reason'.

'My two friends?'

'John Jakes and Archie Perkin. Oh, I realise you don't see Archie as your friend now, but soon you will. It will be Archie who pulls the strings to get you and John Jakes into his regiment. It's what they used to call an elite regiment. They gave it the nickname of the 'Die Hards'. It's all there in *A Soldier's Story*.

'What does being in an "elite regiment" mean, exactly?'

'That you see more action. That you have more chance of being killed,' Jet answered, with some bitterness

I knew, because Jet had told me only today, that I would live for a very long time after the war, but his expression was still set grimly.

'And you say that Archie Perkin becomes my *friend*?' My tone was scornful. I couldn't believe what I was hearing.

'Yes. The three of you will remain firm friends until 1917, even though Archie Perkin was promoted to the rank of captain and you and John were enlisted as what they used to call "other ranks".'

'So, the war lasts until 1917, then. I thought you'd said it will go on for over four years?'

'It does. It lasts until November, 1918. But it will be over for the three of you in September, 1917.'

My head was reeling. I wanted Jet to finish his story and at the same time I didn't want to hear any more. Nor did he want to say anything else, by the look on his face.

'Speak, damn you,' I said. 'I don't want you disappearing on me again.'

I could literally feel the seconds slipping away. We couldn't be far away from the end of his magic fifty-five minutes. I felt like gripping him tightly to prevent his fading

away, even though I knew such an act would be futile. At last he spoke.

'Your regiment will take part in what will be remembered as the Battle of Passchendaele, or the Third Battle of Ypres. Ypres is a town in Belgium. The soldiers used to call it "Wipers". On the twenty-third of September, the three of you will be involved in the advance on the Menin Road Ridge –'

'You've read all this in *A Soldier's Story*, have you?' I said this with sarcasm more savage than I'd intended. Jet was only doing his best, and I could see it that none of this was easy for him. But neither was it easy to sit here and listen to what he was telling me. The as-yet-unknown fate awaiting us left me with a sick feeling. I wanted to strike back in some way.

'No, I didn't read it there,' responded Jet quietly. 'You were never able to write about it,' Jet said. 'Your memory will be a blank for the last part of September, 1917. We've put together as much as we could from the Regimental History. No one will ever know exactly what happened. But...'

He was finding it difficult to go on with his story. And his time was running out.

'But?' I said. 'Damn you, Jet. Tell your story.'

'John Jakes was killed on 23 September, by a German shell, we think. His body was never found in the mud. On the same day Archie Perkin was gassed with mustard gas. It made him blind and badly affected his lungs. He was a wreck by the time he died. You...'

'John is sailing for America at the beginning of August!' I shouted at him. 'He told me so himself. All the arrangements have already been made.'

'He won't go. At the outbreak of war he'll decide to stay behind and join the Army with you. I'm sorry, Tommy.'

'And you told me I was destined for a long life!' I felt cheated.

'So you are. But in that same September you'll be sent home from the Front with what they called severe "shell shock". It's the name they used to give during the war to any psychiatric condition caused by the stress of battle. You'll be luckier than some – you'll be admitted to the St Bernard's Wing of Ealing Hospital, or the London County Asylum as they call it now-'

'Hanwell!'

'You're there until late in 1920,' continued Jet, ignoring my outburst. It was as if he had belatedly realised his time was running out. He tried to accelerate his story. 'Thanks to the support you'll get from Mazod Betham you'll make a recovery. Otherwise you might have spent your life forgotten within the walls of a mental hospital until you died. So many people did. When you get out, after being a patient for more than three years, the two of you will marry-'

'And we'll have twin sons, Bertie and Trevor? Then later on they'll have a sister, Mary? Tell me that much is true!'

'Yes, it is. But there'll be another World War in 1939. Your sons will both enlist in the army in 1940. Then, on New Year's Eve 1944 –'

But it was too late. Jet was fading away, even as he was speaking his last words.

Thursday, 16th July, 1914

This morning, I was on the Hill from six-thirty until eight-thirty in the morning. As seven o'clock approached, I had some hope Jet would show himself. This was the usual time of his appearance. Today I was left in silence, save for the distant shouts of men and children and the whirring of the Hornsby threshing machines in the fields below me. The hay-harvest had now begun in earnest. Normally, I loved this time. Once a year, the starting of the machines made me think of the tuning-up of the grandest kind of orchestra. This year, the distant sounds only grated on my nerves.

Before he'd vanished yesterday, Jet had been in so much of a hurry to tell his tale he'd neglected to tell me when I'd see him again. He hadn't even finished the story. What he had been able to say had planted troubling questions into my mind. What was going to happen to Bertie and Trevor at the end of 1944? And what of the other terrible things he'd told me: John killed; Archie Perkin's life all but destroyed; myself confined to Hanwell Lunatic Asylum. Did Jet and his father think the story of even one life could be told in the space of fifty-five minutes?

It was a forlorn trudge back to my shop along the canal towpath, across the Black Horse Bridge, and along the Old Field Lane. Along the way, I met many labourers with their children, all out for the harvest. Many of those I saw I knew, even though it was the practice for men to come in from as far afield as Hayes and Hanger Hill at harvest time, in the way it would be for the men of Greenford to walk out to their fields in a few days to repay the favour. Unlike in the days of my boyhood, most hay-making these days was mechanised, but it was still an occasion firmly rooted in our rural past and replete with tradition.

As each year, I made a point of exchanging the usual harvest-greeting with all, whether stranger or local labourer, even though my words were hollow and inside I was desolate. I made efforts to maintain this false bonhomie for the rest of the day. From opening my shop-door right through to closing time, the steady stream of customers to which I was now getting used paraded through my door. In each case, I tried to portray myself as the model of a fulfilled and cheerful tradesman. But the effort told on me. I was grateful to shut up shop a full hour early. I wanted to grab a short nap in the chair before I walked down to Greenford Green to see Mazod. I would almost rather have slunk into my bed than gone to see the girl I loved.

*

Betham House was not one of the larger houses around Greenford, but its elegance still presented an intimidating face to me. I paced back and forth a few times before I plucked up the courage to knock the door.

It was answered by Nelly Hodge, Vicky's younger sister. She and Vicky were like two female book-ends in their family of nine boys and two girls. She was years younger than Vicky; more than fourteen or fifteen I should think, but shared the florid colouring of all of her brothers and sisters, who were members of a large family in more ways than one. Already Nelly was plump and, though not yet quite in Vicky's heavyweight class, was otherwise so like her elder sister. I was reminded of this when Nelly curtseyed to me and I was relieved to see her shy grin of recognition.

She called behind her, 'Mr Green for Miss Betham, Ma'am', and with those few words disappeared into a room toward the back of the house.

Theresa Hartson strode confidently from a side room into the hallway. Although I'd seen her many times about the village, I'd never before been this close. She was taller than her niece, and there was a strong family likeness. All the

same, I could see that, even as young girl, she could not have possessed the indefinable element that made Mazod the radiant beauty she was. Nevertheless, the older woman's whole bearing told of elegance and poise making up for any lack of mere physical beauty. She proffered her hand, and for a moment I had the ridiculous urge to kiss it formally and bow low.

'Mrs Theresa Hartson,' she said. 'Although I expect you already know as much.' She smiled easily as she added this. In that moment Mrs Hartson banished much of the nervousness I was feeling at being inside Betham House.

I took her hand in my own, a bit gingerly I will admit, and grasped it lightly. How is one supposed to shake the hand of a lady?

'Thomas Green.'

'Yes, I know that, too. Mazod's already told us much about you. But you prefer to be called Tommy, don't you? It's what our niece informed us.'

'Oh, yes. Please call me Tommy, Mrs Hartson.'

'*Tommy*", rather than "*Mr Green*?' She smiled broadly. 'Well then, "Tommy" it shall be.' I thought for one extravagant moment she was going to invite me to call her "Theresa". Thank goodness she didn't. I wouldn't have known how to respond.

'Your grandfather used to prefer the dignity of "Thomas",' she said.

'You knew my grandfather? I thought you were still living in Hampstead when he was alive?'

'Oh, I was, I was. But my husband used to come to the village in the days when he was a boy. Roger's uncle was the Vicar of Holy Cross for a few years. He told me your grandfather – the old man was known by everyone in the village, so it seems – always insisted on the correct name of

"Thomas". And my husband also said that, in his younger days, your grandfather was the image of you. A very handsome young man, your grandfather, so they all used to say. As you are now, if you don't mind me saying so, Mr Green – Tommy, I should say. I trust your good looks are not what have turned my Mazod's head?'

I flushed with embarrassment at this, and didn't know what to say in response. Fortunately, Mrs Hartson saw my difficulty, and came to my rescue.

'Don't mind me,' she laughed. 'Directness is a family trait. You must have discovered as much from Mazod already. It's a good job you're not standing here talking to my sister Hattie. She's by far the boldest of the family. Anyway, Mazod did say you're a hard worker in your shop. She told me a secret, too – one she asked me to keep from my husband for some reason. You're to be going into partnership with Henry Trevithick, isn't that right?'

'The partnership arrangements haven't yet been settled, Mrs Hartson. There are a few business details to be ironed out. I can't say more at present.' I wished Mazod had said nothing, even to her aunt. Anxiously, I tried to change the subject. 'I'm sorry. I haven't yet had the pleasure of meeting your sister, Mrs Hartson.'

She didn't say anything in response to this. A man holding a newspaper came into the hallway. He was looking a bit flustered.

'What's all this about a partnership with Henry Trevithick?'

The speaker was a shortish, placid looking man. I knew him to be Roger Hartson. He'd entered the hallway from another side room, almost unnoticed by us.

'I - I - um,' I stammered.

'I was saying to Mr Green, Roger,' Theresa Hartson smiled conspiratorially at me. 'That he ought to go into business partnership with somebody like Henry Trevithick. For the calligraphy and engraving business that Mazod's told us all about, remember? Perhaps you'd be able to put a word in for him, Roger?'

It was then I was sure that Theresa Hartson was the dominant partner. She was much more nimble-minded than her husband. I liked this woman, especially for the way in which she'd remembered to call my business *calligraphy* and engraving. What must her sister Hattie be like?

'Oh, yes, I daresay I can do that. Henry's away in Cornwall for a few weeks, but I'll speak to him when he returns.'

'Anyway,' said Theresa Hartson. 'We're all forgetting our manners, are we not? We haven't yet finished the introductions. Do forgive us. Tommy. This is my husband, Roger Hartson. Roger, this is Thomas Green, the young man that Mazod's been walking out with over the last week or two. He likes to be called "Tommy".'

We shook hands in a very formal way.

'Mr Hartson.'

'Mr Green.'

I was sure Roger Hartson wasn't simply following my lead in referring to me as "Mr Green" rather than "Tommy". A moment's thought showed me he preferred the normal form of address. This I didn't mind at all, although I was pleased his wife was calling me "Tommy" already.

'My niece tells me you are an avid reader of the newspapers, Mr Green. She says you worked on one several years ago.'

'Yes, I did. It was the *Independent Record*.' But family circumstances made me leave my job as a reporter.'

'A reporter, eh? That must have been interesting. Can't say I've heard of the *Independent Record*, though. Always been a *Times* reader myself.'

'It was a smaller newspaper than the *Times*.' That was an understatement. 'It isn't published these days.'

'But you're still a follower of the stories in the newspapers? What do you think of this Ulster business, then?'

'When I can, I look at the papers. But I've been so busy in the shop lately. These days, I'm rushed off my feet. I've not had time to read much about the Irish Home Rule question lately.'

I didn't think it would be wise to add that I thought some kind of self-government for Ireland was inevitable. Roger Hartson looked as if he were ready to start a debate on the subject, no matter what answer I gave. Again Theresa Hartson came to my rescue.

'Oh, Roger. You and your old newspapers. I don't want to hear about them, even if the two of you do. Besides, before Mazod comes downstairs, you were going to ask Tommy something. Remember?'

'What was that?'

'Come on, Roger, you're so forgetful.' She turned to me. 'Saturday, the twenty-fifth of July is my birthday. A special one.' She smiled at me. 'No, I'm not going to tell you which one. Let's content ourselves with saying I'm over twenty-five, shall we.'

A special one? That might mean she was in her fiftieth year, though she looked at least five, more like ten, years younger.

If Mazod looked and acted as youthfully as did her aunt when she was fifty, I'd be a happy man. And Jet had promised Mazod would be with me at that age and beyond.

What was it he'd told me – we'd be seeing the first men on the moon together on this "TV" he'd spoken about? The idea still sounded fantastic.

Jet had told me many other, darker, things, too. I made an effort to push those to the back of my mind, and tried to imagine myself talking to Mazod in thirty years' time. That would be in 1944. It was the year before my sons... the ones who hadn't yet been born, would meet some dark fate.

'Young man?'

'I beg your pardon? I'm – I'm sorry.'

'I should think so!' she said. But still she kept smiling. 'Mazod told me that you had a tendency to drift off to unknown places now and again. If you hadn't been giving me such a lovely smile when you were doing it, I'd never have forgiven you. A few of the girls in the village must have had their heads turned by that smile, I shouldn't wonder.'

It had been a good few years since any of the village girls looked on me with any favour, so far as I knew. Reputations linger in Greenford, and the errors I had made in my youth had been embroidered to a ridiculous degree.

'I'm so sorry, Mrs Hartson. What were you saying?'

'I was saying,' she said, with mock emphasis. 'That Roger has arranged an evening in Betham House to mark my birthday. Nothing very big, you understand. There'll be no more than a dozen people – a few neighbours, my sister, Roger's brother, and us. 'Ourselves' includes Mazod, of course,' she added with a twinkle. 'It's a week on Saturday, the twenty-fifth. We'd like you to be here.'

I hoped that when she said "*we'd* like you to come", that included Mr Hartson. I glanced in his direction. He was smiling absently but benignly.

'I certainly would like to come.' I found myself answering with emphasis. This sort of social event was not

something I could count in my experience, but Mazod would be there, as would her two aunts. The one I hadn't yet seen, "Aunt Hattie", would be worth meeting, even though the prospect of doing so was daunting.

'Good; it's settled then. Be here at a quarter-to-eight for eight o'clock.'

At that moment, Mazod came down the stairs. The light in her eyes was shining. Again I couldn't help thinking what a lucky man I was.

'Ah, Mazod. You took your time. If we'd have known how long you were going to be upstairs, we'd have entertained Tommy in the lounge instead of keeping him standing in the hallway. Now, young man, when shall we be seeing you again?'

'Not until Tuesday, I'm afraid.' I looked at Mazod. 'Mazod tells me she's going to visit your sister in Sudbury tomorrow. She won't be back until sometime on Monday.'

'Ah, yes, I was forgetting. But that's all right. You can be my partner in the Sunday Parade after Church. Roger isn't able to come to the Parade and as you say my niece is gallivanting off to see her Aunt Hattie again. Now, don't protest. It's Sunday, after all. I'll see you straight after Church. Roger will be able to go to the Church service at least.'

*

'We haven't got much time left, I'm sorry. We were a long time in your house talking to your aunt and uncle.'

'*You* were a long time talking in my house, you mean. I was standing on the landing, laughing and listening. It was my aunt's idea. "Take your time," she said. "And then I can get to know your young man better." Well she did that, all right. And as for me taking my time, my Aunt Theresa would have been quite happy to leave me with only a few minutes

to walk with you to the front gate. She does like you, Tommy. I'm pleased about that.'

'Yes, I like her, too. She's extremely informal, isn't she? I hope you didn't mind that I agreed to go with her on the Sunday Parade? I know she's your aunt, but...'

'Of course not. You silly boy! You'll only be walking in the parade.' She winked at me. I had never seen a lady do that before, nor even one of the village girls. 'Anyway,' she added. 'The Rector will keep an eye on the two of you for me.'

Without discussing it, we had turned to the right out of the front gate, in the direction of Sudbury. We reached the spot where Archie Perkin had disturbed my hopes by rolling up in his new car the other evening. This time, everything was quiet, save for the song of birds settling down for their evening roost.

'Mazod,' I said. 'What exactly happens on a Sunday Parade?'

'You mean you've never been on one before? You've never even seen one? Shame on you, Tommy Green! We have about half-a-dozen a year from Holy Cross. Nothing happens, really. People simply parade in a loose column around the church area. It's no more than a bit of fun. For some of the Parades, people dress up, but the one in July is to mark the hay-harvest. All they do is carry a hay-stalk with them – the top part of the stalk, that is. So don't forget to bring one with you when you come to church on Sunday.'

'I hadn't planned to come to the service on Sunday morning. I thought I'd be meeting your aunt just for the Parade.' So in arrears was I with my engraving orders, I'd worked out a few of the quieter jobs I could do on Sunday morning.

'But you have to go! My aunt will be looking out for you. Anyway, you can't simply turn up for the Parade without going to the service.'

We walked on a little further, before agreeing it was time to retrace our steps. As we did, I asked Mazod the other question on my mind.

'What do I bring along on the twenty-fifth?'

'Bring along?' Mazod looked puzzled.

'Well, when the boys in the village have a similar thing in one another's homes, it's the custom to bring a jug or bottle of beer.'

'Tommy, you don't bring anything. Certainly not beer. My uncle would be most offended. He prides himself in being able to choose good French wine. You know; Burgundies and Bordeaux. I'm sure he'll have selected what we're going to drink already. Just bring yourself, Tommy.

'Unless you want to bring a small gift for my aunt, that is? I have an idea: why don't you frame a *Haiku* for her. I'll bring one along for you on Tuesday. No – on second thoughts you should frame the one of yours – the one about carp in the moonlight. The present will be all your own work then.'

So Mazod had remembered my *Haiku* after all.

On the way back, I thought what a perfect evening this had been. And, when we reached her front gate, Mazod stretched up to kiss me on the cheek, quite naturally.

But, continuing to walk further along the Old Field Lane, I remembered I'd have to be in my workshop until at least midnight tonight trying to catch up with some of the mounting arrears of work.

And, tomorrow, I'd need to be at the top of the Hill before seven o'clock hoping, if that was the right word, to hear the end of Jet's unfinished story.

Friday, 17ᵗʰ July, 1914

As it turned out, I was on the top of Horsenden Hill well before seven. Although I'd busied myself in my workshop until after one o'clock in the morning, trying to drive away the images Jet had planted my mind, still I was hardly able to sleep, Today, I'd climbed even earlier than normal. I simply knew I'd be seeing Jet on one of his 'pre-programmed' visits, despite his sudden vanishing act on Wednesday.

My lack of sleep meant I wasn't in the best of humours when he appeared at exactly seven o'clock, in the usual place. I was the one who spoke first.

'So how long do you intend to stay this time?' I called over to him.

He walked over to where I sat before answering.

'Forty-five minutes.'

'Forty-five minutes? That's all I'm to be allowed, is it? You only half-way finished your story last time. Now you've decided you're not even going to bother to give me your maximum of fifty-five! You were coming to finish giving me the wisdom of the marvellous thing that brought you here in the first place, I hope. You're not here to deliver a parcel, you know.'

I deliberately didn't offer him his usual seat beside me.

'Look, I'm sorry Tommy. I've told you; all my visits and their timings have been pre-programmed. My father and I planned it out as carefully as we could with the aid of special project-planning software. Things have worked out very differently in practice. I know they have.'

'Software? I suppose that's some kind of working of these computers you're always talking about?' I said. He talked as if these "computers" were the answer to everything.

'You could at least have been more generous with the number of your visits. Even if each one of them is limited to fifty-five minutes, you might at least have arranged to visit more often.'

'No, I couldn't. There's a limit to the overall time I can spend. You wouldn't believe the amount of power consumed each minute I'm in your time. All of this has to be done on one of my own days in 2046. I left the laboratory at 4:30 pm this afternoon by my reckoning. The active phase of this whole project – even my visits to you as a young boy – only started this morning. It's the longest day of my life. I don't mind telling you I'm exhausted.'

'Sit down, why don't you?' I said.

Yet again I found myself relenting. He did look tired. Two weeks ago – two weeks by my calendar – when I'd first seen him on the Hill, his face had been shining with enthusiasm. Now, today, his eyes looked dull and his face pale. He sat down heavily.

'It's not as bad for me as it is for you,' he said. 'There's nothing I know better. Your whole life has been turned upside-down over your last few weeks. And I've only made things worse with my ineptitude. It was much harder for me to talk about the things I needed to tell you on my last two visits than I expected. Today feels even worse.'

'You didn't do so badly. Don't be so hard on yourself.' I tried to sound more sympathetic than I was able feel. In truth I wanted him to finish what he had come to say before he faded away again.

'Thanks, Tommy. It's good of you to say it, even if it's not really true.' I tried to show some patience as I waited for him, even though my mind was brimming over with questions. When, after some time, he showed no sign of being about to speak of the things we both knew he should, I

prompted him. Surely he should be showing more urgency, if he was only going to be here for forty-five minutes?

'Are you ready to continue your story now?'

Still he remained silent at first. Each second was an hour to me.

'You marry Mazod soon after you're discharged from Hanwell,' he suddenly blurted out. There was absolutely no warning. It was as if a dam had suddenly burst. 'It'll be called "The London County Mental Hospital" by that time. The wedding will be in September, 1920. I've seen the photographs. Your twin sons will be born in the following September.'

'And then what happens in 1944?' I tried to keep calm as I asked this.

'There'll be another war in 1939, he said, avoiding my gaze. 'The historians will fill books about how it started, but the cause of the conflict will be nothing else but the after-effects of the war coming to you. It will come on the fourth of August, to be exact. This second war, too, will be terrible for the world. It'll be worse, in a great many ways, than the first. Many more civilians than soldiers will be killed. Your two sons will enlist in the army as soon as they can.'

'And do they join an "elite" regiment like I'm supposed to do?' I asked.

Immediately I regretted my sarcasm, and resolved to let Jet tell his story in his own way from now on. Fortunately, he answered in a straightforward way.

'No. In fact both of your sons will have a fairly uneventful time for most of the war. But then, at the end of 1944, the German Army will launch a desperate last counter-offensive from Belgium. It's a country that doesn't exist in my time. In 2029, the northern half became a province of Holland and the southern half joined with France. The

capital, Brussels, became a Free City as the capital of the European Community.

'Anyway, the history books will record it as the last major battle of the second war. They'll call it "The Battle of the Bulge". It will be the final roll of the dice for Adolf Hitler and the German army. Most of the Allied soldiers taking part will be Americans, but there'll be a British contingent in the north. '

Americans? Were they going to be dragged into this second European war, too? But Belgium again. In that country, Jet had said, the three of us would meet the terrible day in 1917. Now he was telling me in not much more than a hundred years, Belgium would cease to exist. What was going to happen to Europe? But still I held my peace, and waited for Jet to continue. Some seconds passed in silence. I was intensely aware of my forty-five minutes ticking away.

'On New Year's Eve, 1944, Corporal Trevor Green will be with the Thirtieth Army Corps. During the capture of Rochefort at the western end of the salient, he'll be killed by enemy rifle fire. Much more than that, we don't know. Things were confused in the heat of battle.'

Trevor killed? Jet was sitting there to tell me one of my sons, who hadn't yet been born, was going to be killed as a young soldier.

'And Bertie? What about my other son?'

'Bertie will be unharmed, physically at least. He'll be discharged from the army in 1946, and soon afterward he'll marry his brother's former fiancée, Valerie Bush. Many will think he does this out of some sense of duty.

'Both the brothers were spirited, happy boys before the war. They were clever, too. Mazod has a debate with you, ironically on 31 December, 1944 as to whether they should go to University or join you in the family business after the war. By the time of the outbreak of war your business will

have expanded into printing as well as engraving. In 1946, you'll still retain some hope Bertie would be able to return from the forces and pick up the threads.

'There were signs he might do exactly that when he married Valerie. They even had a son, John, in 1947 and a daughter, Sylvia, in 1949. But it doesn't last. Bertie becomes more and more moody. He'll leave his wife in the early nineteen-fifties. In nineteen-sixty he'll be shot in Manchester. The police will put it down to some sort of gangland killing.

'Your own daughter, Mary, never marries. She'll be only seventeen when her brother, Trevor, is killed. It will deeply affect her. Valerie, your daughter-in-law, will be left to bring up your grandson and granddaughter alone. She'll do her best, but it will be a struggle, especially after your own business takes a down-turn. There'll be trouble with paper supplies after the war. And by then you'll be getting on in years yourself, after all.'

'It's not the most heart-warming story I've ever heard.' This was all I could find to say.

John Jakes killed in the first war, myself spending years in Hanwell, and poor Archie Perkin – I still found it hard to believe he'd ever become my friend – were going to die as a direct result of the conflict. Then an interval of not much more than twenty years before yet again the world will be broken apart again. One of my sons will be killed in the second war; my other son and my daughter will be scarred mentally for ever. Why was Jet Green, a man who'd said he was my great-great-great-grandson, telling me these things?

'Our family story does get better,' said Jet, seeing me utterly downcast. 'Your grandson, John Green, doesn't have an easy life but he holds things together. His son, Wayne, thanks to the help of the Turkish ring you found and the family then forgot about, "repairs the family fortunes", as they used to say. I've told you a little about what will happen afterwards.'

'But how can you expect me to get through life with all this in my mind? And what about the millions of people who'll die in the terrible wars you've told me about? Are you some sort of sadist from the twenty-first century?'

'No, I'm not. You'll only have to bear the burden of knowledge of the future until the end of this month, remember. Still, I can see that even so it's a terrible weight to expect anyone to bear. I'm sorry; there was no other way but to recount the history of the twentieth century in all of its horror.'

'But why do tell me at all if the memories are going to be wiped from my mind in a few weeks? Why do you even come here to haunt me from your precious future?'

Jet didn't answer. He simply looked at me, as if wondering what words to use in answer. I grew impatient.

'Well? I'm waiting.'

'Because you, and only you, can stop, or at least shorten, the war that's coming to the world. Without the first war, there won't be a second, nor will there be a revolution in Russia in 1917 with all that follows across the world. I've told you, we're even hopeful we'll be able to avoid the Oil Wars and the Cyber Wars of our twenty-first century. If we had a saner history to build on, my father expects things to be better.'

'You expect *me* to stop the war?' I tried to laugh, but the very idea seemed so outrageous I couldn't do it. 'I'm just a shopkeeper.'

'And I'm only an archivist,' said Jet. 'My job is to look after old documents.'

We looked at each other, and despite the seriousness, or sheer madness, of our conversation, we both smiled broadly and almost laughed together again. Something of our

earlier fragile rapport, so badly lacking of late, made a momentary return.

'But my father, your great-great-grandson, is a genius. He's worked this out to the finest degree. All you have to do is stop an assassination.'

'Then you're too late,' I said. Jet's words filled me with horror as soon as I heard them. I remembered reading the report of the murder in the *Daily Mirror* at the beginning of the month. 'What starts this war in the first place?'

'The assassination of the Archduke Franz Ferdinand in Sarajevo and what followed from it.'

'That has already happened. It was late last month. There's no way anyone could think about stopping it now. If you were serious about preventing the assassination you should have come in June.'

'It's not that assassination I want you to prevent. Europe has been a powder-keg waiting to explode for the first part twentieth century. If we'd prevented the killing in Sarajevo, there'd have been something else happening in international affairs to take its place. Your world is poised for a war. It's a sad thing to say, but it's true. Nothing will stop it from happening.'

'Then I don't understand,' I said. I didn't. Jet was talking in riddles.

'The conflict will start in a few weeks' time and people will soon realise how terrible war on an industrial scale is,' he said. 'But they won't be able to do anything about it, thanks to the actions of the politicians and generals. The war of attrition will grind on for over four years, claiming millions of lives and distorting the whole of history for the remainder of the twentieth century and beyond. In June, 1915, Pope Benedict XV will mount a campaign against the war, but even he will be able do nothing to stop it.'

'So what can a shopkeeper from Greenford be expected to do?' I was mystified.

'There is only one man the people of Europe would have listened to. My father has made all the projections and calculations. The people would finally have paid attention to the combined voices of the Pope and this man, once they'd seen the horrors of twentieth century warfare. But he, too, will be assassinated in Paris at the end of this month.'

'Who is this wonderful man?' The picture was becoming slightly clearer. Still I could not see what I, a simple shopkeeper, could do about it.

'His name is Jean Jaurès. He's a Deputy in the French Parliament. Right at this moment, in your time, he's campaigning for a negotiated settlement to the international dispute.'

'I read a little about Jaurès a year or two back,' I said. 'The man's a Socialist isn't he? Surely people won't listen to him?'

'He's a respected man among the ordinary people of France. Equally importantly, the common people in Germany also have a great admiration for Jaurès. Those two countries will be the prime movers in the war, more so even than Austria-Hungary, even though that's where the fuse has been lit, and Russia, with its lumbering, unstoppable mobilisation later this month. But, no, you're right. Enough people won't listen even to Jaurès until they have seen the deathly effect of battles like the Marne, Gallipoli and Tannenberg.'

I'd heard of the River Marne, but not the other places. Jet spoke as if their names were commonplace knowledge. I was sorry to say I blustered.

'Germany, France, Austria-Hungary, Russia. What about England?'

'Britain, you mean. The Foreign Secretary, Edward Grey, will make some creditable but ineffectual gestures. But you wouldn't expect us to stand aside, would you? We'll join in with the rest within a day or two.'

Jet said this with some bitterness. It was clear to me that he held strong views of his own. They seemed very unpatriotic to me, but I said nothing.

'So, now you're telling me you want me to stop this assassination in Paris?' The idea sounded all the more incredible as I gave voice to it. 'But I'd be quite the wrong choice. I've never been to France in my life. I don't speak a word of French. Why didn't you at least pick on somebody who can speak the language?'

'Because you're the one living on the right time node. Because it's easier for me to visit you: you're my ancestor. And don't worry about not speaking French: you won't need the language to stop the assassination. I've arranged to be with you frequently at the crucial times, right up until the moment before the killing is due to happen. I speak fluent French.'

I looked at him in amazement.

'Then why not stop the murder yourself? Why involve me at all?

'Because I can't do anything physical while I'm in 1914. For me to even try would do untold damage to the time lines. The effect would be entirely unpredictable.'

As he said this his features shimmered slightly, like the picture thrown by a magic lantern bulb that was about to fail.

'You're –'

'Tommy, I told you I have to go now. My forty-five minutes is nearly up. I'll be here again on Monday. Look, my father and I knew this would be a shock to you. How could it

be anything else? I'll talk it through when I see you next time, although we've only projected a thirty-minute visit for Monday. All I can ask you to do is think of the millions of lives you could save. Think of John Jakes. Think of yourself. Think of Archie Perkin. And think of your sons and daughter – your family – *our* family. Do it, please, Tommy.'

It was another full half-minute more before Jet faded away back to his 2046. We said nothing further to each other in all of that time. The two of us looked at each other across the chasm of the years between us, knowing the aching space between generations who could never really begin to understand how the other felt. It might have been Jet's family as well as my own we'd been talking about. But at the end of it all Trevor, Bertie and John could be hardly more than names from the pages of history to Jet. To me, these were the names of my unborn twin sons and my best friend.

When Jet had departed, I remained sitting silently and sadly for a long time, really feeling for the first time as if I were his great-great-great-grandfather. Although I was only twenty-nine years of age, I felt very, very old.

Saturday, 18th July, 1914

Although the *Red Lion* was the nearest inn to my shop, I rarely went inside. The inn didn't have a proper jug and bottle, so I had to go into the main public bar to get some ale to take to my dinner with Vicky and John. There were few customers at that early hour.

'Fill this up with your best porter, Dennis.' I placed the white jug in front of him.

'A woman's drink, that,' muttered the scruffily-dressed man leaning against the bar to my right.

'What?' I said, surprised, turning towards him. The man had made his comment loudly enough for me and anyone else to hear. It wasn't the sort of thing you said in a public bar.

'You should ask for the bitter,' said the man.

I now recognised him as Arnie Stannard. Keith Randall had told me that Stannard was from Southall, so I hadn't been expecting to see him again so soon, certainly not here in one of Greenford's public houses. He'd hardly endeared himself to me or anyone else when we'd played skittles in the *Hare and Hounds*. Already I found myself liking him even less this evening.

'Bitter's the only drink worth anything in this place,' he added, smirking.

I tried to ignore him. But he persisted.

'Still, if you're no good at skittles, then it stands to reason you'd be no good at drinking.'

'I seem to remember rolling better than you in the *Hare and Hounds*,' I snapped back at him. Immediately, I regretted not holding my peace.

'Two pints of bitter, Dennis,' called Arnie over the bar.

Dennis put down the filled jug in front of me, ignoring Stannard. 'That'll be eight pence, Tommy,' he said.

'Thanks a lot Dennis,' I said. 'See you again.'

'Half a mo' mate,' said Arnie. 'You jus' saw me ordering you a pint. You reminded me that somehow you did manage to get a better score than me in the Harey, so I'm doing the proper thing. Even if you were lucky enough to get yerself rolling against a man with a sprained wrist.' He rolled up his cuff to display a dirty bandage, tied loosely around his wrist. I was quite sure he hadn't been wearing this the other night. He'd been playing in the *Hare and Hounds* in shirt-sleeves.

Dennis put two full glasses of bitter down on the bar.

'Forget it,' I said. 'I have to be somewhere else. Have them both yourself.'

'Bleedin' cheek. You go on about beatin' me at skittles – me with a bad wrist an' all – an' then when I do the Honest John thing and get you a pint you won't even look at it.'

This was a delicate moment. I knew if I took as much as a sip from the glass on the bar I'd have to finish it. Then Arnie Stannard would expect me to buy him a pint, and so it would go on. I could see this pugnacious man was already swaying on his feet. I didn't have time for this sort of malarkey; I wanted to be on my way to see John and Vicky. From my pocket I pulled out a sixpenny-piece.

'Dennis, this tanner is for those pints. I theatrically slapped the sixpenny-piece down on the bar. You can use the odd penny to get another half for Mr Stannard when he's ready.'

I turned to Arnie Stannard and gesticulated toward the full glasses. 'These are both for you.'

'Keep yer bleedin' money. Me own dosh not good enough fer yer, that it? An' here's me out fer me last night on Civvie Street. A fine thing I call it. I've taken the Kings Shillin' an' on Monday I'm off ter join me regiment.'

'Which regiment?' Could Stannard be joining the First Middlesex?

'Never yer mind what regiment, yer bleedin' toff. I'll be doing me duty fer King and Country while yer suppin' yer woman's drink in the bleedin' Harey with that big blacksmith fella.'

This was too much. The visions implanted in my brain by Jet's words flashed in front of my eyes.

'John Jakes and I will be there in the muddy battlefields fighting in the trenches alongside all the rest of the soldiers. You'll probably have shell-shock, too, like me. Or you'll be killed like poor John or gassed like Archie!'

'What the bleedin 'ell are you on about, mate? Trenches? Shell-shock? Gassed? Dennis, this man's bleedin' barmy. I ain't gonna buy no drink fer no loony who oughter be in Hanwell! Get 'im outta here.'

Dennis looked at me uncertainly. He didn't know me well, and he, too, had been taken aback by my outburst.

'It might be better if you went on your way, at that, Tommy. You'd better go, too, as soon as you finish the pint in your hand, Mr Stannard. Never mind about the cost of these two bitters. The house will stand a couple of pints. Keep your tanner, Tommy.'

Without another word I picked up my sixpenny-piece and the full jug, turned from the bar, and headed toward the door. As I reached it I felt a light object glancing against my shoulder. A crumpled Wills' packet, obviously thrown by

Arnie Stannard from the bar behind me, bounced across the wooden floor.

'Whoops!' I heard him call. 'Better watch out for bullets on those mucky battlefields.'

*

I was pleased with myself for not turning around in the doorway of the *Red Lion*. The last thing I needed tonight was a brawl. Still, I was shaken up by the incident and deliberately walked straight past the forge, which was only yards away from the public house. I knew I'd need to compose myself before I called to see John and Vicky. I needed to keep walking all the way to the bridge over the River Brent, and then retrace my steps to the forge until I found myself breathing easily again. Vicky, with Hannah behind her, opened the forge door before I could knock on it.

'Tommy! We saw you marching past fifteen minutes ago with the jug in your hand. We thought you'd forgotten where we lived!'

'No, no.' I tried to sound casual. 'I'd just forgotten to do something else. Aren't you going to ask me in?'

Vicky stepped back to allow me to enter, but then bent over almost double in a fit of giggles. Hannah followed her mother's example, and it was some time before I could get any sense out of them.

'What's so amusing?' I demanded. Surely the sight of me walking past your door couldn't have been so funny? Vicky couldn't have known my reason for doing this. I hoped not, anyway.

'Come and see John!' Vicky and Hannah continued to laugh. 'Here, let me take that jug off your hands, Vicky said.'

They led the way into the interior of the house. There I found John sitting on the stool near the fire. Only he looked nothing like the John I knew. His hair, previously on the long

side, was now close-cropped. Instead of his usual friendly grin, he now scowled up at me. But it was the yellowish hue of his skin that most surprised me. He had dark, almost black, rings under his eyes. His eyebrows were thick and bushy, and turned upwards at the tips into points. Devil's eyebrows, they call them, but I'd never seen any as pronounced as this.

'John? What's wrong?'

For a moment he continued to scowl at me menacingly. Then, slowly, his features creased into their usual friendly grin. There was an explosion of laughter from behind me as Vicky and Hannah could contain themselves no longer. John ripped off the false eyebrows.

'These things itch like Hell!' he said. I don't know how I'm going to get used to wearing stuff like this,' he said. He rubbed the top of his head. 'This haircut is going to cause me a lot of grief, too. I can't use make-up for that, so this crop'll be permanent. Look, I've got to go outside to wash this muck off my face before we can eat. Don't mind me for a minute. Sit down and have a beer, old chum. I've already got us a jug in. There'll be two jugs for us tonight.'

*

Vicky, with Hannah trotting dutifully behind her, had gone into the kitchen to finish preparing our meal so, while John was washing his face, I was left to myself. I guessed what John's stunt meant. John had been playfully trying out the kind of film make-up he'd be wearing in California. Or, should I say, the make-up he thought he'd be wearing in California.

Those eyebrows would never see America. He needn't have bothered with that extraordinary disguise. He was wasting his time by having his hair in a severe crop. And I dared not tell him one word of this.

My poor, poor friend.

*

Ten minutes later, John came back into the room, face freshly scrubbed. His appearance still looked quite different with the stubble of hair, all the same. Against his chest, he was holding a sketch of himself wearing the stage make-up.

'Well,' he said. 'What do you think, Tommy? Do I pass the test?'

'It looks exactly like you did a moment ago. Who drew the picture?'

'You did, you daft sod. You drew most of the picture anyway. It was a sketch you did a few years back. I sent it to Charlie so he could add a few lines and shadings to show me how he wanted me to look in the films. He's pretty nifty with a pencil and rubber himself. Only thing is, the result is a bit messy around the hair. See there, where he's had to do a lot of rubbing out? Hope you don't too much mind the way he's spoiled your picture.'

'No, it's no problem at all. It was only a rough sketch. I remember doing it now: I drew it after a night in the Harey. Tell you what, though, John. I'll take this one and draw you a better picture, with the make-up on and all. How about that?'

'Thanks, old friend. That'd be great.'

It would be the first sketch of any kind I'd drawn in two years. Now, I couldn't be sure when I'd be able to find the time to do it, what with so much engraving work to catch up with. But I'd draw the picture, even if it meant me getting my pencils out at three o'clock in the morning. I couldn't do enough for John. Every time I looked at him I thought of the shell that would take him in the muddy fields of Belgium. My friend didn't deserve a fate such as that. None of us deserved what was coming to us.

'This must be my lucky day,' said John. 'You did say you were going to put a fancy frame around the picture for me, didn't you?' John grinned as he said this.

'It's taken as read.' In fact, I hadn't been planning to spend the extra time on framing, but I wasn't going to say this now.

'Good of you to spare the time,' said John. 'From what a little bird tells me you're busy with other things. And I don't mean in the shop.'

'Any chance the little bird was called Nellie?' I asked him.

John laughed. 'She's the one. But I don't want you to tell me about Mazod Betham tonight. Not with Vicky here. She wouldn't understand. It's "them" and "us" as far as Vicky is concerned. You can tell me how your romance with the gentry is getting along over a pint in the Harey one night before we go to California.'

I was glad John wasn't going to be pressing me on this point. Somehow it wouldn't seem right to talk about Mazod with my friend.

'Instead, let me tell you about a great thing I found out tonight,' John continued. 'Besides the news I'm to have my portrait drawn by a soon-to-be famous artist, I mean.

'I went over to the Red Lion to get a fill twenty minutes before you called. You'll never guess who I saw?'

'Arnie Stannard,' I said.

'How did you know he was – oh, of course – you've been in the *Lion* to get a jug yourself. I suppose Stannard was still in the bar when you called. He looked set for a long session. On his tod, the man was. The only company fit for him.'

'Did he say anything to you?' I asked.

'What, him? The runt pretended he'd never seen me before. But I gave him a gentle shove with my shoulder when I went up to the bar. You know; just a little reminder of me for him.'

So, John's action was probably the cause of the unpleasant scene in the *Red Lion* tonight. I could have done without that. But I smiled to think of my friend at the bar with Stannard. He would've noticed a 'shove' from John's shoulder.

'Anyway,' said John. 'I wasn't talking about Stannard. It was someone far more important I had in mind – Mr Weller.'

'Mr Weller?'

'Stone me, Tommy. Don't you remember? You know, he's the Manager of *The New Paragon Palace*.'

'Oh yes, of course. I recall what you said now. It's a shame we're going to miss the Charlie Chaplin film you wanted so much to see, what with you going to America and all.'

John looked at me, a mock puzzled expression on his face

'Why do you say that?' said John. 'Our boat isn't sailing from Liverpool until the fifth. You and I had arranged to go to see *Kid Auto Races in Venice* on the third.'

'You know me. I'm always getting my dates mixed up.' I hadn't been thinking of John's intended sailing date at all, but of the coming Great War Jet had told me about. I'd need to be more careful.

'But you're right, in a way,' John said. 'Vicky and I were going to travel up to Liverpool on the fourth. It'd probably be cutting things a bit fine, so we'd been thinking of going up on the day before. So I might have missed the film. But the really good news is that Mr Weller told me that now

they're having the film earlier than originally planned. So, you and I will be able go to see the film on the first day it's out, a week Monday. That's the twenty-seventh. You on for it, Tommy?'

'Course I am.' I'd have promised John anything. Then I had an idea. 'Tell you what, I could travel up to Liverpool to wave you goodbye from the docks.'

'You sure? I thought you'd told me you were going to the HADs meeting with the Ravens on the fourth?'

'That's on Tuesday evening. So, I'd still be able to travel up to Liverpool early on the Wednesday morning. You're not sailing until the night of the fifth, are you? Anyway, I could always go to the HADs meeting in September, if it came to that. It's not every day your best mate sails to America.'

John beamed with pleasure at my idea. This was my reason for suggesting it. But hearing the lies I was telling gave me a sick feeling inside. I knew John wouldn't be sailing on anything but a troop-ship.

*

The meal was even more enormous than those Vicky usually served. There were hefty slices of roast beef, massive Yorkshire puddings, peas, carrots, sprouts and potatoes all swimming in thick gravy on the enormous plates Vicky always used. Although I did my manful best to eat a respectable amount, I doubted I managed much more than young Hannah.

I managed less than half of the huge portion of rice pudding Vicky served. John had two big bowls full.

'Lovely meal, Vicky. I'm sorry I couldn't do justice to it. My appetite is not up to much tonight. I suppose it's because I'm going to miss the three of you.' Another half-truth.

'Go on with you, Tommy. You only ever eat as much as a sparrow,' said Vicky.

She turned to her husband. 'But he'll be coming to see us in California, won't he John? Perhaps American food might be more to his taste.'

'That he will. As soon as we get ourselves settled, Tommy will be coming to California to see us. Maybe we'll get him to stay for keeps. We'll try to get him a part in the films, shall we? You wouldn't make much of a villain, though, old friend. You haven't got the face for it like me. Even with jars and jars of make-up. Too much of a pretty boy, you are, my son. I can see you as one of these romantic heroes.'

I didn't reply. I couldn't trust myself to speak, and not only because I didn't want to tell any more lies. My eyes were filling up. Vicky placed her plump hand over mine and patted it gently. She caressed mine affectionately, almost sensually, in a smooth up-and-down movement.

'Don't worry, Tommy. We'll miss you, too,' she said.

She kept her hand on top of the back of mine. I did not care to look up and meet either her eyes or those of John.

'Do you remember the days when we were in the Clock School together, Tommy? Even before John came?' she said. 'All the girls were sweet on you.'

'I shouldn't think so,' I said. 'Some of them might have liked me well enough when I got a bit older, but in those days they didn't pay me much attention.'

For years I'd always thought of Vicky as a kind of accessory to John. Now, she was speaking on her own account. I wasn't very comfortable with the affection she was showing to me, especially with John sitting just across the table.

'All the girls did like you, you know. They were always talking about you. It was Tommy this and Tommy that. All the time they were saying those things; I'm surprised you didn't know.

'I noticed it all the more, because the other girls used to call me hurtful things like "fat little duck". They ignored everything I ever did or said. But not you, Tommy. Not you; my Tommy was always talking to me and asking how I was.'

'Mummy?' Hannah's high-pitched voice piped its question into the room. 'Do you love Uncle Tommy?'

There was a moment's awkward silence.

'Of course I do, Hannah. We all do, don't we? That's why he'll be coming to see us in California.'

Sunday, 19th July, 1914

The throaty voice of Edward Terry, Rector of the Church of the Exultation of the Holy Cross, rumbled on above our heads. Here, inside the Church, the air was still and stifling. For some reason, I was more keenly aware of the musty smell of the walls than I was of anything else. As the sermon plunged its sacerdotal depths, I wondered if I dared to close my eyes for a moment, sitting as I was alone in my customary place well to the back of the Church. But, even with the war coming, I was enough of a hypocrite not to want to fall asleep in the presence of the gentry of the area.

I assumed that nearly all of the other members of the congregation would be equally as bored. The only person I could see definitely paying close attention to the sermon was Frederick Crees. He was sitting bolt upright, his extraordinarily long legs jutting out awkwardly below the pulpit.

Most of the usual Sunday morning worshippers were seated in the church: the Bennetts, Mr and Mrs Otter, Mr Tigwell, William Markham, and the numerous members of the Hanson family. There were also many of the less exalted lights of Greenford present, like the Ravens and myself. In anticipation of the Parade to follow, I noted the presence of Mr and Mrs Hartson in the third row; he in a grand silk hat and she in an unfussy, rather smart bonnet. Mazod wasn't there, of course. How I wanted be with her in Sudbury; to be introduced to her Aunt Hattie as 'her young man'.

Edward Terry's lesson was yet another diatribe against the separation of the Welsh Church from the Church of England. For some reason I couldn't fathom, the Church was vehemently opposed to the idea. It was the third time this year I'd heard a similar rant coming from the pulpit on this subject. As I missed coming to Church as often as I dared, I

calculated this would probably be the fifth or sixth occasion on which the more regular churchgoers would have endured a similar sermon.

Quite what relevance the topic of the Welsh Church had for the people of Greenford I failed to see. Mr Thomas and Mr Vaughan were the only residents of the village who came from Wales, and that was many years ago. Both of them, as far as I knew, were entirely indifferent to the subject. I was sure they'd have tried to keep a distance from Terry to avoid being lectured on these ecclesiastical intricacies. What was more, I knew the matter was due to go before Parliament after the summer break, so what was the point of all this hot air?

Neither Terry, nor anyone churchman in my hearing, had uttered a word about the events in Europe. In the latter part of this month, if the newspapers bothered about them at all, the news had probably been relegated to a small paragraph in the middle pages even Roger Hartson failed to notice. Talk about fiddling while Rome was burning. Only what lay ahead of us was going to be far worse than any event in ancient history: much more than Rome was going to burn. This was what Jet had told me.

The only way I could keep myself awake was to count the number of times that Edward Terry used the extraordinary word someone had cooked up – surely as some kind of joke – to describe the Church's position on the issue of separation of the Churches. And soon after the fifth use of the extravagant "antidisestablishmentarianism", this dreadful sermon at last came to a close.

*

'Well, young man, I'm entrusting the care of my wife to you for the next hour,' said Roger Hartson. 'I'm only sorry I can't join you both.'

'Take no notice,' said Theresa Hartson as soon as her husband was out of earshot. 'He's only going to see one of his stamp-collecting cronies in Ealing. Roger will be perfectly delighted with the prospect of spending a guilt-free afternoon pasting away at his bits of coloured paper. Or whatever it is these philatelists do when they get together.'

She smiled mischievously. I thought it showed a lack of respect inappropriate for a wife to voice about her husband, especially to someone like myself who belonged a younger generation, but she spoke the words lightly enough to get away with it. Even so, I thought it would be better if I made no verbal response, so I merely nodded.

'Don't look so shocked, Tommy!' she smiled. 'You'll find out I'm always saying outrageous things. Roger can probably guess what heresy is on my lips at this very moment. He's used to it all. A real dear, is my husband. But, seriously, we're both very grateful you're accompanying me. Now, my niece tells me this is your first Sunday Parade. Surely that can't be true?'

'I'm afraid it is, Mrs Hartson. In fact I'm not really sure what I'm supposed to do today.'

'Nothing. You do absolutely nothing. Except, I suppose, walk in a dignified column with the others taking part in the parade. It's not a long walk, so we pace it out in a stately way. We only walk past the Rectory, Greenford Hall and the Rectory Cottage. And, Tommy, please try not to look as serious as you do at this moment.'

She gave me a mock-chiding glance, but then smiled pleasantly. So, the route would be the one I'd nervously trodden a few Sundays ago. On that day I was waiting anxiously for Theresa Hartson's niece. Now I was accompanying her Guardian, almost as an equal. A lot had happened to my life in the intervening two weeks.

'I'm so sorry I don't have a proper silk hat to wear', I said. 'This bowler seems inadequate for the occasion. So many of the men here today are wearing something more dignified. I'm sure could have borrowed a decent hat from somewhere, if only I'd stopped to think.'

'What absolute nonsense. Do you usually wear a silk hat on a Sunday? Look at Mr Vaughan and Mr Raven. They look perfectly smart in their bowlers.'

Instead, I found myself gazing enviously at the likes of Messrs Bennett, Otter, Tigwell, Markham, and Crees. No fewer than three members of the Hanson family were wearing silk hats. The second son's hat was excessively tall; it almost towered up to the lofty height occupied by Mr Crees. A thought struck me.

'Where's Archie Perkin?' I asked, surprising Mrs Hartson.

'Archie? Oh, he never attends the Sunday Parades. He dismisses them as a rural remnant of Paganism. Charming boy! I think they're no more than a bit of fun, myself.'

It seemed to me Theresa Hartson and Archie Perkin were equally right, in their different ways.

'Ah, at last. We're moving off. I see Mr Crees is taking the lead this Sunday. Shall we?' Mrs Hartson offered her arm to me.

*

The parade was exactly as it had been described to me: nothing more than a sedate circuit of the oval formed by Greenford Green's larger buildings. What I hadn't anticipated was the peculiar, and I suppose no more than semi-formal, social ceremony at its conclusion. Everybody who'd taken part in the parade shared a word or two with everybody else, or more often people simply exchanged a polite nod.

I was glad I was with Theresa Hartson. She did most of our talking. If anyone was surprised to see the two of us on the parade together, they didn't show their feelings too much. Perhaps they didn't dare to do so in the face of: "*You know Mr Green? Yes, of course you would.*" This was the invariable way in which she introduced me.

When we spoke to Mrs Raven, that lady responded with an alarmingly vigorous nod. Then she became wreathed in smiles. You could almost see her thinking, "my boy is really making his mark today". It was only with this thought I remembered the Ravens had no children of their own. Still, this meant they'd have no sons to mourn in the Great War that would be on us in a few weeks.

*

'You'll walk me back to Betham House, of course?'

'Naturally, Mrs Hartson.' I offered her my arm. She laughed, but took the arm anyway. It was only then I realised she hadn't intended us to walk down the Old Field Lane in this fashion.

'Don't go so fast, please, Tommy. I want the two of us to talk about something important.'

'What would that be?'

'Now, you know exactly what I'm going to say. Don't play games, please. It doesn't become you. I want to talk about Mazod. I want to speak to you about you and Mazod, to be more precise.'

'I'm very fond of Mazod.'

'Yes, you do seem to be. I'm quite sure you are, in fact. But are you as set on Mazod as she is on you?'

'It would be all I could ask if she were half as keen on me as I am on her.'

We walked on for a few yards in silence. Theresa Hartson seemed to be considering what to say next. I hoped I hadn't tried to be too clever with my answer.

'What you must realise, Tommy, is that Mazod is a very forthright young lady. She says exactly what she thinks without a moment's thought for the consequences of her words or indeed of any wider considerations. It's the way I've always tried to bring her up and I'm proud of her for being so unflinchingly direct. But being so bold can cause – shall we call them complications – in matters of romance? Do you see what I'm saying?'

'You're saying I'm no more than an ordinary shopkeeper and I'm not good enough for her. Is that it?'

'Heavens, no. I'm not a snob, Tommy. In fact I'm more than a little offended you think I might be.'

I didn't leap in with an apology. This was certainly my first inclination, but I wanted to see what else she was going to say.

'If Mazod wants to tip her hat at what you insist on calling "an ordinary shopkeeper", she'll have my full backing,' she said. 'And my husband's, too; Roger's far from being as stiff as you may think he is. Anyway, from what Mazod tells me; you're rather more than an ordinary tradesman. Your business horizons are set to widen very shortly. Didn't you tell me so yourself?'

She was clearly making a reference to Henry Trevithick's mooted partnership. I couldn't tell her things weren't yet quite as firm as she and Mazod were assuming. A lot was riding on my discussion with the businessman when he returned from Cornwall. The date of our interview was firmly engraved on my mind. It was going to take place next week, at precisely at ten o'clock on Thursday the thirtieth, he'd said. Mr Trevithick's words were never far away from

my thoughts these days. I tried to remember the rest of my conversation with him before I replied to Theresa Hartson.

'There are many details to be worked out,' I said, speaking very cautiously, not contradicting what I'd said to her a few days ago. 'But, yes, I'm confident that my business will be expanding very shortly.'

'Good. I'm sure the facts that you're working for your living and that you're ambitious in business are two of the things that Mazod rates highly in you. Most of the young men in whom local society might expect her to take an interest are not quite so self-sufficient.'

'Like Archie Perkin?' I found myself mentioning his name again.

'Well, yes, Archie perhaps. But of course he has independent means. I do happen to know that he's very keen on her.'

'So am I.'

'Yes, as I've already said, I'm sure you are. I do hope I'm right in my belief. All I'm really saying, Tommy, is that I'm very fond of my Mazod and I wouldn't want her to waste her time with anyone who isn't at least as fond of her.'

'She wouldn't be doing that.'

'Good. Then we understand each other very well,' she said, as we reached the front gate of Betham House. 'Thank you very much for being my partner in the Parade today. It was appreciated. I shall look forward to talking to you again when you call for Mazod during the week. And of course, you'll be with us for a longer time at my birthday evening next Saturday.'

'It was a pleasure, Mrs Hartson, to accompany you on the Sunday Parade. I look forward to seeing you in the week, too. Good day to you.'

She turned smartly and opened the garden gate. But, before she entered, she looked back toward me and spoke again.

'And because we now understand each other so well,' she said, just as I was about to turn to retrace my steps down the Old Field Lane. 'I know you won't be in the least offended when I say to you that if you let Mazod down in any way, you'd have me to reckon with. You'd find I can be most formidable. Good day to you, Tommy.' She gave me a radiant smile as she said this.

*

Walking back along the Old Field Lane, I thought of what Mrs Hartson had to say. I was sure she could be every bit as formidable as she'd said. She needn't have worried: what I wanted more than anything in the World was a future with Mazod. This was what Jet had promised me; I knew I had to keep a tight hold on this wonderful thought. It gladdened me to know that this strong-minded woman was watching over her niece.

It had been a wonderful Sunday: for once I was glad I'd come to Church, despite Edward Terry's appalling homily. But, with every step I took along the lane, Jet's sombre warnings, and the thoughts I'd almost succeeded in banishing from my mind in the sunlight of the afternoon, came back to haunt me. It was as if Jet were a nagging ghost from the future, dogging my every step.

Even on a day like this one, the task he was trying to lay before me could never be far enough away from my thoughts for as much as a few precious hours.

Monday, 20th July, 1914

'I'm not going to do it, Jet.'

This was what I'd made up my mind to say as soon as he came into view. In fact I all but shouted it at him while he was still materialising in his infuriating way. He ran over to where I was standing.

'What did you say?'

'I can't do whatever miracles you're expecting from me. You and your father have chosen the wrong ancestor. You have another thirty great-whatever-it-is grandparents besides Mazod and me, as you were so keen to point out. Go and persuade one of them to alter history and stop this Great War.'

'But you can't pull out at this stage. We've got so much invested in the project.'

I looked at him coolly. He was in a state of pure panic.

'Why not? There's no reason why you can't go back to your precious 2046 and do your preparations all over again. After all, you can as well travel back to 1914 from the year 2047 or 2048.'

'It's not so simple. I can't cross the timelines again. Any date to which I've already travelled back, that's anything between November, 1890 and July, 1914 – the twentieth of the month, or "today" as you think of it, to be exact – is now closed to me.'

'You asked me yourself only last week if I wanted to continue with this. What you said then was – correct me if I'm wrong – that if it was too much for me, I should stop. Well, I've decided it is too much for me. I want to call an end to this nonsense now. There are too many other things going on in my life at the moment.'

Jet looked crestfallen. But I'd decided: he'd picked on the wrong ancestor. This one had to give all his energy to winning Mazod. And, yes, although as recently as a month ago I'd never have believed I'd be thinking such a thing, I wanted to become a successful member of the Greenford business community. I stood my ground, crossing my arms before me. I had no intention of offering him a seat this morning.

'My father was angry with me for saying you had the choice,' he said. 'He told me it showed unforgivable weakness on my part. Besides, I said those things before I told you about our family history. It's true; I did have reservations about the weight of knowledge in what I told you. But I've told you now; I can't retract what I said.'

'Your damned "psi-program" is going to do it for you at the end of the month, isn't it? You've told me as much yourself.'

Jet didn't know what to say to this. I pressed on relentlessly. All of my resentment at being bossed around from the twenty-first century was now rising to the surface.

'Anyway, shouldn't you already know this? I've been writing it all down in my journal, exactly as you asked. It must be very strange for you to read your own words before you even say them.'

'No, I haven't read any of the words I'm going to use. I don't know what either of us is going to say or do. My father would never let me look at your journal, even when I was a child. He's only told me some odd bits and pieces, that's all.'

So it was becoming clearer now. The real mastermind behind the ruin of my life was definitely Ollie Green. Jet was no more than his agent. And he was a not-very-competent agent, into the bargain. I did feel some sympathy for him,

though not much. It was my life that was being torn into pieces by this game he and his father were playing.

'Well, you ought to be able to guess what I'm going to say now,' I said. 'This is all over for me. It's finished. I've got other things to deal with. I'll somehow live with the awful things you've told me until the end of the month, and then my mind will be clear of this poison you've dripped into it from your twenty-first century.'

'I've failed, then.'

At that moment, Jet looked so pathetic I felt I had to say something further, just to ease his discomfort.

'Come on, Jet, you haven't really failed.'

'I have.'

The weakness he betrayed by his words incensed me, but I tried to carry on with my explanation. Perhaps what I was really doing was to try to explain things to myself.

'Look, let's say you did somehow succeed in preventing the wars of the twentieth century. If this time node idea of your father's really worked out, who knows what future history – what *your* history – would hold? It would have to be very different from the history you know. There will be millions of people who aren't going to die in the wars, for a start. I won't be writing *A Soldier's Story*, that's for sure.'

'No, but you'll be writing something else that will have a similar effect,' he said. 'And you're right; a change on a time node will alter things. But not as much as you might be supposing. The phenomenon of the 'Elasticity of Time' will see to that. My father has calculated that the only really significant impact on our family would be that he and I would be descended from your son Trevor and Valerie Bush. Bertie and Mary will probably have families of their own.

There won't be a Second World War. The death of his twin brother in that war won't be there to screw Bertie's life up.'

Screw his life up? Another odd expression, though I could guess exactly what it meant. Jet seemed so unshakeable in his beliefs. I tried a different argument.

'Aren't there supposed to be an infinite number of parallel universes to cover an infinite number of possibilities?' I said, remembering something I'd read. 'In some of those universes you, or an alternative version of you, will succeed in persuading Thomas Percival Green to do what you want. In some of those universes, that Thomas Percival Green might succeed in stopping this Great War before it wrecks the world. In some there might not even be a Great War at all. But *this* Tommy Green, the one you're speaking to right now, will let things take their natural course, thank you very much.'

'You've heard of the theory of parallel universes, Tommy?' Jet evinced some surprise at what I'd said. 'I thought the idea was something Hugh Everett came up with in about 1950. He was a PhD student in Princeton University, I believe. I'm sure that's what my father told me.'

'No,' I said. 'If you check I think you'll find that the concept was around at the beginning of this century. That's the *twentieth* century I'm talking about, in case there's any doubt in your twenty-first century mind.'

Now, I didn't have any idea where and when I'd heard of this concept- it wasn't called "the theory of parallel universes" as far as I remembered – but it gave me a lovely warm feeling to think of Ollie Green desperately searching through his *computer databases* in 2046. Perhaps these wouldn't be as infallible in the future as Jet and his father seemed to assume. But Jet quickly resumed his didactic mode.

'Well, parallel universes and alternative realities are great ideas,' he said. 'But I'm afraid they're no more than that. About fifteen years ago Professor Williams showed the whole theory to be built on a fallacy in quantum mechanics. There is and can be only one reality; the one you and I live in. If I fail in this one, I fail completely.'

So, Jet was reminding me yet again that, if I did nothing, millions of people would die in these two wars, including John Jakes and my own son Trevor. And I'd spend years locked away in Hanwell as a lunatic. He wouldn't let me forget this for a second.

But the whole idea was ridiculous. How on Earth could I even think of preventing the assassination of this Frenchman? And why should Jet, or his father, to be more accurate about it, think I could? I knew I'd regret saying my next words, even before a sound left my lips.

'Anyway, why should you and your father think I could stop the murder of this Jean Jaurès?' Jet's attention immediately perked up. 'Not that I'm even going to try, mind you,' I quickly added, when I saw his expression change. 'I'm no hero. I've never fired a gun in my life, nor have I even held one.'

'You wouldn't have to be hero, Tommy, and nor would you need a gun. No-one has to be killed. Don't forget, it's all recorded in history. As things stand, soon after nine-thirty on the evening of the thirty-first of this month, Jean Jaurès will be finishing a supper with some socialist friends at the *Café du Croissant*, in the *Rue Montmartre*. It will seem an entirely normal event to everybody.

'Then, an ultra-nationalist by the name of Raoul Villain, a member of something called the *ligue des jeunes amis de l'Alsace-Lorraine,* will fire two shots at Jaurès, mortally wounding him. History will even record that Villain carried his pistol in one pocket and two typed pages of Maeterlinck's *Blue Bird* in the other All you'll have to do is

stop the killing from taking place. It won't even be really dangerous.'

'All I have to do is stop him firing his gun? And you're trying to tell me it's not even going to be dangerous?' I laughed derisively. 'Come off it Jet; do you and your father think I'm that stupid?'

'You'll know exactly what Raoul Villain is scheming, even before he knows it himself. My father and I have worked out exactly what you'll need to do. If you follow our plan then, no, it won't be really dangerous.'

'Well, I'm not going to do it, all the same. If you can't come back to 1914 again yourself to persuade one of your other ancestors to go to Paris on this not-really-dangerous adventure, your father will have to come to do it himself.'

Jet seemed nonplussed at this suggestion.

'He can't,' he eventually said. 'He's needed at home to operate the psi-computer programs and to deal with any eventualities.'

'It's not my problem to work out how you're going to do it.' I was becoming impatient now. 'Send some other member of your team, then.'

'There are no other members of our team. There's only me and my father.'

'No other members of your team?' I was surprised at his answer. 'And I thought you told me you were really an archivist?'

'An archivist is what I am. My father persuaded me to assist him when my twin sister Tilda left the project. The two of them had worked together for years before they parted company. She's a psi-computer specialist like my father.'

Now I looked into Jet's eyes, as if seeing this young man properly for the first time. I'd been an absolute fool. It

was no slick scientist from the future who'd been driving me insane for the last three weeks, but a second-choice, very ordinary man, pressed into service by his father. I wondered with what I was truly dealing.

'You said this project wasn't an official Government one. How unofficial is it supposed to be?'

'It's a private one,' said Jet, more than a little uncertainly.

'And is it legal?' I persisted.

'Not really.'

'I said, is it legal? And if you don't tell me the whole truth I'm going to walk right down Horsenden Hill this very instant and will hope never speak to you again.'

Jet looked at me. His eyes widened like those of the frightened little boy I now knew he really was. When he spoke, I was finally sure he was telling me the truth.

'All unauthorised time travel is illegal. The Government passed a law when too many people started to use it casually. That's where so many of the ghost stories from the mid-nineteenth to the mid-twentieth centuries originated. The so-called spirits seen by numbers of people were no more than careless time-travellers.'

'And why did your sister Tilda stop working with your father? Tell me the truth, Jet.'

'They had a fundamental disagreement about what he was trying to do. Tilda said history should look after itself.'

'Then I agree with Tilda. Goodbye, Jet. I won't be seeing you again.'

Without waiting for his answer, I marched down the Hill as quickly as I could. I guessed Jet wouldn't try to follow me: the thirty minutes that he, or more accurately his father, had allowed for today, was almost used up.

'I'll be here on Wednesday Tommy. Please come to talk to me.' I heard his voice calling pathetically from behind. Then there was a silence of a few moments before I heard him again. This time he was shouting.

'Can we say we're to let history look after itself if so many millions of people are going to be killed? Can we still say it if one of those people is your best friend? And if one of them is your own son? Can we still say it then?'

I looked around angrily, but already he'd faded from view.

Tuesday, 21st July, 1914

I had been so confused since yesterday's encounter with Jet. Wildly conflicting ideas had been swirling around in my head until it ached.

After talking to Theresa Hartson on Sunday, the way forward had finally seemed to be clear: Mazod was my priority and I should try to ignore any distractions, even the miraculous one presented to me by Jet, or in truth by his unseen father, Ollie. And yet how could I say Mazod was so important to me if I was prepared to ignore the death of one of our unborn sons and the ruin of the life of the other?

This was the dilemma I'd been wrestling with for the last thirty-six hours. I'd failed to come up with any sane answer. It was clear to me I'd have to find some way of talking to Mazod about this conflict in my life. After all, it was a life I wanted her to share. But how could I think of a way of explaining the problem to her that wouldn't immediately condemn me as a raving lunatic in her eyes? Even as I walked down the Old Field Lane towards Betham House in the evening, the solution failed to come to me.

*

'Good evening, Mr Green. You'll have called for Miss Betham?' Nellie Hodge curtsied slightly. This time there was no quick smile of recognition from Vicky's sister. Perhaps she'd seen my own frown and misinterpreted the reason for it? I tried to banish the cloud from my features but Nellie did not respond in a similar way. Rather, I'd have said that this time she looked confused at seeing me on the doorstep of Betham House.

As soon as I followed Nellie into the hallway, Mrs Hartson stepped forward to greet me.

'Good evening Tommy. How nice to see you again. Mazod is upstairs; she won't be long.' An impish light came into her eyes. 'Don't look so alarmed. I really am telling you she'll be down with us soon. You won't be getting an interrogation from me this evening as you did last week. Or during our friendly chat after the Parade on Sunday. I really did enjoy your company, by the way. Ah, here's my niece now. You see, Tommy, you won't be cornered by the fire-breathing dragon this evening.'

The last thing I could imagine Theresa Hartson being would be any kind of a dragon. I knew that for me to try to express this thought would sound contrived and false so did no more than smile as she disappeared into the parlour. She was a remarkable woman.

Mazod looked breath-taking tonight. As she walked down the stairs towards me, she lit the hallway of Betham House with her presence.

'Well, where would you like to go?' I asked her.

'Since we've got a bit more time tonight, I thought it would be pleasant to walk down to the footbridge over Coston's Brook again. Do you remember our very first walk together? Yes, I can see by the expression on your face you do. But there'll be no chance of our finding a cloudburst again. It's a beautiful evening.'

It certainly was a fine evening, and to get caught out by the weather again would be improbably unlucky, so I readily agreed. Soon, we were ambling down the Old Field Lane together. It would have been perfect, except that I knew I'd soon have to find some way of telling her about what was on my mind

But what should I say? Should I tell her I needed to go to Paris to save the world? Walking through our village on a peaceful summer's evening with Mazod made the very idea seem ridiculous. And if I couldn't even bring myself to think

about it sensibly, what hope did I have of explaining it to her?

*

I didn't realise it at the time, but our walk to Coston's Brook was the high point in our all-too-brief courtship. Mazod held my arm tightly, chattering away happily. We arranged that I'd call for her at Betham House on the evenings of Thursday and Friday this week. And, of course, I'd been invited to her Aunt Theresa's birthday evening next Saturday and she was full of plans for that. She even asked me if I'd mind not seeing her tomorrow, because she wanted to visit her Aunt Hattie in Sudbury. She *asked* me!

Oh, Mazod!

*

'That's a Bullhead,' I said. 'Or, thinking about it, it might be a Minnow.'

'Nonsense,' said Mazod. 'You get no fish in Coston's Brook, unless a Stickleback from the Brent gets lost sometimes. It could have been no more than a Pond Skater you saw.'

So Mazod knew more about the brook than I'd assumed. I was still putting off the moment when I'd have to talk about the thing eating away at my insides. I remained hunched over the fence on the footbridge, looking down at the waters of the brook, not really knowing how to begin what I wanted to say.

After a minute I straightened up and looked up at the sky. 'It's a lovely evening. Not a cloud in sight,' I said. 'We're not going to be caught out by a cloudburst this time,' I added, nervousness making me refer once again to this subject.

'Tommy, you didn't bring me out here for a weather forecast. What do you really want to talk about? You've been distracted since we arrived here. What's wrong?'

'Nothing really,' I said, trying to meet her eyes. The opposite was true.

'Come on, Tommy. Don't go back to your old ways and try to hide yourself away from me. We're supposed to be walking out, remember? Now, tell me what's on your mind?'

'It's difficult to explain.'

Mazod folded her arms across her chest and fixed me with a severe look.

'Because a thing's difficult to do, it doesn't mean you shouldn't attempt it. In fact, it means you have to try all the harder. Now, come on.'

'Mazod,' I said. 'You know I want my life to be with you.'

'It's too soon for a proposal, Tommy. Take your time. Let's enjoy walking out together for the next few months.' The way she said this told me that if I was going to propose this evening, she'd have taken it very seriously.

'I wasn't going to propose.'

'Oh?'

'Not tonight, anyway. You're right. We should make the most of our courtship for the time being. But Mazod, what would you say if I told you I knew a way to make our life together secure for the future?'

'You're doing your best, Tommy. You'll be seeing Henry Trevithick next week. Mrs Raven, from the shop down the road from you, told Nellie you're going to the next meeting of the local traders' association. And I know you're rushed off your feet with orders in your shop. I'm proud of you.'

The things she was saying and the way she said them made my heart race. But I had to press on.

'Those things are not exactly what I meant. I'm talking about securing our lives in a wider sense. I'm talking of making the lives of everyone else in the world better, too. That's what I wanted to tell you about.'

Mazod looked puzzled. I could hardly blame her. I wasn't doing a very good job with explanation.

'Then I really don't know what you're trying to say,' she said.

'Look,' I said, trying desperately to think of a way to let Mazod know of the insane visions spinning in my head. 'If you knew a way to make the world a better place for everyone, wouldn't you take it?'

'Of course I would,' she said, now starting to show her exasperation. 'All of us should go through life thinking of others and trying to make the world a better place for them. But I don't see why you should be talking about this. Not now. We should be just walking and – well, enjoying each other's company. For Heaven's sake let's do that, instead of me standing her listening to you talk in riddles. Tommy, I don't understand what's got into you tonight. Come on, let's go.'

She stretched out her hand. I wanted to take it, to walk on with her and for us to behave like any normal courting couple. But I knew if I didn't try to speak now, I never would.

'I need to explain, Mazod. Please let me talk.'

She relaxed her tensed frame slightly, but I couldn't help but be aware that at the same time she edged a pace away.

'I'm listening.'

'I really do know a way to make our lives better,' I said. 'But I'll have to go away soon for a week or so to do it.'

'You can't do it now! You're coming to our house for my Aunt's birthday evening on Saturday. She'd never forgive you if you missed that. Neither would I!'

'It's all right. I can leave on Sunday or Monday. I don't have to do anything until near the end of the month.'

'You can't go then either,' Mazod said. 'You told me you'll be seeing Henry Trevithick on the thirtieth of this month. Your whole future – our whole future – depends on your meeting with him. I really don't understand what it is you're trying to tell me, Tommy.'

'Mr Trevithick will understand if I explain things to him.' Would he? I doubted it. 'I'll arrange another meeting with him for the week after next.'

There were the beginnings of tears filling her eyes.

'Why should Mr Trevithick agree to any such thing?' she said 'If he can even understand what it is you're asking. You haven't done a very good job of explaining whatever it is you were trying to tell me!' she shouted. This was an understatement.

'Anyway,' she continued, her voice rising in tone. 'You're very well aware that Mr Trevithick is away in Cornwall. You wouldn't be able to talk to him if you're going away yourself. Where is it you're supposed to be going to do this so-important thing, anyway?' Her lips had started to tremble.

'Paris,' I said. 'I have to go to a place called Café du Croissant, not far from the big river, I believe.'

'Paris!' echoed Mazod. 'A café? I've heard of these so-called cafés! There's only one reason a young man goes alone to Paris. I've never heard it called "making the world a better place" before. Huh! But perhaps you'd call it that.

Yesterday I overheard the servants talking about the way you were when you were younger.'

The servants! There were only two at Betham House: Vicky and a woman from the North Country with whom I'd never exchanged more than a "Good Morning".

'I listened at the kitchen door to the two of them talking for a long time, said Mazod, her face now white. 'I couldn't believe what I was hearing. Mrs Tanner was telling Miss Hodge she'd heard the most alarming stories about you. But then I thought about it. You were younger back then. It really seemed to me you'd changed. So I gave you the benefit of the doubt and tried to forget all about this gossip. Now I see you haven't changed one little bit. You're putting your lewd desires before everything else, even before our future happiness. And I remember the way you acted the last time we were on this bridge together!'

'Mazod-'

'Keep away from me, Thomas Green. Now I'm going home. And don't you dare take one step to follow me.'

Mazod marched off, and I watched her rapidly receding form all the way until she disappeared from my sight the end of the footpath at Greenford Hall. Not once did she so much as glance back in my direction.

I looked disconsolately below into the cloudy waters of Coston's Brook. I don't know how long I spent doing this. Then, briefly but unmistakably, I saw a small fish rise to the surface. I was absolutely sure it was a lone Bullhead.

*

Long before I reached the forge, I could hear the sound of hammer upon anvil. John was working very late tonight. This wasn't like him. He always started his labours at some unearthly hour but then laid his tools down punctually at six o'clock. Only dire emergencies would see

him back at the forge after this hour, and then only amidst much grumbling.

My original thought had been to call in with my new sketch of him in his film make-up tomorrow evening. Now I wasn't at all sure if I'd ever be allowed to call at Betham House again, so I'd decided instead to call into my shop on the way back from Coston's Brook to get the picture for John tonight. If anyone could lift my sagging spirits even a little, it would be John.

There was something else I wanted to do at the forge, too. It was a more important thing. I knew I couldn't tell John about the Great War, but I could at least do my best to make sure he and his family went to America. If I could, I'd try to persuade them to leave a few days earlier than they'd planned.

*

'John!' I had to shout to make myself heard above the hammering. 'I've brought the picture for you.'

He put down the hammer, sweating profusely. At first he looked not at all pleased with the interruption, but when he saw it was me he smiled broadly.

'Tommy!' he said. 'Good to see you. What've you got there?'

'A drawing of a film-villain I know, in full make-up.'

'Let's see it,' he said, walking over to me. 'I'd better not hold that nice clean frame in my filthy hands. Hold it up to show it to me.' I held it up. 'It's marvellous. Thanks Tommy. It'll be going to California with us. Put it over there on that stool, if you would. That's the only clean place in the smithy. I'll pick it up later.'

'Here?' I asked, walking over to find one of the three stools looking something like semi-clean.

'That's the one. It's not too grubby. I don't mind telling you I'll be glad to get to California and leave all this muck behind.

John surprised me with his remark. If there was one man who'd seemed to me to be happy in his work it was John. It went to show how little we know about people, even those we think we know well.

'I didn't expect to find you out working in the forge at this hour,' I said.

'I'm trying to clear up some last jobs before we sail for America. We're leaving Greenford in less than two weeks, and everybody wants no end of work done all of a sudden.

'Course, you realise I'm not telling anyone we're sailing to America. On the Sunday evening we'll be here and then on the Monday morning we'll be gone. This place is not even going on open sale: I've already found a buyer who's happy to keep the deal quiet for me. The sale is all done, except for some of the legal mumbo-jumbo. Tomorrow, I have to sign some papers. I know you wouldn't be saying anything about our plans to go to America, Tommy. It's why I was happy to tell you about it. Nobody else on this side of the Atlantic knows a peep-o'.

But I hadn't kept it a secret. I'd told Mazod. I only hoped she'd said nothing to Nellie Hodge, Vicky's sister.

'What's that you're working on now?' I asked, changing the subject in an attempt to hide my embarrassment.

'A candlestick, though it might not look much like one yet. Here's its big brother so you can see what it's is going to look like,' John said, holding up an elaborately-scrolled black candlestick. 'What do you think?'

'It's wonderful, John. This is really graceful. Did you do all this from out of your head?'

'From this drawing,' John said, reaching down to pick up a piece of rough paper and holding it up for me to see.

Even through the grubbiness of a short life spent on John's floor, I could see it was a very fine drawing.

'Who drew this?'

'The chap who asked me to make the pair of candlesticks drew it, Mr Perkin. He told me he'd based it on some candlesticks he'd seen in a painting. The picture's not so bad, eh? Nearly up to your standards.'

'Mr Perkin? Do you mean Archie Perkin?'

'He's the only Mr Perkin in Greenford, so far as I know.'

'And you're making these for him?'

'Now look, Tommy,' said John, grinning. 'I know you've got a thing about Archie Perkin, but the man's a real gent once you get to know him. He's got quite a sense of humour and isn't stuck up like so many of the well-to-do around Greenford. For this little job he's paying me five guineas. Good, eh? But, tell you what, I've promised him they'll be ready for collection tomorrow afternoon. And, like I said, in the morning I have to go over to a solicitor in Ealing, to sign some papers and pay through the nose for the privilege of doing it. I'm trying to catch the light this evening. So, if you wouldn't mind...'

John was asking me to go. And so far I hadn't yet so much as mentioned my hope that he and Vicky would sail for America earlier than planned.

'Before I go, there's something I wanted to talk to you about.'

'Can't it wait, Tommy? There's not much light left this evening. You'll be seeing me next Monday, anyway. We're going to see Charlie's film at the *New Paragon*, remember?'

'All I want to say is this. You make sure you go to America whatever happens. Can you leave before the end of the month?'

'Trying to get rid of me? You know I can't go swanning off just like that, Tommy. There's the forge sale to be finished, odds-and-ends to clear up, all manner of things to do yet. You wouldn't believe the half of it. It's why I'm stuck out here so late tonight. Anyway, you already know we're going, Tommy. We've booked our passages from Liverpool and Charlie's arranged everything at the American end. I wouldn't miss this chance for anything in the world. You know that.'

'Anything?'

'Anything. If the Brent flooded the night before, I'd still go. If there were riots in the Old Field Lane, I'd still go. Lord sakes Tommy, if the Martians came and invaded us like in that Wells' book you're so keen on; I'd turn my back and get myself off to America. You above all people should know how important this is to me.'

'And what if the invaders were sent from Europe, say by the German Emperor?'

'Tommy, we're leaving Greenford and going up to Liverpool on Monday the third of August. Two days later we'll be sailing to New York. You'll be there, waving us off from the dock. Remember? Now, please go home and let me finish my work. Otherwise I'll be stuffing candles in the candlesticks and finishing my work in the dark. I'll see you on Monday and we'll be off to the *New Paragon Palace* together. Be here at six o'clock and we'll give you a bite of something before we leave for Southall.'

John wouldn't listen to another word. He picked up his hammer and made as much noise as he could with it. I took this broadest of hints and went on my way. As I was walking back to the Old Field Lane, I knew with miserable certainty that John wouldn't make it to America. He wouldn't even make it to Liverpool, in all probability. I couldn't even be sure he and I would get to Southall on Monday.

Wednesday, 22nd July, 1914

This morning, and for at least the rest of the month, I'd keep well away from Horsenden Hill. Of this much I was certain: listening to Jet had done enough to ruin my life.

The number of callers at the shop had at last started to fall off a little. Although I was still well behind with my orders, constant late-night working meant I didn't have quite the disgraceful backlog weighing me down as it did a few days ago. I knew I should really have used this morning's bonus time to catch up with a few more of the overdue orders. Instead I'd decided to frame the *Haiku* I'd written for Theresa Hartson's birthday.

The last thing I expected was to be allowed anywhere near Betham House on this coming Saturday or on any other day in the future. I'd have to ask John or Vicky to get Nellie Hodge to sneak a package into the house. Nellie could easily leave it somewhere Mrs Hartson would be sure to find it. Mazod or her guardians might well smash the frame as soon as they saw who it was from but a promise was a promise; I'd told Mazod I was going to give her aunt this birthday present and this was what I planned to do. Besides, they might even... but who did I think I was fooling?

It was a nearly a quarter-to-eight by the time I'd finished the copperplate calligraphy and the framing. I'd used the same pale green card as for Mazod's *Haiku* nearly three weeks ago. The result was, if anything, neater. But when I looked at the lines of verse on it:

> *Moonlight on water*
>
> *hidden by cloud. Carp flick tails*
>
> *and summer is gone.*

they seemed awkward and lumpish. I felt hollowed-out and drained: my brief summer had ended yesterday, not in 1907.

I realised I'd only tried to write the *Haiku* because I'd thought Mazod would like it. Well, the other things I'd done hadn't pleased her at all. And she thought I wanted to go to Paris to satisfy my carnal urges! Nothing could be further from the truth. Now I didn't want to go to Paris at all. How could I have thought, even for a second, that I should?

I felt like smashing the frame and ripping the green card into a thousand pieces. In the end, I decided to go through with what was probably going to be a pointless exercise and to wrap the gift up in a piece of brown paper. At least then I would get this awkward verse, and the disappointment it represented, out of my sight.

Just as I'd decided to do this, the muffled bell above the door started to waggle insistently. Who could this be? No-one would be expecting me to unlock the street door for another hour at least. The bell-clapper moved again, so furiously this time that its impromptu gag dropped to the floor. Suddenly, the infuriating tinkling sound rang out through my shop at full volume. The effect couldn't have been worse if somehow the Sunday bell of Holy Cross Church had been transported into my presence. I covered my ears with my hands.

'All right, all right! I'm coming!'

The bell kept ringing maddeningly as I fumbled with the key to the inner door.

'I said I'm coming!'

It was Jet. Unmistakably, I could make out the outlines of the shoulders of his blue suit, the round face, and the pale auburn hair protruding from beneath the brim of his carelessly-worn hat. As I made out the shape of this too-familiar figure through the small window in the street door,

an icy shiver passed through my whole frame. Still he continued to pull insistently at the bell, even though he must have seen and heard me struggling to open the door.

'What do you want? Why have you come here to my shop?' I demanded, flinging the door wide.

He looked about him and pushed past me into the interior of the shop without ceremony. His face was red and he was breathing heavily. It was some moments before he could recover himself enough to speak.

'...ran all the way from the Hill,' he gasped. 'You weren't there!'

'I told you on Monday I wouldn't be. This madness is over.'

Again he struggled for breath. He must have been running Hell-for-leather.

'I haven't got much time to talk. You're the one who has to do this. Your life is the only one on a time node I can reach. My father is sure of his facts. If you don't go to Paris, millions of people will die. Your friend... your son.'

'I've heard all this before. You and your father have wrecked my life already. I refuse to listen to another word.'

This did not silence him. Breathing heavily, he continued doggedly, ignoring what I'd said.

'Tomorrow, Baron Giesl, a representative of the Austro-Hungarian government, will serve an ultimatum to the Serbian government in Belgrade,' he said. 'This will be the first major step towards the Great War that's on its way to the world. You'll be able to read about the Baron's visit in your newspapers on Saturday morning. Then you'll have to believe what I'm saying to you.'

'No more of your tricks from the future. I don't want to listen. Anyway, I've never once said I didn't believe you.

I've told you: you've picked on the wrong ancestor. This one has other things going on in his life. You and your father will have to think again.'

And where were those "*other things*" now? My hoped-for future with Mazod was over before it had begun. This was thanks to the interference of Jet and his father.

'Russia will mobilise in defence of Serbia,' Jet continued breathlessly. 'Germany will back Austria-Hungary. France will join with Russia. We'll get dragged into the war.'

I stood behind my counter and folded my arms, making no reply. It wasn't for me to try to change history. My own life was in ruins; I could think of nothing else at that moment.

'Please Tommy. Please.'

Still I said nothing, even though I wanted to scream out loud.

'Please.' It was too late, and he knew it. His image flickered, and then went out like a guttering candle. I was reminded above all else of one of those unreliable new electric bulbs giving up the ghost.

*

It was a long time before I could persuade myself to settle behind the shop counter and resume the task of packaging the frame. Over the last few weeks, my dull life had become all too full. Mazod had briefly illuminated it; I now knew absolutely she was the love of my life. At more or less the same time, the malign influence of Jet had complicated things. Complicated! That had to be the understatement of all time. Now I was sure I wouldn't be seeing either of them again, or at least I'd only see my lost – lost almost before I'd begun to win her – as a cold, distant figure. It would be much worse than not seeing her at all.

I was in a trance as I finished wrapping the frame, tying the string and applying the sealing-wax as if in a dream. Then I spent a long time wondering what I should write, or indeed if I could dare to write anything at all, on the outside of the package. If I wrote a too-friendly message, it would surely be interpreted as sarcasm. If I wrote nothing, or only my name, I would myself feel this to be too aloof. In the end, I picked up the same pen I'd used to write the *Haiku* and wrote in my best copperplate "To Mrs Hartson. On your birthday."

I wasn't sure whether to add "From Tommy"; "Tommy"; "Thomas Green" or "TP Green, Esq." I was coming to the conclusion it would be better to add nothing – Mrs Hartson would soon enough realise who'd sent the gift when another ringing of the bell above the door caused me to start violently. My hand, still holding the pen, was poised above the package and its sudden movement left two small ink-blots on the brown paper.

'*Jet has come back from the future to haunt me,*' I thought immediately. But, no, through the inner door bustled the figure of Mrs Raven, wreathed in smiles.

'I know you'll forgive me Mr Green. But I saw that young man come in and I simply had to call over to – but where has he gone now?'

I thought quickly. If I said he'd merely gone upstairs for a moment, Mrs Raven would quietly insist on waiting for him. She'd seen him come into my shop and would be sure he couldn't have left it in the space of a minute or two unseen by her.

'He's gone upstairs to lie down. He's – he's unwell.'

'Oh, I've just been watching him running all the way along the Old Field Lane,' she said. 'He didn't look at all unwell to me.'

'That's it,' I said, inventing desperately. 'He's tired out, rather than unwell as such. Jet has had to go and lie down.'

Mrs Raven looked at me quizzically. She stood up on tip-toes to peer over my shoulder. I was conscious of the open door behind me and had a strong urge to glance back over my shoulder. From the look on Mrs Raven's face, I even thought she'd be able to see Jet standing there, smiling his round-faced smile at her and making a mockery of my words. Somehow, I resisted the impulse to look behind me. At last she spoke again.

'Well, to go by the way he ran like a hare down the Old Field Lane to your shop, perhaps I shouldn't be surprised if he's tired. He ran all the way down to your shop as if the Devil and all his hordes were chasing after him. Carrying his hat in his hand to stop it blowing off, he was. It looked quite comical from where I was watching through my shop doorway, if you don't mind my saying so.'

Mrs Raven looked at me, clearly expecting a response. I made none and she continued.

'When he reached your shop, he looked at your nameplate, put his hat back on, and straightaway started tugging at the shop bell as if he were trying to pull it off the wall. I was going to come over to make him stop, because I thought you'd still be up the Hill on your usual morning walk. It surprised me when you did open the door, I can tell you.'

She looked down at the ground. I could see her wondering whether or not to give voice to the question that was at the front of her mind. After a moment she spoke again.

'Bit sudden though, wasn't it? What I'm saying is that he must have gone upstairs within a few minutes of coming in your shop. It's got to be a bit strange. I mean to say, his

coming to see a cousin he couldn't have seen for years, and then going straight up to bed as soon as he gets here. Very odd, I'd call it. Especially when he seemed so determined to make you open the door.

'I hope you don't mind me saying these things, Mr Green? But we've been friends for years, the two of us.'

I didn't answer. What could I say?

'It's not that I'm nosy or anything, mind, but are you sure everything is all right?' she persisted, when she saw I still wasn't going to answer. 'I know you've been working very hard lately - I've seen your workshop light on until very late – and I'm sure you'll have a lot on your mind what with Miss Betham and all.'

'No, no. There are no problems. Thank you for asking.' Everything was far from being right, but there was precious little Mrs Raven would be able to do about it.

A thought occurred to me. 'Why do you call Jet my cousin?'

'Jet, you say? That's a funny – I mean, unusual – name.' She looked abashed at her verbal slip but I could see she was determined to see through her enquiry.

'Well, he's surely got to be your cousin. He's the image of you, except for the rounder face and his colouring. In fact, I'd have sworn he was your brother, but I know for a fact you haven't got one.'

'No, he's a more distant relative.' Was a remote descendant a more distant relative than a cousin?

'He's a well set-up young man, anyway. Very handsome, I must say, and the smart blue suit he was wearing was a treat. Those brown boots he had on were beautifully polished, too, I must say. Immaculate, he was. You could see at a glance how expensive those clothes must have been. He must be doing all right for himself. What does he do?'

'He's an archivist.'

'What's that?'

'Somebody who looks after old papers.' For a brief moment I tried to imagine Jet working away at dusty files. I couldn't. It was more likely he worked with those damned *computers*.

'I do think it's a bit odd, all the same. The way he's acted, I mean.'

Again I made no response apart from trying to force a polite smile for Mrs Raven.

'I mean, the way he came into your shop and went more or less straight upstairs. It's not the sort of thing you'd expect.' She was insisting far beyond the limits of politeness, but I could see she was doing this from unselfish motives. All the same, it was getting harder to take. 'After all, he couldn't have seen you for a long time. It must be ages since you've been away from Greenford. Are you sure he'll be all right upstairs there?'

'Oh, he's seen me often enough. Not here in the shop, that's all.'

'Do you think he'll be coming downstairs soon?'

I sensed Mrs Raven was starting to give up on her interrogation at last. Not a moment too soon; it was beginning to wear me down and I felt like I felt like screaming at her to go away and leave me in peace.

'No, he was very tired. I'll bring him over and introduce you tomorrow, if you like. How about that?'

'Yes, it would be lovely. I'd like that.'

'If you're quite sure there's nothing I can do then,' she said. 'Anything at all?'

'No, I – wait a minute, though.' My eyes alighted on the package. Perhaps I could get Mrs Raven to drop it off for me? If I got Nellie Hodge to leave it around Betham House for Mrs Hartson to find as I'd first planned, something might go wrong. I wouldn't want Nellie to get into trouble.

'There is one thing you might do for me. If you're quite sure you wouldn't mind, that is? On Saturday, would you mind dropping this off at Betham House for me?'

I handed her the small package. She looked at the inscription on it doubtfully.

'This is a birthday present for Mrs Hartson, isn't it? I thought Nellie Hodge had told me you'd been invited to go to the house yourself on Saturday?'

So, my every doing was the subject of tittle-tattle in the village already, was it? Goodness knows what the gossips would say about me when more of the story reached their ears.

'I – I might not be able to go myself.' She looked at me questioningly as I said this. 'It depends on what Jet has got planned,' I improvised. It sounded weak even to me.

'But you could always deliver it to Betham House before...' Mrs Raven's expression changed. 'No, Margaret Raven. You've bombarded poor Mr Green with more than enough questions for one morning.' She wrinkled her face, miming the buttoning-up of her mouth.

'Yes, of course. It will be a pleasure to drop the present off for you on Saturday, Mr Green,' she smiled. 'Don't you forget to bring your cousin around to meet me tomorrow. Bring him around this evening, if you get the chance. I'll take myself off then, and leave you to it.'

At last she went. I felt exhausted by all the lies I'd told. Yes, Mrs Raven, you certainly have quizzed me enough

for one day. And I didn't know your first name was Margaret.

Thursday, 23rd July, 1914

Mazod had never actually *said* I shouldn't call around for her this evening. This was what I kept repeating to myself as I made my way along the Old Field lane towards Greenford Green. But I knew I was grasping at the flimsiest kind of straw.

What else could I do? Jet had painted an unutterably bleak picture. The only glimmer of hope he'd given me was when he'd said Mazod would become my wife. Such a thing seemed even more improbable now than at the beginning of the month, but some sort of reconciliation was the only thing I could think of trying to achieve. Either it was that or I'd continue to sit behind a locked shop door, hopelessly turning things over in my mind.

When I reached it, Betham House seemed calm and peaceful. There were birds chanting their evening chorus in the trees behind the garden, and even two late-flying bumble bees busy among the daisies on the front lawn. It was hard to see this idyllic scene and imagine the horrors soon to be upon us.

I walked up to the front door and tapped uncertainly on the impressive-looking brass knocker. Now, I felt even more nervous than when I had done this for the first time, though this evening my apprehension had a different quality. When I had knocked the door previously, there'd been excitement and anticipation at the root of my unease; this evening there was only despair. It was a long time before anyone came to answer the door. I wondered whether I should knock again. It was as well I didn't, because it was suddenly opened, framing Nellie Hodge. She looked at me, giving no hint of friendly recognition.

'Miss Betham says you're to wait outside the front gate. She'll be down to speak to you in five minutes.' She spoke as if I were a stranger.

And that was all she said. Then she looked at me briefly as if I were an unwanted commercial traveller and closed the door smartly. I thought it as well I'd asked Mrs Raven to deliver Theresa Hartson's birthday gift, rather than trying to use Nellie's services. I could only hope she and her sister Vicky hadn't yet spoken.

There was nothing else for me to do except wait outside the gate as Nellie had instructed. I was painfully aware of this wooden barrier shutting me off from Mazod and the world of the Hartsons. Still, at least Mazod had said she'd speak to me. My dread was that she'd want to do it in the company of the formidable Theresa Hartson.

Nothing happened for eleven minutes: I knew this precisely because I kept looking at my fob-watch as the minutes ticked by with agonising slowness. At last, I saw a yellow-clad figure through the coloured glass of the front door. Mazod was at least alone, but she did not emerge immediately. Instead, I could see her standing quite still. Perhaps she was steeling herself for the task ahead of her. Had it come to this?

Finally, she did step out of the door, and marched with brisk determination up the long garden path towards the front gate where I was waiting. As she approached, she gave the briefest of glances in my direction. In her look I could not read any kind of affection, nor yet dislike or hate, but rather an undisguised contempt. That was so much worse.

'Mazod –' I said, although I didn't know what I was going to say afterwards.

'Not here, Mr Green. Not with the servants watching. You've become their favourite subject of gossip as it is. I certainly don't want them to hear what I've got to say. Walk

on to the left twenty yards or so if you would. I'll be right behind you.'

Mr Green! And it saddened me to think I must now be cast in the role of arch-villain in the eyes of Nellie Hodge. It could only be a matter of time before she spoke to her sister. And Vicky would be sure to tell John whatever Nellie had told her.

All I could do was walk up the lane as Mazod had asked. I was keenly aware of her presence a few paces behind me. Less than two days ago we'd been walking out together.

'That will be far enough, I think,' she said.

I turned around. 'Let me explain,' I said. 'The Paris trip wasn't going to be at all what you think. I won't be going to go to France at all, now you've made it clear you don't want me to go.'

'You can go to Paris, Mr Green. You can go to Timbuktu if it's what you want to do. It's absolutely no concern of mine.'

'My journey to Paris was to protect our future. It was to save the future of everyone. I've had a visitor, do you see? He was a special visitor. He told me-'

Mazod's look stopped me in mid-sentence.

'Have you quite finished? I didn't come out here tonight to argue with you, or to listen to another word of your gibberish. I came to tell you what has happened to *me* since the last time we spoke. Are you going to listen? Because if you're not, I'm shall go straight back indoors again. When I've finished, I'm going to ask you a question, only one. I want you to answer me honestly. Is that agreed?'

'Agreed.' Mazod's expression left me no alternative. I knew a strong will lay beneath her feminine allure but I didn't expect her to present me with such an implacable face.

'When you told me on the Coston's Bridge about your plan to visit Paris, I was shocked and upset. Not only for the purpose for which you were going.' Here she held her fingers to her lips when I made to protest. 'But also because of the proposed timing of your disgusting adventure. You intended to be in Paris at the very same time Henry Trevithick was going to call on you. This is the man who holds the key to your future, I would remind you. A future that, for one foolish moment, I thought you and I might be sharing. Not now, Mr Green, not now. I must have been suffering from some form of temporary insanity to have even contemplated such a thing.'

'It's important to understand –'. The look she gave hushed me again.

'As I said, I was upset by what you'd said. Then I hurried home, as you know. I thought I'd controlled myself, but my Aunt Theresa could tell there was something amiss. That was when I lied to her; your actions led me to tell a lie to my aunt, Mr Green. To my shame I told her I'd been upset to find a dying bird in the Old Field lane. I thought she'd believed me.

'Then, yesterday morning, as she was saying goodbye to me before she went off to visit her old aunt in Hampstead, she suddenly held me tightly. "Mazod," she said. "I know you were holding back the truth from me last night." Then she told me not to worry, but that she wanted me to think about it quietly and tell her all everything when she returned to Greenford on Saturday morning.'

'I'm sorry you had to lie for me,' I said quietly.

'I didn't lie for *you*,' she said, eyes flashing. 'I did it because I was embarrassed at being taken for a damned fool by you.'

'That's the last thing –'

'About half-an-hour later,' she said, ignoring what I was trying to say. 'Archie – Mr Perkin – called in on his way to Harrow. I told him the whole story. Or what I then *thought* was the whole story.'

She looked at me accusingly. This time, I knew better than to try to say anything in my defence.

'You know exactly what I'm about to say, Mr Green,' she said. 'At first Mr Perkin didn't want to tell me anything. But then he had to admit that two weeks ago, he saw you when he was in Acris Street, over in Hanwell. He told me exactly what he was doing there, too. *He* told me the truth.'

She paused for a moment. Then she asked the question she'd said she would.

'Now it's your turn, Mr Green. What were you doing there? Would you care to tell me that now?'

At first I couldn't answer. 'I was seeing a woman friend,' I said at last.

Then I added something to make my admission sound a bit better. I was telling her what might be no more than a half-truth.

'It was time to say goodbye,' I said. I knew immediately it was stupid of me to have said such a thing.

'Liar! She was a common prostitute!'

'Rosie is more than a common prostitute,' I protested.

'Oh, you played draughts, did you? Then I must have misunderstood what I've heard about her. Tell me, does she charge for each game she plays?'

'Archie Perkin was there before me,' I said. 'He'd have paid her.'

'I know very well he did. Mr Perkin admitted as much himself, thank you very much. Men can't help making beasts

of themselves, sometimes. But he wasn't the one who was supposed to be walking out with me. *You* were.'

'Mazod-'

'Be silent Mr Green. And don't call me by my first name, if you please. In fact I'd much prefer it if you didn't address me or even look at me ever again.'

'All I wanted was –'

'My thought was to tell you myself exactly why this is over,' she said, interrupting me. 'What an absolute idiot I've been. Mr Perkin is going to call around and give your ears a box when he returns to Greenford on Saturday. And he'll be sure do it, have no fear. He was the welterweight champion for his year at Cambridge, in case you didn't know. Now, you and I have absolutely nothing more to say to each other.'

She turned on her heel, and strode out of my life.

*

The Old Field lane had never seemed so long before. I trudged back – to what? I couldn't say. When I arrived at my shop doorway, I stood outside aimlessly, looking at my watch. It was only a few minutes after eight o'clock and I couldn't bear to go inside yet. Throughout the day I'd sat there hopelessly with the door locked and the "closed" sign hanging on the window. Several times there'd been a maddening ringing of the bell, or tapping on the window. This would have been customers come to collect their overdue orders or, worse, Mrs Raven calling to see Jet, so I tried to ignore the sounds.

I walked to the top of the Old Field Lane and turned left, still not really knowing where I was heading. Should I call into the *Red Lion*? My last visit there had been uncomfortable. Arnie Stannard should have joined his regiment by now, so I could at least feel safe he wouldn't be there this evening, but I'd never much liked public houses

anyway. Should I simply drift towards the River Brent or
Perivale? It seemed so pointless; as empty as my life was
right now.

For a moment I even wondered if I should walk up
Cuckoo Hill to Hanwell and Rosie. But no; I'd never called
at her house in Acris Street without an appointment.
Anyway, she didn't see men in the evenings. For all I knew, I
might be an intruder upon some domestic scene: her front
door might be answered by the imagined Mr Rosie. I
shuddered at the thought. Besides, hadn't Rosie said
something about going to see a sister?

So, as perhaps I knew I would from the beginning, I
decided to call in at the forge to see John Jakes. I could only
hope Vicky and Nellie had not yet spoken.

*

'Well, what brings you here again?' said John, as soon
as I stepped into the small parlour. Vicky went straight into
the kitchen, banging pots around noisily. 'We don't see you
for weeks and then you can't stay away.' John grinned as he
said this, but I sensed some restlessness behind his words.

'Nothing really. I thought I'd call in to see you. You'll
be off to California before long, after all.'

'John...' said Vicky, appearing in the doorway.

'Look, Old Son,' said John, looking very
uncomfortable. 'Vicky and I really haven't got much time
tonight. This solicitor chap is going to be calling at half-past-
eight. Even more forms he wants signed, if you can credit it.
These lawyers, eh? So, if it's not important, maybe you could
call around another time?'

Framed in the doorway, Vicky pursed her lips
anxiously at me, obviously keen to see me on my way.

'I'll come to see you some other day' then,' I said.

'Look,' said John. 'I'll be seeing you on Monday anyway, but why don't you call in on Sunday as well? I'm sure I'll have cleared up most of what there is to sort out by then. You can have a bit of lunch with us. Unless, that is, you plan to go to Church again?'

'No, I won't be going to Church this week.'

Nor would I be going on the week after, nor ever again.

Friday, 24th July, 1914

I knew if I were to remain brooding about Mazod behind the counter of my shop for another day, I'd go mad.

My original thought was merely to go to Lamb's bookshop in West Ealing to see if I could read more about the Frenchman, Jean Jaurès. Old Man Lamb had always been happy to let me browse among his piles of books so long as I ended up purchasing something. I was glad to have some plan of action, however weak and pointless it may have been. But, as I was stepping out onto the pavement to lock the outer door of the shop, a man running down the lane collided heavily with me, almost causing the two of us to go sprawling into the road.

'Sorry!' he said, looking at me as if I were the one at fault.

'You!' I said.

Only it wasn't him. The smart dark blue suit, the Homburg tilted jauntily back on his head, even the highly-polished brown boots were the same, but it wasn't him. I glanced down at his hand, half expecting to see the ornate Turkish ring. But, unlike the other, this man wore a pair of pale yellow gloves.

I wanted to urge him to rip off those gloves. Perhaps I had some thought to see if beneath the gloves he was wearing an identical ring to the one in my pocket, ready to deposit in the London and County Bank. If my ring hadn't been tightly tied with brown paper and sealed with a generous helping of wax, I might have been impelled to pull it out there and then to compare it with the one I imagined was on his finger. But this man wasn't Jet, or at least he wasn't the Jet I knew. His face was longer and thinner, the features different and more

angular. Although he also had pale blue eyes, they shone with a subtly different light.

'What's your name?' he demanded of me, looking at the brass nameplate outside my door, rather than at myself. His way of speaking was different from that of the young man I knew.

'I could ask you the same question,' I said. 'After all, this is my shop and this is my village.'

He looked at the nameplate again.

'Well, this is a stroke of luck,' he said. 'You're Tommy Green, aren't you?'

'That's what the nameplate says, doesn't it? Now, would you mind telling me exactly who you are?'

'You can call me Jet.'

'Jet? You're Jet Green? But you look so different.' I felt quite disorientated when he answered.

'No. Why do you say that? My name is Jet Perkin. I'm looking for – for my cousin.'

I looked at him, not knowing what to say.

'Do you know where he is?' he urged me. 'Archie – Archie Perkin.'

I did know where he was. Mazod had told me this much. But who was this man? And could he really be Archie's cousin? I didn't believe this for a moment.

'I said,' he repeated, speaking slowly as if he were addressing an imbecile. 'Do you know where Archie Perkin is?'

'He's in Harrow. He'll be back tomorrow.'

'Tomorrow?' The newcomer looked concerned. 'I'm already much too late. Today is the twenty-fourth, isn't it? That only leaves me a week.'

Jet Perkin was in a rare lather.

'Today is the twenty-fourth of July, as you say,' I said, imitating his tone. 'That's not much more than a week away from the Great War that's going to consume Europe and much of the rest of the world. I know all about what's going to happen.'

I don't know what it was making me tell him this, but saying these words, in an almost journalistic way, suddenly made it sound all the more terrible to me. The effect on the new Jet was electric. His eyes widened and he stepped back half a pace, looking at me with alarm.

'How do you know this?' he said.

I was tempted to answer "because you told me", but I knew this wouldn't be the right thing to do. Neither would it really be true.

'I had a dream,' I said.

He studied me, with something in between respect and fear in his eyes.

'Look, I can't imagine how you know this, but I need to see my – my Archie Perkin. He's the only one who can do anything to prevent the worst of from happening. I've only got a week to get him to do it.'

'I've told you. He's away in Harrow and won't be back until tomorrow. You'll have to wait until then, or else get yourself over to Harrow.'

'I haven't got time for either. Look, I'm going to have to trust you. After all, you are Archie's best friend.'

Why did the two Jets keep saying these things? 'Go on,' I said.

'Let me warn you; I'm going to tell you things that will make you think I'm quite deranged. But this is an emergency. I have to do it.'

'Try me,' I said. 'I may not be as surprised as you think.'

'I live – I live in Seattle, in the United States. That's a long way from here. I've come from my home to get Archie Perkin to stop a murder before the war you dreamed about starts. It will be a war so terrible as to disfigure the whole of the twentieth century. Please hear me out.'

'I'm listening,' I said. 'But you'll find I know more of the story than you think. This country you've come from: it's not really America, is it? The likes of us would call it "2046", wouldn't we?'

Jet Perkin gaped at me. 'How can you possibly know that? I do live in Seattle, but in the Seattle of 2046.'

'Never mind how I know it. Now, suppose you tell me the plain unvarnished truth and stop trying to invent silly stories you think a man from 1914 will believe. I want the whole truth, mind. I know you've come from the future. Your father sent you, didn't he?'

His mouth drooped open further.

'I thought so,' I said. It was good to have the upper hand over a man from 2046 for a change. 'Now, don't waste any more breath and tell me plainly what you've come here to say.'

He looked down the lane, then at me, blinking uncertainly. It was easy to see that he wasn't very bright. At last he spoke.

'My father conceived of a plan to alter history. His idea was to make the Great War shorter so it wouldn't have so many awful repercussions throughout the century and into our own time. He knows about time travel, my father. Many

say he has the most brilliant mind of our times.' He looked at me, trying to gauge my reaction to his words. I tried to remain sanguine.

'Yes, I know all that, too. But, tell me, why have you waited until so late in July to come to 1914?'

'That's the puzzling thing, don't you see? My father has tried to send me back to dates much earlier in the month, and even into Archie Perkin's youth so I could do some imprinting, but this is the earliest date I could reach. My father can't understand what the problem is.'

'Maybe someone has left a boot-print on the timelines,' I said.

I don't know what made me say this. Insight? Intuition? An inspired wild guess? But the effect on Jet Perkin was immediate. He looked wonderingly at me, and there was unmistakable panic in his eyes.

'What? What are you saying?' Then he looked at the contraption on his wrist. It was like the one Jet Green wore, although silver in colour.'Oh my goodness!' he cried. 'My time's almost up. I'll have to go. I'll see you tomorrow. Or I might be seeing Archie Perkin. It depends on what my father has to say.'

Then, with not a word more, he turned and ran down the Old Field Lane, a sprawling, ungainly run, in the direction of Greenford Green.

'You won't be seeing me,' I muttered to myself. 'I'll make sure I have other plans.'

*

The idea of what I should do had already been taking root in my mind. Now, the odd encounter with Jet Perkin filled me with a resolve I hadn't felt for days. I was so engrossed in my thoughts as I turned to walk on towards

Ruislip Road, I almost didn't see the person coming towards me. It was Mrs Raven.

'Why, Mr Green. We don't often see you coming in this direction at this hour of the morning. I was watching you talking to that cousin of yours, thinking I'd have a chance to meet him at last, when all of a sudden he raced off back down the lane again. Doesn't he ever walk anywhere? It's a very funny way to act, if you don't my saying so.'

A look of consternation came across her face as she gazed over my shoulder in the direction Jet Perkin had run.

'What's wrong, Mrs Raven?' I asked her. But I could guess what it was.

'Well, I was watching your cousin running down the lane, thinking how awkward he looked. He seemed to be quite different from Wednesday; I'd have described the way he ran then as athletic, today it was so awkward-looking. Then I took my eyes off him – barely for a moment, mind – to talk to you. And then when I looked back again he was gone. I can't understand it.'

'Oh, he's always disappearing off somewhere or other. I shouldn't worry about it if I were you, Mrs Raven.'

'But there was simply nowhere he could have gone. The lane is very long and straight where he was running. It was almost as if he'd vanished into thin air.'

'Maybe he did exactly that.'

'Now, don't be silly, Mr Green. It was only a figure of speech I was using.'

For a moment I had the urge to tell Mrs Raven the whole truth. Then I quickly realised she'd think I was insane. At long last I'd decided on the task ahead of me, and could do without further complications at this stage.

'What I mean is, he probably dived into one of the fields,' I said, instead. Another lie.

'Does he often do things like that?' asked Mrs Raven, clearly shocked.

'All the time. He does some very odd things.'

'Perhaps it'd be better if I didn't speak to him.'

'Oh, he's quite harmless. No more than a bit eccentric, nothing worse. He'll be back tomorrow. Speak to him then, if you see him. Even if I'm not around myself.'

'If you're sure...'

It was hard for me to keep a straight face as I tried to imagine what Jet Perkin and Mrs Raven would make of each other, if they did meet. It was a shame I wasn't going to be around to see it. Despite the grimness of the situation, I was pleased I could still find some levity in it.

'Well, I must bid you good day, Mrs Raven. I'm off to Ealing.'

'But you're due to be opening your shop in half-an-hour.'

'Something very urgent has come up, I said. 'I won't be opening the shop today.'

'Ah,' said Mrs Raven sagely. 'You don't have to tell me. It's because of Mr Trevithick, isn't it? That's why you didn't open up yesterday. *I* know.'

Henry Trevithick. I'd all but forgotten he was supposed to be coming to see me in less than a week. I didn't answer Mrs Raven. Instead, I merely gave her a conspirator look and raised my hat. Then I set off in the direction of Ruislip Road. Despite everything I was feeling surprisingly jaunty. Perhaps this was because I'd finally decided what I should do.

*

The best thing about Mr Lamb was that, if you were in the mood for it, he'd happily leave you alone for an hour, though never a second more, to browse among his untidy piles of books while he sat in the front of his shop puffing contentedly on his pipe.

Today was such a day. I could have as easily, and more sensibly I suppose, have asked Mr Lamb to turn up something specific to my needs. He'd have enjoyed himself clambering over the piles of books, like some bibliophile monkey. Very likely he'd have returned with exactly what I wanted. Today, though, I'd been happy to outline my wishes in vague terms, and to let him point with his pipe-stem toward three huge stacks of books in the recesses of the shop.

Many people can't stand it, I know, but I like the musty smell of old books. It grew all the stronger as you penetrated further into the interior of Lamb's Bookshop. The books on European politics had been firmly relegated to the back of the shop, so I was getting my full quota of olfactory stimulus as I looked for what I wanted. I'd not had the chance to indulge this pleasure for some months, due first of all to my financial difficulties, then to preoccupation with Jet's visits and my abortive courtship of Mazod. I wanted to make the most of it this time.

After some fifty minutes of searching, I began to think I'd nevertheless made the wrong choice. I could find few books on European socialism among the stacks to which Mr Lamb had pointed, but I didn't want to have to ask him to search for the right book. This I would have seen, illogically perhaps, as a small defeat.

Then, as I was about to give up hope, my hand fell on a neat, brown-covered volume called *The New Europeans of the Left*, by an author called James Coke. It was only three years old, so shouldn't need careful dusting like so many of my purchases from the bookshop. Part two of the book

consisted of individual short chapters on the leading European socialists. Of the Russian socialists I'd seen in London seven years ago, I noticed that only Lev Bronstein merited a chapter to himself.

A photographic portrait gallery of a few of the politicians appeared on the centre pages. There were pictures of Rosa Luxemburg; Sydney Webb, Karl Liebknecht and others. And there, very prominently, was what I'd really been searching for: a picture of John Jaurès. The caption told me the photograph had been taken in 1909, immediately before the conference of something called *Section Française de l'Internationale Ouvrière*. This was recent enough to serve my purpose.

Auguste Marie Joseph Jean Léon Jaurès, as I learned his full name was, had been born in 1859, a few years after my father, and so would have been about fifty at the time the picture was taken. Even in a photograph, it was easy to see the politician had penetratingly intelligent, light-coloured eyes. He had fair- or grey-coloured hair, and was a burly, bearded figure. A lot of faith had been placed in this one person by my visitors from 2046, I couldn't help thinking.

'Have you about finished, Mr Green?' Mr Lamb, emerging from behind the stacks of books, was right on time.

'Yes; I've found exactly what I want.' I held up the brown-covered book to show him.

'Mmm; don't know about that. We get a lot of call for books of that order.'

I chuckled inwardly. I was well aware there'd be a virtually nil demand for a book of this type. That was why it was kept here among the piles of political volumes at the back of the shop. And Mr Lamb very well knew I'd be aware of this. Still, this was a ritual we had to go through every time I bought something from him.

'How much, then?'

'It'll cost you seven-and-six, a book like that. Fine book, that is. Good cover and everything. Anyone else but you and I'd be asking for eight bob.'

Mr Lamb would have been expecting me to bargain with him as usual. I could have happily lowered his asking price to three or four shillings. So he was surprised, and probably a bit disappointed, too, when I pulled out three half-crowns and dropped them into his palm.

'You've got a bargain there,' he said.

My purchase was no bargain: I'd paid only a shilling under the original publisher's price. But he was a good enough businessman to talk about the value of the book with conviction. Mr Lamb was probably regretting not pricing the book at ten shillings.

'Well, I'll be off then,' I said. 'It's a pleasure, as always, Mr Lamb.'

'You'll be off back to your shop in Greenford? We don't usually see you on a Friday. Wednesday's your more usual day for calling.'

'No, I've got to pay a visit to my bank first.' I didn't tell him I intended to withdraw every penny of cash I could, as well as depositing the Turkish ring.

Saturday, 25th July, 1914

It was incredible even to think it but I knew it would be entirely up to me to do what I could to alter the appalling history of the twentieth century. This was something I only now fully understood, even though Jet Green had been telling me so forcefully and for so long. And maybe, I could allow myself a sliver of hope: I might somehow find a way of recovering Mazod's love for me along the way, if things went well. But would they even begin to go right?

Only yesterday, as I was leaving Greenford for Lamb's bookshop, I'd finally decided the detail of what I must do. My only course of action would be to go to Paris and do my best to stop the murder of John Jaurès. It sounded like the tallest of orders, even if Jet Green had told me exactly where and when the killing was supposed to take place. He'd even given me the name of the person who'd commit the assassination, an unbalanced nationalist by the name of Raoul Villain.

How I wished now I'd had the sense to let him give me details of his father's plan for preventing the death, or even to say precisely how the murder was to be committed. The worthless knowledge that in one of his pockets Villain would be carrying two typed pages of Maeterlinck's *Blue Bird* mocked me.

This was an intimidating thing; my intention to go to Paris. I couldn't speak a word of French. It would be the first time I'd been out of the country, or even for any great distance away from Middlesex and London. And it was a journey I'd be making alone. Jet Green had promised he'd go with me, but I could hardly expect Jet Perkin to be there in the same way.

Not that I'd want this bewildered young man to accompany me. Anyway, the new Jet seemed to think any chance for salvation lay with Archie Perkin. Let him think

that; I could only hope neither of the Perkins would get in my way.

It would be hopeless for me to attempt to see Mazod again at all soon. I'd be sure to make an even worse mess if I did. There seemed to be little left for me in Greenford at present. And, who knows, could it be I'd really be able to succeed in cutting short this terrible Great War as Ollie Green had planned? I would be saving millions of lives, including that of my unborn son. If I were still to have a son, that would be. I found the idea hard to comprehend as I surveyed the ruin of my life.

If the war did end in 1915, I wouldn't be incarcerated in Hanwell in 1917, either. John Jakes would go to California instead of dying in Belgium. But I have to admit the primary thought driving me on was that an earlier end to the war would somehow give me more chance of making amends with Mazod. I couldn't see how this might work out but didn't care to examine the idea too closely.

So, it was with a faint glimmer of hope as well as with trepidation that I packed the ancient carpet-bag, all I'd be taking to Paris. For the first time in weeks I felt in control of my own destiny. Being pulled this way and that from the future had been bad enough. Managing my courtship of Mazod so hopelessly had been worse. And the knowledge that this wonderful girl had been doing her best to make things easier for me was hard to accept. At least now I knew my destiny was firmly in my own hands.

There were three things I still had to do after attending to my luggage. I drew out one of my last remaining sheets of note paper, and started to pen a short note in my best copperplate:

'*Dear Mrs Raven*,' it read. '*I have to go away. This isn't something I can explain now but I promise to tell you everything I can when I get back to Greenford in August.*

You've always been a good friend to me, even though I'm sure I've often been a disappointment to you.

'Could I ask you to do one more thing for me? When you see him, would you please tell Jet not to follow me to Paris? This is where I have to go. I'd like to thank you for your help and kindness over the years. It means so much, believe me.'

I read what I'd written and wondered if I should leave Mrs Raven some sort of message for Mazod, although quickly decided this was something I could only sort out myself. Was I also going to ask Mrs Raven to say a word to Henry Trevithick in explanation for my failure to be at the meeting about the future of my business next Thursday? Or even to say why I might not be able to go to the HADs meeting? No. So I signed the note off *'Thanks. Love, Tommy Green'*. I hoped Mrs Raven – Margaret – would like that. She deserved it.

I sealed the note in an envelope, addressed it to 'Mrs Margaret Raven', and then set about the more difficult task of writing a letter to John and Vicky. It would have to be longer than the one to Mrs Raven. Even before I put pen to paper I knew it wouldn't be easy to express what I wanted to say. This wasn't the only reason the letter took me so long to write. I was dissatisfied with the result when I read it:

'Dear John and Vicky,' it read, *'First of all I'd like to tell you both how much your friendship has meant to me ever since we were children together. This short letter is to say let you know I have to go to Paris on some very urgent business. It will be the most important journey of my life. I can't begin to say in a letter like this what it's all about. Nor could I expect you to understand if I called in to see you at the forge and tried to explain. Please forgive me for giving you only half a story in writing and believe me when I say this is all I can do for now. When I get back from France I'll do my best to explain everything.*

My visit to Paris means I won't be able to call in on Sunday for a meal. I deeply regret not being able to see the Charlie Chaplin film with Joh, as well. I know this film is so very important to you, John, and I'm so sorry I won't be there watching it with you. Please, please, believe your friend Tommy.'

Above all I was aware that, despite what I'd written, there could be no excuse for me not calling into the forge to say goodbye to my friends in person. But how could I have begun to explain to John I was going to Paris instead of to the Chaplin film? He would never understand. Who could blame him?

This letter would have to do for now. It was better than nothing at all, if not by much. I read it again and added a postscript: *'PS: PLEASE make sure you go to America at the beginning of August, no matter what happens.'* And what would happen? It might be all up to me now.

On this envelope I wrote the full postal address and sealed the letter inside it with a heavy heart. I'd have to buy a postage stamp in Ealing and this made it seem all the more impersonal.

Letters written and bag packed, I was left with one final task in the shop before I set off. There were still a few pieces of the pale green card under the counter, so I picked one up and, using my thickest pen, scrawled a message to Jet. Which Jet would that be? Jet Perkin, I presumed. All it said was *'Gone to Café du Croissant in Paris, Jet. Leave it to me. See Mrs Raven in the newsagents'.*

I didn't so much as sign the card, merely hung it up beneath the "closed" sign. And then I stepped out in the street, locking the door behind me. The knowledge that I might be doing this for the last time chilled me. My journey to Paris was to try to stop a murder: it might be me who took the bullet.

*

Raven's shop was empty of customers. I'd hoped there would be some; then I'd have the opportunity to deposit the envelope on the counter before making a rapid exit. Unusually, Mr Raven rather than his wife was alone behind the counter. There was nothing else for it, so I walked up to him and handed the envelope over.

'Would you be so kind as to give this to Mrs Raven?' I said, as matter-of-factly as I could.

He stared hard at the envelope in his hands.

'What's this?' he said.

'Only a short note'.

'Is it about the HADs meeting?'

I thought he was acting oddly as he eyed the name on the envelope.

'No, it's not really about the meeting,' I said.

Why was he behaving so suspiciously?

'Because if it is, you should know Mrs Raven and I have always done everything for our business together. You should have addressed this here letter of yours to the both of us.'

'It's not about HADs. It's a private matter.'

'A private matter, you say?'

His brows knitted. I began to regret using a Christian name on the envelope, and signing "love" on the letter: I had visions of him ripping open the envelope in a fit of unwarranted jealous rage. This was the longest conversation I'd ever had with Mr Raven. It wasn't one I wanted.

'Look, it really is nothing. I have to go away for a few days and I wanted Mrs Raven to do a small favour for me

whilst I was gone. There's no more to it than that. I'm sorry I didn't address the letter to the two of you. You can open the envelope if you like. If you don't think Mrs Raven would mind, that is.'

Mr Raven continued to stare at the envelope, saying nothing further. I turned and left the shop in silence, grateful to be away from Greenford before Archie Perkin called to display his pugilistic skills. My last memory of the village in that July was of passing John's forge, from which the sound of hammering was emerging. I wondered if the letter I was going to post to him later would be in any way adequate and was tempted to go in to say something to my friend, but dared not.

*

In such a hurry was I that I delayed getting a newspaper until I was safely on the Chatham side of the newly-refurbished Victoria Station. I thought it was odd that they hadn't tried to unify the main termini for Europe five years ago, but my search for news soon subordinated such idle speculation. None of the worthwhile organs seemed to be available; there'd been something of a run on them among the London crowds, so the newsagents kept telling me.

Eventually, I was able to track down a copy of the *London Mercury*. This was hardly the place to look for reliable international news, but it would, I hoped, be better than nothing. On page three, there were four column inches reporting the news from Belgrade. At six o'clock on the day before, Baron Giesl, the Austro-Hungarian minister, had delivered an uncompromising note to the Serbian Government. This was exactly what Jet Green had told me to expect.

The note from the Imperial Government apparently made all manner of demands of the Serbs following the murder of the heir to the throne in Sarajevo. The reporter, a man called Graham Henderson, wrote in a short

accompanying commentary that the outraged Serbians had appealed to the Imperial Russian court for support and protection. *Would Russia fight in a Serbian quarrel?* The excited Henderson had concluded his short piece with fine rhetoric.

According to Jet Green, the answer to Henderson's question was going to be "yes". The consequences were going to be dire for every one of us.

<center>*</center>

Although I remembered being told that the South Eastern Railway had bought out the London, Chatham and Dover Railway some years before, nobody could have told the old company this, because the ancient compartment in which I found myself sitting alone was still painted in the less-than-smart black of the former railway company.

It was a full half-an-hour before the train steamed out of the station. I relaxed and watched idly through the carriage window as Greenwich, Woolwich and then Dartford trundled by, looking sleepy and peaceful in the afternoon sunlight. When the coach rolled slowly out of Northfleet, I realised this was the furthest I'd ever been from home. Despite my time as a journalist, the greatest distance I'd travelled was in my boyhood. I'd been taken by my mother to visit a Great Aunt in the riverside town that was a destination for promenaders.

After Gravesend, just as we were about to enter the tunnel to go south to join the Chatham line proper, the train suddenly clanked to an undignified halt. There followed nothing but a long silence. I rose from my seat and looked up and down the corridor. There seemed to be few passengers on the train. There was no guard in sight I could ask what was happening so I went in search of one.

Two carriages down, I found the man. He was lounging idly in the corridor, making no attempt to explain to passengers why we were delayed. I approached him.

'What's happening?'

'We've stopped, Sir.' He looked annoyed to have the peace of his afternoon disturbed by a mere passenger.

'Yes, I know we've stopped,' I said. 'What I'm asking you is *why* have we stopped?'

'We don't know yet. There's something happening on the Chatham line.'

'Look, I need to get to Paris. When will we know what the delay is?'

'You'll need to get a boat to go to France,' he said. The guard was an absolute master of stating the obvious. I resisted the impulse to make an impatient retort.

'Will you come down to tell me what's happening as soon as you know? This is an urgent matter. I'm seated two carriages up the train.'

'Yes Sir. Glad to be of service, Sir.' He didn't look as if he were.

I walked slowly back up the corridor, not in the best of humours after my encounter with the railwayman. We had already entered the cutting before the tunnel, so this was hardly a scenic spot at which to come to an unscheduled stop. I resumed my seat unhappily. Another twenty minutes had passed before the guard slid the door back to poke his head into my compartment.

'There's a delay on the Chatham line ahead of us, Sir.'

'And what is it?'

'Seems they've put a couple of extra trains on for the Chatham barracks. Troop trains for the Royal Marines, so they tell me.'

'Troop trains for the Royal Marines? Why should that be? What's happening?'

'No need to get alarmed, Sir. The Navy is always doing things like that to us folks on the railways, especially at weekends.

I supposed he was right. This was probably no more than a routine training manoeuvre. Nothing much seemed to have happened in Europe this month, except for yesterday's Austro-Hungarian ultimatum, as reported in the *London Mercury*. I'd kept the open newspaper on my lap since we'd left Victoria. But the fact that troops were on the move made me more nervous, all the same.

'How long will we be delayed here?' I asked him.

'Don't know that yet, Sir. I'll come and tell you as soon as I know.'

Without waiting for a response he slid the compartment door shut and strolled back up the train. The passengers in the coach beyond mine, if there were any, were to be kept in ignorance.

He didn't call back to speak to me again. I decided to spare myself the frustration of another conversation with this annoying man. It was the best part of an hour before the train whistle suddenly blew, startling me.

We made slow progress through Chatham, Gillingham, Sittingbourne and Canterbury. It was already late afternoon before at long last the train drew alongside the platform of the LCDR Harbour Station at Dover. By that time I'd already decided to stay overnight in the town and make the crossing to France the next day, rather than trying to do so this evening.

I told myself I'd made this decision for practical reasons, rather than from any motive on my part to delay the beginning of my European venture.

Sunday, 26th July, 1914

'What do you mean, I won't be able to make the crossing this morning?'

'Probably not in the afternoon, either, Sir. It's a Sunday and the passages we have are already booked. You can try your luck later if you like, but my advice to you is to wait until tomorrow. There'll be plenty of space on the boat then.'

I wasn't looking for the booking clerk's advice but supposed it was sound. He seemed a good-hearted enough man. It didn't really matter if I wasn't in Paris much before the end of the week; in fact time would be lying heavily on my hands in the French capital during the coming week. Anyway, the only real decision open to me was to postpone my sailing until the Monday. But this would leave me with a day, and a Sunday at that, to spend in the town of Dover.

It was a long, slow walk around the curve of Admiralty Harbour. I was undecided as to how I should fritter my time away. The thought even crossed my mind of wasting an hour at a service in the friendly-looking seamen's church I'd passed at the western end of the harbour, though I did manage to resist this impulse. Finally, I found myself wandering aimlessly around to have a look at Dover Castle.

As I approached the corner before the castle hill, my interest was caught by a crowd of people semi-circled at a respectful distance from a squad of cavalry troopers. The soldiers were resplendent in their shiny breastplates and tasselled helmets, and their mounts had a fine parade-ground sheen on their black coats. They were standing in a rank, perfectly still. That is, the men were sitting perfectly still; the horses were swishing their tails from side to side and snorting imperiously. Sometimes these fine beasts even took a haughty step backwards or forwards, as if to show their

independence. Somehow, these small movements made these noble creatures look all the more impressive, like the finest weapons of war they were.

For a moment, I wondered if the presence of cavalrymen had something to do with the coming Great War, although quickly reasoned there were too few of them for any serious military action. They were probably here for some ceremonial purpose. Still, although their number was small, it was easy to imagine a troop of horse *en masse* striking fear into the armies of Austria-Hungary or Germany as they charged over the battlefield.

With a high-pitched, indecipherable shout, the officer detached his mount from the rank and slowly rode around to face his men. Then, he drew his sabre and bellowed again. The troopers responded by drawing their own weapons and thrusting them upwards. All of these movements were executed in perfect unison. Finally, the officer wheeled his horse around once more and all of the dozen or so cavalrymen led off in the direction of the Castle.

I watched admiringly, joining in with the crowd's applause. Although I'd never been an enthusiast for military pomp and ceremony, nor indeed for anything to do with soldiering, I had to admit this sight was an inspiring one. To think of thousands of cavalrymen like these charging across a field of battle made me feel a bit more sanguine about the terrible things Jet had told me to expect.

The crowd quickly dispersed but I decided to stay to watch the column until it disappeared around the corner in the direction of the castle. Then I sat down on the public bench and looked once more at the short report of Baron Geisl's visit to the Serbian court in yesterday's *London Mercury*.

'You don't want to believe the half of what you read in a rag like that!'

The voice, one with an impressively resonant timbre that seemed oddly familiar, came from a man already sitting on the bench. I thought it was an extraordinary thing to say to a stranger. I turned indignantly to face him. He was a slight man, dressed in a light-coloured suit. His full black beard was the first thing anyone would have noticed.

'Hello, Tommy,' he said.

I couldn't place him, and distractedly thought the beard was even more luxuriant than the one worn by John Jakes. It was ill-matched to the speaker's meagre frame.

'Do – do I know you?' I said.

The man didn't answer directly, but placed his two small hands horizontally in front of his face so as to hide the beard. Then I recognised him immediately.

'Duncan Allen! I haven't seen you in years. You went to work for one of the big papers before I left, I seem to remember'

Allen had worked with me on the *Independent Record*. He was quite the laziest journalist on the staff, and probably in the whole of London. But he was also an exceptionally talented one. He could turn in first-rate copy at the drop of a hat.

'That's right. I didn't stay there for long. I decided to give a home to this furry creature,' he said, stroking his beard. 'And the editor took against the idea for reasons best known to himself. Said it was going to be the beard, me or him. I told him the beard was staying where it was. He wasn't interested in my suggestion to find himself a more useful career, so I went to the *Courier* for a few years. Now I'm with a newspaper that really recognises my talents.'

'Which one is that?' I asked him.

He tilted his beard upwards, and looked disapprovingly down his thin nose at the newspaper still spread across my lap.

'The *London Mercury*?' I said. 'You're working for the *London Mercury*?'

'Don't sound like that about it, Tommy. It's not completely useless. They pay well enough. It's what really counts. You left the newspaper business altogether, so I heard?'

'Yes. I had to go back to my home village to look after the business.' I hoped he wouldn't want to know more. 'Family matter. But what brings you to Dover?'

'Oh, I've come to see a man about a dog,' he said, vaguely. 'Woman about a cat or something of the sort, anyway. Where were you planning to eat?' he asked.

'I haven't made any plans yet.'

'You'll be hard put to find somewhere decent in Dover on a Sunday,' he said. 'Tell you what,' he said. 'I'll treat you to a first-class lunch. Meet me back at this bench two hours from now – that's at half-past-noon – and we'll walk there. It's not far. See you then.'

With that, he sprang up from the bench with surprising agility, and ambled off down the street, looking back to give a cheery wave. Politeness, I suppose, should have made me decline this offer from a man who'd never been more than a colleague but I really did have no clue as to what I'd be doing for a meal. This was why I'd I held my silence. So, that was lunch taken care of. Now I had the rest of the morning to kill.

*

Dover on a Sunday morning, with no company but my own, proved to be every bit as dull as I had feared. I did nothing but walk the streets, hoping forlornly for another

sight of the cavalry. The troop couldn't have been going to the castle at all. I returned to the bench at ten minutes after noon. By a quarter-to-one, there was still no sign of Duncan Allen.

I looked up and down the road anxiously. Had he forgotten about me? Then I saw him, strolling casually in my direction.

'I hope you haven't been waiting for long?' he said easily, when he reached me.

'No,' I lied. I could see this was the answer he expected. Anything else would have been a waste of breath on my part.

'Well, come on then. We mustn't keep Mollie waiting.

Mollie? I thought Duncan's wife was named Betty?

I followed Duncan as he led the way. We had to ascend some steep steps and a formidable hillside terrace, and after that follow down a narrow alley before we came to a largish, and clearly once-splendid house in what was one of Dover's poorer quarters.

'Not bad, is it, despite the area?' said Duncan, knocking at the brightly-painted front door.

It was opened by an enormously fat woman with heavily-rouged cheeks. She was wearing a shiny green dress, adorned with elaborate white lace fringes around the collar and voluminous sleeves. Was this Mollie? It was.

'Mollie!' said Duncan, throwing his arms about the woman, or at least as far about her as they'd go. 'I told you I'd be back soon. Here's my friend. He's going to eat with us, like I said. Tommy's his name. Tommy, this is Mollie.'

I thought for one alarming moment that Mollie was going to engulf me in her huge arms and clasp me to her

over-generous bosom, but instead she smiled a rather sweet, girlish smile seeming out of place on the dimpled face of this giantess.

'What's for lunch girl?' said Duncan. 'I could eat one of those cavalry horses I saw down the town this morning.'

*

Lunch consisted of four golden-brown sausages for each of us, some cauliflower and cabbage, and a decorous serving of creamed mashed potatoes. It wasn't the huge meal I was expecting from Mollie's vastness, but it was absolutely delicious. The sausages were quite the best I'd ever tasted.

Only the two of us, Duncan and myself, ate in the dining-room. Mollie disappeared somewhere into the back of the house, and our meals were served by a thin, worried-looking girl of about sixteen. Duncan hardly spoke while he ate, fast and furiously for such a delicate-looking man. I was content to concentrate on my own meal after the meagre breakfast of a slim strip of fatty bacon and a few fragments of greenish tomato I'd made at my lodgings this morning.

After the meal, Duncan leaned back contentedly in his chair while we supped from enormous mugs of dark brown, very sweet tea brought to us by the serving-girl, who crept into the room as if she thought she could do it without being seen. Duncan made no sign of wanting to start a conversation, but I thought it would be impolite if I did not do so.

'I thought that Mollie would be eating with us?' I said.

'Oh, she'll grab a bite in the kitchen. She prefers it that way. Maybe she'll have two bites. Or three,' he said, smirking.

'Would you mind if I had a *Wills*?' I asked him. 'I've got a full packet. Would you like one?'

'Never touch them,' said Duncan. 'But you go ahead.'

He watched in silence as I lit the cigarette and puffed out a cloud of smoke. I knew that Duncan was waiting for me to tell him what I was doing in Dover.

'I suppose you're wondering what I'm doing in the town?'

'It did cross my mind,' he said. 'But then, I knew you'd tell me when you were good and ready.'

'I'm on my way across to France,' I said. 'I'm off to Paris tomorrow, in fact.' I didn't want to tell him why I was going there.

'I see. *Parlez vous français*?'

'What?'

'I thought you didn't speak the language. You're going to find it hard in France.'

'I'll manage.' I hoped I would.

'Well, you're in luck. I'm off to Paris myself tomorrow. We can travel together. I'll be able to put you on the right road. I won't be able to do much more, though. I'm going for the *Mercury*. Covering the big story, I am, or at least I hope to be there to catch the end of it. At last I've managed to convince the editor I've actually got to be in the city to write properly about what's going on. It will give me another chance to see Gay Paree, anyway.'

'The big story? You mean the repercussions of what happened in Bosnia?'

'Bosnia? Where's that? No, I'm talking about the trial of Madame Caillaux, of course. All the newspapers are running with the story. You must have heard of the case?'

'No. I haven't had much chance to see the newspapers in the last few weeks,' I said. We looked at each other in

mutual disbelief. I hadn't heard of this Frenchwoman and it seemed he hadn't heard of the assassination in Sarajevo.

'It's a sensation. Made for the *Mercury*, the story is. Madame Henriette Caillaux, the second wife of the French Minister of Finance, put about half-a-dozen bullets into Monsieur Gaston Calmette, the editor of *Le Figaro*, back in March. Seems the first wife of Joseph Caillaux, when they were still married that was, had intercepted some letters her husband was going to send to his lover. You know the sort of thing: "from Jo-jo to Ri-ri". The editor of *Le Figaro* was going to publish one of the letters, or at least that's what darling Henriette thought. So, the same afternoon, the sweet girl pumped her bullets into him.

'The public in England as well as France are eating up every word of the trial story. It's in all the newspapers, not just the *Mercury*. There's a lot of sympathy for our Henriette. I wouldn't be one bit surprised if she gets off. In fact I'm sure she will. It's why I wanted to catch the end of the trial. Now, what's all this about Bosnia?'

'At the end of last month the Archduke Ferdinand was assassinated in Sarajevo –,' I started to say.

'Oh, *THAT*. Even the *Mercury* covered that story. Sarajevo's in Bosnia, is it? But it's only a local Balkan matter. All the fuss has died down now, I should think. They're always doing mad things over there. Nothing at all to do with us in England.'

I could not believe what I was hearing from Duncan. But then, many of my countrymen would be thinking similar things. That is, if they thought about Sarajevo at all.

'It's bound to have wider implications across Europe,' I said. For a passing moment, I thought of telling the truth, but then he'd surely think I was mad. And I couldn't have blamed him.

Duncan rocked back perilously on the wooden chair, and then placed his hands comfortably behind his head.

'I don't see why anybody should take any more notice of another killing in a place like that than of the trouble between the Serbs and Bulgars last year,' he said. 'Anyway, the *Mercury*'s readers wouldn't be interested in reading about it. It's politics. Give them a good, juicy story any day. But enough about newspaper stories. I'm not working today. Where are you staying tonight?'

'Oh, I'll just stay in the boarding house where I was last night.'

'No you won't. Mollie's got spare rooms. I'll bet the place where you're staying is as grim as hell, isn't it?'

I pictured the tiny strip of bacon; the religious slogans on the walls; the hard bed; the hatchet-faced landlady.

'You don't have to say anything,' Duncan said. 'I can read your face like a book. You'd never make a poker-player, Tommy. We'll walk over and get your luggage now.'

*

Dinner consisted of a tasty Shepherd's Pie. Mollie could certainly cook, even if she chose to eat once again in the kitchen. After an hour's desultory conversation about our former colleagues on the *Independent Record*, I decided to turn in for the night. Almost as soon as my head hit the pillow I fell asleep; I was strangely tired after an undemanding day.

Two hours later I was awoken by noises from the next room. There were sounds echoing through the wall of groaning bedsprings; shrieks and breathless giggles from Mollie; and deep chuckles from Duncan. The two of them seemed to have endless stamina. There were still sporadic sounds of excited lovemaking coming through the wall as I at last dropped off to sleep again. The first light of the grey

morning was already showing itself through a gap in the curtains by that time.

Monday, 27ᵗʰ July, 1914

Duncan caught my eye, exaggeratedly mimicking the booking clerk standing in front of him. He tried to rock his head from side to side, open and close his mouth in a fish-like manner, and knit his brows all at the same time. It was all I could do to keep a straight face.

'Would you mind telling me again why you want to go to France, Sir?'

'It's for a book I'm researching,' I repeated. 'A book about the French politician, Jean Jaurès.'

Now I realised it'd been a bad mistake to make up such a story. The booking-clerk was an entirely different person from the friendly and helpful individual I'd seen yesterday. This one gloried in his officialdom, and had pricked up his ears at my mention of the name of Jaurès.

He'd immediately called over to the stony-faced customs-officer. This man now stood impassively between Duncan and the booking-clerk, listening to our exchange intently. I would never have told such a far-fetched lie but I had to make something up on the spur of the moment. I could hardly tell the truth. With Duncan Allen standing within earshot, something literary sprang into my mind.

'Because you see, Sir,' the official continued as if there'd been no break in our conversation. 'We've been told by our manager to keep a special eye out for anyone whose motives for going to the Continent might be suspicious. I've heard this Mr Jaurès is a sympathiser with the German Empire, so naturally I put two and two together. We guardians of the public interest can't be too careful, you know.'

'Monsieur Jaurès is not a sympathiser with Germany!' I was getting frustrated now. Jaurès may have been in the pay

of the enemies of the Crown for all I knew, although I doubted this from what Jet had told me and what I'd read. Still, if the booking-clerk had said the German Emperor was on the side of the Germans I'd have denied it.

'All right Tommy?' Duncan had stepped forward hurriedly when I raised my voice. 'Is everything in order, officer?'

It was easy to see that the booking-clerk relished being addressed as "officer". He puffed himself up visibly as he replied to Duncan.

'Thank you for trying to help, Sir. It is appreciated. But I'm afraid I'll have to ask you to mind your business. I have to question this gentleman on official matters.'

'It is very much my business, officer. Mr Green will be doing some research for his book as he says, but he's also going to Paris as my assistant. I'm Duncan Allen, senior journalist with the *London Mercury*.'

With a flourish, Duncan slapped down his press identification card on the desk in front of the booking-clerk, who regarded it doubtfully. Then Duncan delivered the killer blow:

'Of course, if there's any difficulty at all, I'll be pleased to have a word with the Port Commissioner, Commander Birmingham. Would it be easier for you if I did that?'

The name "Commander Birmingham" seemed to pass through the booking-clerk like an electric current. He immediately picked up his pen, dipped it in the inkwell, and started to write my name on a ticket. The customs-official said nothing. He now fixed his stare straight ahead of him and stood to attention rigidly. I swear his first instinct as he heard the name of "Birmingham" was to salute.

'No, Sir. There'll be no need for that,' said the clerk. 'I was merely checking. If you ask me, things will be so much better when they introduce these Port-passes they're talking about. Then honest officials like us – we're only trying our best to do our jobs, you know – can cross-check them against proper passenger-lists and suchlike to make sure the journey has been correctly authorised. Make everything so much easier, a thing like that will. And these Port-passes will make the country safer, you mark my words.'

As he finished his writing, pressing the ticket fussily with a neat square of blotting-paper, I couldn't help thinking that when the Great War started he'd get his wish for more papers and rubber-stamps. It would be a step along the road to the kind of society I knew Jet to be living in.

*

'How did you know this Commander Birmingham was the big wheel around here?' I asked Duncan, as we walked out of the building. 'Where did you get to know him?'

'I don't know him from Adam and wasn't even aware he was the number one boss in the port until I happened to notice his nameplate on the door back there,' he said. 'But at least now I know exactly why you're going to Paris. I thought you were never going to tell me. Come on, we'll have to get our skates on. The boat sails in twenty minutes.'

*

The Port of Calais was now coming closely into view. Thank goodness this was a short crossing; I was desperately hoping to be able to keep the contents of my stomach where they belonged. As I was struggling with the violent rocking of the vessel, Duncan returned from his wanderings around the decks of the ferry-boat.

'Lovely crossing this,' he said breezily. 'Calm as a mill-pond.'

'There must be some mighty funny mill-ponds where you came from,' I said. 'Where was that, anyway?'

'The beautiful town of Dover is the place I call home. I thought you knew. I moved to The Smoke when I wasn't quite twenty. Just a boy I was, back then. Still, I like to get down to the old place as often as I can. And, whenever I can make it, I get across to *La Belle France*, too. It's a great place, France. You'll love it.'

'You go down to Dover to see the old home town, eh?'

'Yes. And to see Mollie.'

'You know, I always thought your wife was called Betty.'

As soon as I said this I knew I shouldn't have said anything. Duncan had already been very helpful to me, even though when we were colleagues we'd never been much above friendly acquaintances. But he answered me without a trace of embarrassment.

'Betty is my wife. She lives in Wimbledon with our kids, Albert, Percy and young Winnie. And I'm there, too, most of the time. Mollie and Betty are sisters. We all used to live close to each other in Dover. Betty's a wonderful girl but she's not as – well, the French would say *sympathique* – as her big sister. She knows about Mollie and me, Betty does, I'm pretty sure of it, but I don't like to rub it in her face by telling her where I'm staying every time I go down to Dover for the night.'

From the sounds I had heard last night, I could guess what *sympathique* meant. I didn't want Duncan to go into more detail, so quickly changed the subject.

'Did you hear of anything about developments on the Continent while you were about the boat?'

'That was my plan,' he said. 'I am a journalist, you know. Even if I do work for the *Mercury* these days, I'm still a journalist. Yes, as a matter of fact, I did learn a thing or two you'd be interested in knowing. Some of the things I heard got me pricking up my ears on my own account, too.

'There've been demonstrations in Vienna and Berlin over the weekend. It seems like they're making it tough on the Serbs. The one who killed the Archduke in Bosnia was a Serb, don't you know? Anyway, the ultimatum Austria-Hungary has given to Serbia is a very demanding one. It looks as if their plan is to deliberately push them into a corner. Apparently, Serbia hasn't worked out how to reply to Austria yet. And the word is that the Austrians have the unconditional backing of Germany. Things could get a bit out of hand if these politicians aren't very careful.'

'So what happens now?'

'I don't know, Tommy. You're supposed to be the expert on this sort of thing, aren't you? It depends on what Russia does for Serbia, I suppose.'

I did know. Russia would back Serbia; France would get behind Russia. And, as Jet had told me, "we wouldn't be able to stay out of it".

*

The Port of Calais was an undistinguished place. This was the first time I'd so much as stepped on foreign soil, and the town was a disappointment to me. It wouldn't have been so very different from Dover, if it hadn't been for all the people around me talking in another language. I found this intimidating.

'How far is it to the railway station, Duncan? I thought I saw it back there.'

'We're not going to the station.'

'Where are we going, then?'

'*You* are going to the *Brasserie du Globe*. You can have a bit of lunch there, without getting yourself into too much trouble. *I'm* going to see a friend of mine. Her name is Janine. I haven't been able to see her once this year yet.'

'Janine? You've got a girl in France called Janine?'

Duncan laughed. 'Not like Mollie,' he said. 'This is a strictly commercial arrangement. She's got some things I want; I've got some things she wants.'

'What things do you have?' I asked naïvely.

'Francs,' he said.

We walked down a wide road and what Duncan had called the *Brasserie du Globe* came into view. It was a splendid-looking establishment, with lots of tables on the pavement outside. These were covered by broad sunshades. The scene looked very attractive in the sunlight.

'Well, I'll be leaving you here,' said Duncan. 'Janine's place is on the other side of town. I'll come back to get you at four o'clock and then we'll get the train to Paris.

I must admit I panicked. 'But I don't speak any French!'

'Look, I'm not your nursemaid, Tommy. You were going to come to France on your own, remember? Point to the things you want.'

Duncan was quite right. He'd already been very helpful to me.

'Sorry, Duncan,' I said. 'My nerve failed me when I saw all those French people. I'll be all right. But I would like to be able to say a few words in the language.'

'Do you think I can teach you French in ten seconds?' Duncan laughed. 'Very well. You're going to have a cheese omelette for lunch, like it or not. That's *une omelette fromage*. For drink you'll have *une carafe d'eau* and *un coup*

de rouge. You'll get some bread with the omelette anyway. You call it *du pain*. Two things you ought to be able to say are 'please' and 'thank you'. So, remember *s'il vous plait* and *merci*.'

'And how do I say –'

'Lesson over, Tommy. It's time for me to go to see Janine. See you here at the *Brasserie du Globe* at four o'clock. Maybe at half-past if Janine looks after me well.'

Duncan turned and walked off, humming softly to himself. There was nothing else for it but to sit at one of the tables outside the *Brasserie*. Immediately I found my seat I opened my carpet-bag, pulled out my journal, and started to write on one of the loose sheets I'd tucked inside it. Before they faded from my mind, I thought I'd better jot down the words Duncan had taught me. I had no clue as how to spell French words properly, so 'please' became 'see voo play'. Then I remembered I hadn't written up my journal since Saturday, so I started to work at my journal using one of the pencils I'd brought with me for the purpose. I became so engrossed in my task I failed to notice the moustachioed, apron-clad man coming up to my table.

'*Monsieur?*'

This wasn't a word Duncan had taught me.

*

The omelette was delicious, as was the crusty bread served with it. *Un coup de rouge* turned out to be a glass of red wine. I'd never tasted wine before. It turned out to be sourish; it wasn't at all sweet as its appearance and mythology suggested. I was reminded that two days ago I should have had my first taste of wine at Betham House. I thought of Mazod. What was she doing at this moment? Did she think of me at all? I didn't know.

I was grateful for my journal. It filled some of the afternoon stretching out ahead of me. But it was only two o'clock when the waiter was at my table, holding up four fingers to indicate the number of the francs I should give him from the bundle of notes and pocket-full of coins Duncan had changed for me back in the harbour.

'*Service non compris, Monsieur*,' he said when I counted the money into his palm.

I didn't have a clue what this meant, but the way the waiter was glaring told me well enough. Quickly, I exchanged the four franc coins for a five-franc note, which brought a grateful smile to his face. I had made one friend in Calais, at least.

Tuesday, 28th July, 1914

Paris! People might call it the City of Dreams, but I didn't see it that way. It's a dull place when you have nothing to do all day but wander around the streets waiting for your new friend to return from his day in the court-room.

I knew I shouldn't complain. Duncan had wanted to stay nearer to something he called the 'Seine Tribunal' but when I told him of the area I wanted to go myself, he'd been good enough to help me find a room in a small building he referred to as a *pension*. This was located in the *Rue de Croissant*, just off the *Rue Montmarte*.

It wasn't so cheap, and was none-too-clean into the bargain. Still, it had two things in its favour. The first was that the *pension* was only a few paces from the café where Jet Green had told me I'd find Jean Jaurès on Friday evening. The second was that now there could be no danger of forgetting the second lesson in the French language I'd managed to squeeze out of a reluctant Duncan. Last night, I'd wanted to know the word for coffee – I knew the French eschewed tea – and he'd told me to ask for *du café*. In the same way, when I'd asked him what I should try for breakfast, he'd said *des croissants*.

So, this morning I'd done exactly this. I'd walked down to the helpfully-named *Café du Croissant,* which I found at number 146, on the corner where *Rue du Croissant* intersected with *Rue Montmartre*. The *croissants* proved to be delicious pastries, though it did feel distinctly eerie to be sitting in the very place where I knew a murder was to be committed this coming Friday night.

The café was crowded, even when at half-past-nine I plucked up the courage to enter a room full of Frenchmen and bring my ten-word vocabulary into use. It was hard to imagine how a murder could be committed in this busy place. At least there was no way a murderer could expect to do the

deed with any hope of getting away with his crime. Perhaps this was the way of things with political assassinations: Gavril Princip had been arrested almost immediately after shooting the Archduke in Sarajevo, at least according to what I'd read in the *Daily Mirror*.

After breakfast, I remained in my seat for a quarter-of-an-hour, trying to visualise how a murderer would go about his business in this café. I kept coming back to the same conclusion: the only way would be for him to come through the doorway as if he were a normal customer, then march right up and fire his pistol at Jean Jaurès.

So, my best plan of action would be to keep Jaurès directly in my sight at the crucial time, and then to intervene quickly when a newcomer approached his table or acted suspiciously. I knew the killer, this Raoul Villain, wouldn't be someone already seated at Jaurès' table; Jet had described him as an 'ultra nationalist'; hardly someone a Socialist would choose as a dining companion.

Somewhat reassured by this deduction, but all the more nervous at the enormity of the task before me, I left the café to tramp the streets of Paris. And this was how I spent most of my day, save for a return to the café for a lunch consisting once more of *omelette fromage* and *un coup de rouge*. To avoid getting lost in unfamiliar streets, I did not walk far, but kept to the spider's web of streets with names like *Boulevard Poissonièrre*, *Rue de Richelieu* and *Rue Etienne Marcel*. Those names might sound romantic, but believe me: the streets were very ordinary.

*

At eight-thirty in the evening I was back in the café again: Duncan had told me his intention was to look in before nine o'clock to tell me about his day in the Seine Tribunal - and, I hoped, to give me the information I'd asked him to root out. At nine-thirty, my nerve failing me at the waiter's third and more impatient "*Monsieur?*" in the space of half-

an-hour, I ordered my second *coup de rouge* and an *omelette fromage*. Tonight, I'd promised something different for both myself and Duncan. But Duncan hadn't yet arrived and my vocabulary didn't extend to a piece of beef or chicken.

The couple on the table next to mine were brought a delicious-looking chicken dish soon after I'd placed my order. I listened to their conversation to try to learn what the word for "chicken" was, but I failed to distinguish anything in the rapid stream of French. When the man began glancing suspiciously in my direction, I desisted.

It was almost ten o'clock by the time Duncan strolled in, wreathed in smiles. My omelette was long gone and I had only a mouthful or red wine left.

'Sorry I'm late,' he said, taking the seat opposite mine. 'The trial didn't finish until nine o'clock. What a day!'

'What can I get you to eat? I've already had something.'

'No food thanks, Tommy. I've got to dash in a minute. I'm having supper with a couple of the journalists from the *Matin* and the *Temps*. I've only called in here because of my promise to find out something about Jaurès and Villain. I've found out a lot. But something else is brewing. Something that's right up your street. It's going to be really big.'

'You've had a good day, then?' I tried not to let my excitement at what Duncan was saying show too much

'You could say that. The best kind of day for a journalist to have. I'll have a glass of wine with you before I go.'

Duncan caught the waiter's eye and signalled for two glasses of wine. At least I assume that's what he did; his gestures were almost imperceptible, but the waiter came over with two glasses brimming with red wine.

'*Voilà* Monsieur Allen!'

'He knows you?'

'They all know me here, Tommy.' He took a generous mouthful from his glass. 'Well, I thought for sure I was going to miss all the fun, but they all tell me that today, the last day, was easily the best of the whole trial.'

'What happened? Was the Frenchwoman found guilty?'

'You are joking, Tommy. This is France, remember? Madame Caillaux was always going to get off. The Public Prosecutor, Monsieur Hervaux, knew as much when he was giving his final address to the jury. You should have seen him, fat thumbs tucked into his waistcoat as his fingers did a majestic dance across his huge midriff. You could almost believe he meant what he was saying when he implored his countrymen to find our Henriette guilty of wilful murder with premeditation. Even he, though, had the sense to add that they "could allow for the existence of extenuating circumstances". Still, the man was playing a part, and he knew it. The French understand the importance of theatre in this sort of trial.'

'Do you think she was guilty?' I asked. What I really wanted Duncan to tell me was about Jaurès and Villain, but I knew I should be patient.

'Of course she was!' he said. 'The woman was as guilty as Hell. But what's that got to do with anything? A handsome lady is our Henriette. The jury retired at ten minutes to eight and they were out more or less an hour later. They probably only had time to discuss the finer points of Madame Caillaux's bosom in the jury-room. You should have seen the uproar in the court when they announced the verdict. There was a wild demonstration in favour of Madame. I tell you, there'd have been a riot if she'd been found guilty.'

I marvelled at Duncan's cynicism. Surely things couldn't be as bad as this? The tribunal was a court of law, after all. But I kept these thoughts to myself and watched quietly as he ran his fingers through that impressive beard with satisfaction.

'So, it was all a foregone conclusion, then?' I said, trying to prompt him.

'It surely was. There was one lovely moment earlier in the day when the prosecuting solicitor, Maître Chenu, forgot for a minute why he was there. He was lecturing the jury about thinking of justice for the murdered man's children, and called our Henriette "a clever and self-collected woman who didn't seem to show true feeling". You could almost hear the booing and hissing from the theatre boxes - whoops, from the public galleries I should say.

'Then Chenu went on about Joseph Caillaux's dark ambition, and how the crafty man had "forgotten" to tell his wife on the day of the murder about the reassuring discussion he'd had with President Poincaré. Calmette would never have published a private letter in *Figaro*. It was a tricky moment for the lovely lady. But Henriette Caillaux had the answer.'

I could see that Duncan wanted to be asked what it was.

'Well, aren't you going to tell me what she said?'

'It wasn't what she said. It was what she did. She fainted. It was hilarious to see her being carried out of the court.'

'It was the moment when the verdict was decided, then?'

Duncan grinned. Anyone could see that had happened in the Paris trial was still the most important thing going on in the World as far as he was concerned.

'Well, that was when it was put beyond the slightest doubt, you'd have to say. Maître Chenu was fighting a lost cause when he complained about all the fainting, pointing out that Madame Caillaux hadn't shown a moment's bodily weakness when she'd pointed her Browning revolver at poor old Gaston Calmette.

'Fair point really, But nobody wanted to listen. A formidable woman is Henriette Caillaux. Somebody actually told me she really wanted her husband to challenge Calmette to a duel. A duel! To think of it! Not Joseph Caillaux! His idea of a good fight was to send a woman out with a loaded gun to fire the bullets for him. Joseph Caillaux was the one weakness in his wife's case. He's not the best-loved man in Paris. Do you know he was even trying to introduce an income tax like ours at home? Despite the handicap of her husband, Henriette won through with her feminine charm. And, of course, she chose the perfect moment for her fainting act.'

Then I voiced the thought that'd been in my mind almost since I'd met Duncan in Dover. I didn't mean to do it, but the words tumbled out.

'You know, I envy you. You know so much about women: Molly, Betty, Janine. My own attempts at getting close to them always go so wrong, somehow.'

'*You* envy *me*? Our colleagues used to call me "The Gnome" when we worked together on the *Independent Record*. They called you "Casanova". There were stories of you having a fancy woman or two somewhere in West London.'

They thought I had a fancy woman in West London? Two fancy women? Some garbled rumour about Rosie in Hanwell must have reached my fellow journalists on the *Independent Record*. How did they get to hear anything about Rosie? I'd myself listened to some of our more unkind former colleagues referring to Duncan as "The Gnome", but

didn't know any of them called me "Casanova". I couldn't think of a less appropriate nickname. Was Duncan making it all up? I studied his face, but he seemed to be sincere in what he was saying.

'No, really. I'd like to hear what you've got to say about women,' I said.

It was Duncan's turn to look at me questioningly.

'You are being serious?' he said. 'There's no big secret I've ever found. All I'd say is don't be afraid to let women know what's really on your mind. A romantic would say "tell them what's in your heart", but "minds" will do for the likes of you and me.'

Letting her know how I really felt was something I'd never managed with Mazod. I wanted to ask Duncan more, but he rose to his feet, draining his glass.

'Well, I've got to go. I'm late already. Gheusi and Marais, the French journalists I'm having supper with, will think I've gone back to Dover. Or even to Wimbledon!'

I was alarmed. The knockabout stories of the trial were entertaining enough when Duncan recounted them, but he hadn't yet told me what I really wanted to know.

'You were going to ask the French journalists what they'd heard about Jean Jaurès and Raoul Villain, weren't you?' I said, uncertainly.

'Oh, yes, I was forgetting. Well, everyone here seems to know Jaurès, so that was easy. And I struck lucky with Villain. But I haven't got time tonight to tell you about it, otherwise the three of us will be sharing a midnight supper. Can you meet me in here, at nine-thirty in the morning? We'll have breakfast and I'll tell you what I've found out then. And I'll also tell you about the big story brewing. Something right up your street, it sounds like. I'll know more after I have supper with Gheusi and Marais.'

'What is it?' I asked him.

He rubbed his index finger along the side of his nose..

'Tomorrow,' he said. '*Bonsoir, Monsieur Tommy.*'

Wednesday, 29th July, 1914

It was a quarter-to-ten before I ordered my *café* and *croissants*. There was no sign of Duncan but I knew I needn't worry. He was one of those people who treat punctuality as a mere bagatelle. It was after ten-thirty before he wandered in from the sunshine of the Paris streets and ambled casually up to my table.

'Hello, Tommy,' he said. 'Glorious day. Sorry I'm late this morning.'

'That's all right,' I said. 'It's not important.'

'No, really. I did plan to be on time today, but I was up until two o'clock this morning, talking things over with Gheusi and Marais. There was a lot to discuss. There's been no end of things going on already this morning. I've just come off the telephone to Gheusi.'

'Well?' I said.

'Later,' said Duncan. 'I've a feeling this is the last morning of this week I'll be able to relax. You were going to get me *le petit dejeuner*, remember?

Duncan seemed to assume that by some miracle I'd learned French overnight. But I didn't have to be a linguist to guess the meaning of what he'd said, so I signalled the waiter. When the breakfast arrived, he tucked into it enthusiastically. He ordered small roll-type things as well as the *croissants*, choosing two of each from the basket the waiter brought to the table. I was surprised when Duncan happily dipped all of his pastries into the huge bowl-like vessel his coffee was served in. He'd clearly decided to leave what I'd years ago observed to be excellent, even fastidious, table manners behind him when he'd crossed the English Channel.

All the time he was eating he kept up a stream of chatter. He might as well have told me what he'd come here

to say before eating. Still, it was interesting enough to hear him talk. I learned this was already his fourth visit to France this year, and his third to Paris. He was deliberately vague about his reasons for coming, but I guessed that any visits to Calais were for the purpose of sampling the professional services of Janine.

Betty. Mollie. Janine. And heaven knew who else. When Duncan and I were colleagues on the *Independent Record*, I hadn't guessed the half of it. But I could see that this remarkable little man, despite the impression I'd formed years ago of his indolence, was also a very sharp operator. You could see him turning everything over in his mind, examining every aspect of everything from different points of view. My own career as a journalist had been a comparative failure; however much I liked to pretend to myself this was entirely due to family reasons. And my attempts at the courtship of only one woman had been hopeless.

'Right,' said Duncan, pushing his plate away and wiping his lips symbolically. 'You want to know about Jean Jaurès?'

'I've read a little in a book,' I said.

He waved his hand dismissively.

'Books tell you what the author chose to write down five or ten years ago. I've tried to find out some current information about Jaurès. It was easy. Turns out he's a journalist, like us. Well, like me these days, anyway. Do you know someone reminded me I even had a long conversation with him once? Two years ago, this was.'

'You've spoken to him? I thought he was a politician rather than a journalist? You keep well clear of political journalism, don't you?'

'He is a politician, really. A Socialist. One of the Rights of Man boys. But he's also the founder and editor of *L'Humanité*. You can imagine the interests of *L'Humanité*

and the *Mercury* hardly overlap. That was why I couldn't place him at first. But it turns out that two years ago he and I had a very long discussion, here in this very café. When Marais reminded me about the occasion, every detail of the day came back to me vividly.'

Duncan smiled, combing his hand through his beard. In his characteristic way, he was pleased at having landed what he no doubt saw as a small professional coup, even one obtained as a passing favour for an old colleague.

'I was sitting at that table over there,' he continued, nodding towards the opposite corner. 'Doing no more than relaxing with a glass of wine, I was. It'd been a hard day, and I didn't want to talk to anyone. Anyway, this Frenchman strolled up to me and demanded to know if I was English. Well, I didn't want to answer at first. He looked like a street porter dressed up in his Sunday best, what with his bull neck and broad shoulders. You get all sorts walking up to you in Paris, wanting to practise their English.

'It turned out he didn't want to show off his English, after all. He knew some; quite a lot as it turned out. He'd learned it so that he could read *Macbeth* in the original. Can you imagine? As luck would have it, it's a play I know well, but he was like a dog with a bone, asking this and asking that. Why is Scotland not an independent country now? Do they still believe in witchcraft? You can guess the sort of thing. Wore me out, it did. And, after he'd finished talking about *Macbeth*, he wanted to know if I'd read *Don Quijote*. Turned out he'd learned Spanish so he could read that, too. Well, I've never read the book. I've never even read the whole thing in English. I know the story about the tilting at windmills, of course. Everybody knows that. A remarkable man is Monsieur Jaurès.'

Duncan gazed into space for moment, looking more thoughtful than I'd ever seen him. I thought I'd better prompt him.

'What's he doing now?'

'He's here, there and everywhere making no end of speeches about what he calls the need for European understanding. As if we could ever understand the Germans and Austro-Hungarians, let alone the Serbians! That's what he'll be doing later today, so they tell me. He'll be going to Brussels when he gets back from Lyons. Lecturing to the Second International, that's his plan. You know, all that nonsense about how there can be no such thing as French Socialists and German Socialists; only International Socialists. If you ask me, a message like that won't be received in a kindly way outside of his Socialist cliques, but if anybody can get the message across, Jaurès can.'

A sudden thought struck me. 'You're not a Socialist?' I asked.

'Me? Come on Tommy. Don't say things like that. You'll get me into trouble with my editor. I didn't want to know about any kind of politics.'

I noticed Duncan's 'didn't'. Was he going to tell me something else? But his mention of Brussels raised a more immediate concern. Would this mean he wouldn't be in Paris?

'So, Jean Jaurès is going to Brussels, then?' I felt an odd mixture of hope and fear rising within me. Maybe Jet had made a mistake with his dates? 'Does that mean he'll be away on Friday?'

'No. He'll be back in Paris tomorrow evening, so they told me.'

I tried to give nothing away by my expression.

'What about Raoul Villain?'

'Ah, he was a very different matter. I couldn't find anybody that knew him, or who'd even heard of him. Then Claude, a journalist from *Action Française*, overheard me

asking one of the others about Villain. Claude knows Villain, slightly at least. He'd done some odd work for their paper - it's a gibbering nationalist rag. You don't have to be a politician to know that much, Tommy. Don't think Claude is a crazy nationalist, either. He's only a newspaperman doing a job of work.

'Villain has done no journalism, you understand, only some casual circulation-pushing. Claude says from what he's seen there has to be more than a touch of madness about the man. Did you know his mother's been a lunatic for years? So was the grandfather on his father's side. And, if a journalist working for the *Action Française* says someone's not the full shilling, that someone must be howling at the moon.'

'What does he look like?'

'Oh, there's nothing much you'd notice. Smooth skin and pale blue eyes. A little Italian-style moustache. Dandified hair, though not much of a beard. Claude says what you'd most remember about Villain are his haunted eyes. He says it's like the man is always on the look-out for demons in a dark corner of the room. Probably he is. Still, I can do better than tell you about him. Have a look at this.'

Duncan pulled out his wallet and extracted a photograph. It was of five men, four of them standing in a group by a desk, on which a copy of *Action Française* was prominently displayed. They were laughing at some private joke. The fifth was standing to one side of the others. This man, who had to be Villain, wasn't sharing the amusement.

Although the picture was on the small side and had been crumpled through careless storage, it was easy to see the ghost at the feast matched the description given by Claude of Raoul Villain. Because of the lighting of the photograph, it wasn't possible to decide whether he had dark or fair hair, but even in this small print his eyes suggested some kind of desperate intensity.

'What's he doing in this photograph?' I asked. 'It looks as if it was taken in a newspaper office. I thought you said Villain wasn't a journalist?'

'He's not. Villain likes to try to worm his way into things.'

I looked again at the picture. It would make my task on Friday night so much easier.

'Can I keep this?'

'Of course you can. Claude keeps all sorts of things in his pocket-book he doesn't really want. By a stroke of luck he happened to have kept this. The chubby blond one on the end is Claude, by the way. He probably thought I wanted the picture to see him. The vanity of the man, eh? I certainly wasn't going to tell him I only wanted a picture of Villain. Tommy, I can't think why you want one, either.'

I didn't want to tell him any more than I had already, so simply smiled. Fortunately, he didn't press me on the point. It was clear he wanted to tell me about whatever was really on his mind.

'Aren't you going to ask me what the *something big* I told you about is, Tommy? No wonder you didn't stay in the newspaper business if you miss a trick like that.'

'I knew you were going to tell me, Duncan,' I laughed.

'You're right. I was going to tell you,' he said. 'But I'm only telling you because it was you who put me on the trail in the first place. Don't go giving this story away free to all and sundry, now. In fact, you make damn' sure you don't tell anyone except your chosen editor before this hits the press.'

'Go on,' I said. 'You've got me interested.'

'Remember how you were asking about the business in Serbia and Bosnia on the way over? I'd thought it was nothing but a local squabble, but you set me off on the idea it could be more. Well, it seems you were right. A lot's happened since we crossed over to France.'

He leaned forward and spoke more quietly.

'Austria-Hungary rejected the reply they got from Belgrade to their ultimatum and now they've declared war on Serbia. That's right; they've gone and declared war. Bloody fools. It's looking as if this is what Austria-Hungary was aiming for all along, if you ask me. The assassination in Sarajevo provided the perfect excuse they'd been looking for. All they're doing is taking advantage of events. They've wanted to teach the Serbs a lesson for a long time, so I've found out.

'Edward Grey, the British Foreign Minister, was all for arranging some sort of high-flown International Conference to discuss things - over a nice cup of tea, I suppose - but the Emperor and his merry men were having none of it. They're supposed to be talking now with the Russians, who've somehow become involved on behalf of Serbia. It's all very messy, and it's getting worse by the day.

'Now, here's where it gets interesting.' Duncan looked at me, satisfaction written all his features. This has only just happened, Tommy. It's hot news. The hottest you'll ever hear in your life.'

Here he paused for effect and again looked at me hard. I suppose he was wondering if my instincts as a journalist were still alive. But I wasn't hearing his story as a journalist. I tried to give nothing away by my reaction. After only seconds, his excitement got the better of him and he went on with his account of events.

'It seems everyone suspected Germany of egging Austria-Hungary on from the side-lines, but Gheusi now has

absolute proof of it. And – this is the really sensational thing – tomorrow morning, the three of us are going to have a very private meeting with two of the top French Civil Servants. Gheusi has only just managed to arrange the meeting. It's what I was on the telephone to him about this morning. They're going to tell us exactly what they saw. As long as we promise not to use their names, of course.

'I can tell you what Gheusi told me on the telephone a short while ago. Early this morning, the two civil servants we're seeing tomorrow witnessed a row between Louis Malvy, the Minister of the Interior, and Joseph Caillaux, Henriette's dear husband. Malvy was telling Caillaux that, while he was busy in court, Russia had asked France if she should mobilise. The Russians had wanted to know whether they could count on French support if they did this. Malvy dithered about a bit but eventually he had to admit to Caillaux that he'd given in to what the Russians had asked. "We have engaged ourselves to support her," was apparently what he said. Pompous ass'.

His eyes glistened as he was telling his story. But, to Duncan, that was exactly what it was – an exciting newspaper story.

'Caillaux went wild when he heard this. He told Malvy he'd exceeded the terms of the Treaty of Alliance and was unleashing a European war. Caillaux was really furious. As for the civil servants, well, it really alarmed them, as well it might. As it happened, one of them was going to see Marais straight afterwards on another matter, so the two of them went together and spilled the beans about what they'd seen. Marais immediately told Gheusi and then told me. Marais has got hold of the idea that I'm a political specialist, thanks to the questions I was asking for you.'

So it was all falling into place, precisely as Jet had said it would. Inside, I shivered. Duncan, to whom this was

no more than a potential newspaper story, continued to chatter away happily.

'Each of us is going to break the story in his own newspaper. The only thing is, not one of the three of us is really a political journalist. I've talked to Gheusi and Marais and we all want you to be in on it. What do you say to that?'

'I'm no expert on international affairs, Duncan. Besides, I've told you: I've come here for Jean Jaurès.'

Duncan looked nonplussed at my low-key reaction..

'You don't know what you're saying! This is the biggest story to have landed in my lap in my twenty-five years as a journalist. And I'm offering to share it with you. You can sell the story to any newspaper in London, except the *Mercury*. I wish I didn't have to break the story in the bloody *Mercury*.'

What else could I do except stick to the line about Jaurès?

'I've come to Paris to write about Jean Jaurès,' I said. Duncan looked at me as if he couldn't believe what he was hearing. 'I also want to make a drawing of him – you know, like the one I did of the Russian anarchists. You'll remember that. I'm going to do the drawing in this café on Friday.'

I'd recalled that Duncan's last day at the *Independent Record* was the day I'd brought my drawing into the office. He'd enthused about it: perhaps this was one of the reasons why he'd been so friendly to me since we'd met in Dover on Sunday.

'Yes, that was a wonderful drawing. But Tommy, tell me this: how do you know Jaurès will even be in here on Friday? He often goes to the *Coq d'or*, so they tell me. Anyway, he'll still be here next week for you to sketch to your heart's content.'

'He won't be – that's to say, he might not be.'

'Jaurès won't be far away, you can bet on that much. On the other hand, those civil servants might see the sense of getting out of Paris after they've talked to us.' I could see that Duncan was getting exasperated. 'Look, my friend Marais knows your Frenchman well,' he said. I've told him about your interest. He says it'll be no problem to get an introduction for you next week. I'm sure that Jaurès will be happy to let you make your sketch in the offices of *L'Humanité*. They're just down the road from here, at number 142. What could be simpler?'

'I want to do the drawing without Jaurès knowing I'm doing it,' I persisted. 'It will be more authentic that way.'

This was pure invention. I had no intention of making any kind of drawing of Jaurès. I was alarmed at the ease with which the lies continued to trip off my tongue. But above all, I did want to be in the *Croissant* on Friday night. This meant I couldn't afford to have any journalistic distractions. Duncan simply stared at me, the wondering expression in his eyes soon changing to something like contempt.

'I can see I'm wasting my time here,' said Duncan. Without another word, or even without looking at me again, he rose from the table and stomped out of the café.

*

The tedium of pacing the network of streets around *Rue Montmartre* again, just as I'd done yesterday, was not something I felt equal to, so I picked up the *Rue du Louvre* instead and headed south. Surprisingly to me, I arrived at the broad River Seine quite quickly. The first bridge I came to, so a brass nameplate informed me, was *Pont Neuf*, which joined the left and right banks of the river via an island in its middle in a pleasing way.

I'd heard of *Pont Neuf*. It was famous for some reason, no doubt connected with the huge cathedral I could see at the other end of the small island. Still, I decided not to

cross the bridge but to wander leftwards along the river bank, something I could see a number of other people doing, usually as courting couples.

Although I was alone with so much on my mind, and only a short time before I had parted company unhappily with the only friend I'd made in years, all seemed oddly well with the world in the late-morning sunshine. I could hardly blame Duncan for acting as he did. After all, he knew me to be a former journalist. He had, from no other motive than generosity as far as I could see, given me the opportunity to take a share in what he saw as the story of a lifetime.

I walked for some distance along the river bank until I was directly opposite the Eiffel Tower, a magnificent steel structure built about twenty years before. Already it was famous throughout the world. It seemed to stand loftily above Paris for most of my walk. When I drew level with the structure, I felt at last I had truly visited this city.

This first part of my walk I enjoyed. It helped me to relax, even to begin to put aside thoughts of what had brought me here. But, retracing my steps, I was more and more reminded of the reason I had come to the city. Try as I might, I could not help but be aware that the happy, mid-week strollers I could see would, in a matter of days, be living under the dark clouds of war. By the time I was approaching *Pont Neuf* again, I was thoroughly depressed.

Jet had insisted that I, and only I, could make this war shorter and less painful to my world. Only I knew Jaurès was going to be killed on Friday evening, and only I could do anything to prevent it from happening.

It was now half-past-one, and I decided to have something to eat in sight of the river, before I walked back to the *Rue Montmartre*. I found a pleasant place called *Café Bailleul*, with plenty of open-air tables. It reminded me very much of the *Brasserie du Globe* in Calais. And I didn't have to suffer *omelette fromage* again. The man on the table next

to mine was eating a delicious-looking pancake, so when the waiter came up to me, I pointed to his plate in triumph.

'*Crêpes avec miel, Monsieur*?' he said.

I nodded eagerly. Now I knew how to order two dishes, as well as breakfast, in the French language. Duncan might have been proud a day or two ago. Now I felt sure he'd prefer not to hear my name again.

*

The *crêpes* were as delicious as they looked. Miel proved to be honey, which I'd loved since boyhood. Whilst it would be the grossest kind of exaggeration to say my spirits were restored as I walked back along *Rue de Rivoli* to get back to *Rue du Louvre*, at least the thought of the task before me and what it would mean to my world if I failed had slipped a little further back in my mind.

Coming towards me from the opposite direction was a woman wearing a striking purple dress and hat. She was not attractive in any way, in fact one would have to say she veered towards ugliness, even if she did have an oddly arresting appearance. Her lips were bright scarlet and she was wearing vast amounts of powder, especially around her slightly-hooked nose.

I confess I'd forgotten my manners, and was staring at her quite openly. When she drew nearly level with me, she stood stock still on the pavement, fixing me with a stern gaze and holding up three beringed fingers.

She was a prostitute, of course, and three francs was her fee. Three francs. The price of an *omelette fromage*.

I hurried on towards *Rue du Croissant*, but couldn't get the image of the hook-nosed woman out of my head.

Thursday, 30th July, 1914

That dream again! Last night was the third in a row I had awoken in the dark bedroom of the *pension*, lathered in sweat.

As before, it had started idyllically, with Mazod and me emerging into the sunlight from Holy Cross Church. All of Greenford seemed to be gathered to cheer the newly-married couple. Even the Rector, Edward Terry, was present and clapping politely. Mazod was smiling at everyone. I was entranced by the way her veil glided, in an almost ethereal way, as she turned her head from side-to-side to acknowledge the well-wishers. It was the happiest day of my life. I could hear myself whispering exactly those words, '*the happiest day of my life*'.

With scarcely a transition, as often happens in dreams, the two of us were climbing the stairs of Betham House. For some reason, a small crowd was still present. They were looking up from the bottom of the staircase, applauding more gently now. I was not in the least surprised to see my mother and father amongst them. Nor was I in any way perturbed to be able to see the whole scene, including my own back view, as we ascended the stairs. We moved with an unworldly dignity; as if our movements had slowed to a tenth of their normal speed.

I found myself beside Mazod on a huge bed, with soft pillows and rich yellow coverings. These were the exact hue of the dress she'd been wearing a few weeks ago. She looked at me, and I watched happily as her hands travelled down to her bosom to loosen the ribbons fastening the white silk nightdress she was already wearing. To spare her blushes, and I suppose my own, I moved my cheek gently to brush against hers. Strangely, I was unable to feel the sensation of soft skin I'd been so eagerly anticipating.

I snapped my head back. Instead of Mazod, I was looking down at Rosie in the bed, her head resting on the pillow. She was looking up at me, laughing, hardly able to contain her excitement and eagerness. Rosie pulled down the coverlet, revealing that she was quite naked. With a sudden movement, she crooked her arm about my neck and brought my face down against those flattish breasts. All was dark as my eyes closed, though once again I could feel nothing. When I blinked and raised my head, the huge form of Mollie, Duncan's girl from Dover, lay beneath me.

Then I felt a small hand shaking my shoulder. I looked up to see Mazod, once again clad in her wedding dress, complete with veil. She was standing there, looking aghast at what I was doing.

I leapt out of bed. My gaze was immediately caught by a row of chairs, ranged neatly along the wall. Their occupants, all women, were pointing and laughing at my nakedness. They were murmuring to each other and generally acting in a ribald manner. I say I could hear murmurs, though in fact all the women were talking loudly, filling the room with a uniform noise. In the general hubbub I could not distinguish any of their words.

Slowly, their faces came into focus. There was Rosie, Mollie, now transported across the room, the Frenchwoman in the purple dress, Vicky, Mrs Raven and even Theresa Hartson. I tried to cup my hands to cover my modesty. This made them nudge each other and point at me. At this point, I woke up.

*

What this dream meant was clear to me. It had been three weeks since I had known any release for the desires welling up inside. The physical pressure behind my eyes was almost painful now, however much I struggled to ignore it. It was of little use trying to tell myself I should have more

important things on my mind. The madman was straining on his chain again.

After I'd eaten breakfast, I tried to make plans for the vital day tomorrow, but my mind kept returning to grosser thoughts. At half-past-eleven, as I'd known all morning I would, I rose from my table at the *Café du Croissant* and retraced my steps of yesterday.

The woman recognised me as soon as she saw me on the *Rue du Louvre*. Her welcoming expression gave the illusion of making her fractionally more attractive, but it was no use trying to pretend she was any kind of beauty. She still wore the extravagant purple dress from yesterday, although now I could see it was grubby and unravelling at the hem. Her skin was sallow, even greasy.

All this I noted at a level below the conscious; I was really only aware of the three fingers she held aloft in triumph. I returned the three-fingered salute and she turned abruptly towards a side-turning called *Rue Berger*, giving me the briefest of half-smiles.

Then, from the corner of my eye, I saw someone whose presence pulled me up abruptly. It was Duncan Allen. At first I thought he was going to approach and speak to me. All he did was stand there, hands on his hips, regarding my actions with wry amusement.

For a moment, I thought of walking over and speaking to him. After all, he was right to think I'd acted unreasonably. He'd been immensely helpful to me. The woman looked back at me. She moved her hand across her hips provocatively, almost obscenely. I tried to turn away from her and make toward Duncan. But I'd lost him: he'd disappeared through the crowd. I tried to focus on the image of Mazod, as she'd appeared in my dream, so young and pure. It was no use. I hurried after the woman.

The woman's route led us through a maze of small streets. This was a much less attractive, even squalid, part of the city. There were gangs of small children, hostile-looking women and suspicious-eyed men everywhere. It was reminiscent of the East End of London, where I'd lodged as a journalist. I was keenly aware I was a stranger in a foreign city, and conscious of the dangers this might bring. The woman didn't look around to check whether I was following her. She kept on walking quickly.

When the prostitute reached a large house in a side-street that, if anything, seemed even grubbier than its fellows, she stopped and mounted some chipped stone steps. Still she did not turn in my direction, but left the peeling front door of the house ajar after going through it. I hesitated. My physical urges made me want to march straight up the steps and follow her but I couldn't forget this was a menacing part of an unknown city. What if there was a knife-wielding Parisian thug waiting on the other side of the door?

The desire within me kept me rooted to the spot and I hesitated for fully a minute. Then the door was peeped open a few inches, and the woman's face half-emerged from the darkness. At first she looked displeased, but when she saw me still standing there she smiled broadly. Then she tipped her head to one side, and held up three fingers again. She disappeared inside the house, leaving the door open more widely.

'Tommy, what are you doing in this part of Paris? I thought it was you I saw and had to run after you. I was just about to give up looking and go home.'

I turned around. It was John, standing quite alone. He was the last person I'd have expected to see in this foreign city.

'John? What are *you* doing here?' He looked so uncomfortable, as out of place as if he'd landed on the moon.

'I read your letter. Vicky said you must be in serious trouble to write a letter like that. So I've come to Paris to take you home. I've had the Devil's own job finding you, even with the help of the card you left in your shop. I was seasick on the boat, I don't mind telling you. So, come on. We can make the afternoon ferry still if we hurry back to the station now. I know the way, or at least I think I can find it again. It's called "Garnor" or something daft like that.'

'But you're sailing to America next Wednesday with Vicky and Hannah to start your new life!'

'That's five days away. There's something for me to do in my old life first. Anyway, I've put our sailing back for a fortnight. Cables between Charlie and me have been flying across the Atlantic. I've even got the buyer for the Smithy to hold off for a bit, even though the three of us will spend two nights in the Red Lion. Everything's arranged.'

'You shouldn't have done this for me!'

John looked down at the ground. Then he looked up at me and smiled.

'To tell you the truth I didn't do it all for you. The reason I'm standing here now is for you, yes. But the reason I've put the sailing back is different. I've been having conversations with Mr Perkin all this week. He's a man in the know. He tells me there's a lot going on the Continent and I want to wait to see what happens.'

'Archie Perkin!' I was incredulous.

'Don't say it like that, Tommy. Mr Perkin is a decent bloke. He tells me that Russia will soon be at war with Austria-Hungary and Germany. France may go in on the side of Russia.'

I felt cold when I heard John's words.

'And we'll be dragged into it,' I said.

'That's where you're wrong Tommy. There's a lot of feeling against fighting in a European war. We'll never get involved. But France isn't the place to be now. Come home with me. We've got time if we hurry.'

I looked at John, not knowing what to say.

'I – I can't John. There's something I have to do first. Everything's all right. I'll catch the boat on Saturday, I promise. As soon as I'm back in Greenford, I'll call around to the forge.'

'Tommy, come back with me now. What you have to do can't be all that important. Nothing can be. What is it, anyway?'

'It is important. Trust me. I'm sorry, John, I can't tell you what it is.'

John looked perplexed. He didn't understand. Did I?

'Maybe I could stay and help you? I could get the boat tomorrow.'

'No John. This is something I have to do alone. I can't do it until tomorrow evening. Go back to Vicky. She and Hannah need you.'

'And young Tommy.'

'Yes, And young Tommy. Don't forget him, no matter what happens.'

John didn't know what to say. What he did was step forward and shake my hand warmly. This was the first ever handshake we'd shared. Then, he turned his back and was soon out of sight.

I could hardly believe I'd seen my friend in this foreign city.

The Frenchwoman, obviously wondering what was the reason for my delay, had swung the door open again. She'd been watching my conversation with John.

My desire returned instantly. Then I thought again. Mazod might have been wrong about my reason for coming to Paris. But she hadn't been wrong about Rosie. And the stories she'd heard about my adventures in youth had been essentially true. Did my baser feelings mean I was now going to risk failing the world in the way I'd failed in my love for Mazod?

I shook my head. The woman shrugged her shoulders and closed the door.

*

Back on the *Rue du Louvre*, I was at a loss about how to fill in my time until tomorrow evening. This morning, I should have been in my shop in Greenford meeting Mr Trevithick to discuss my future in business. On Monday, I should have been at the *New Paragon*, watching *Kid Auto Races in Venice* with my good friend John. He hadn't so much as mentioned this when he and I had spoken an hour ago. Yesterday, I'd even been due to see Rosie. I wouldn't have gone to Hanwell if all hadn't gone so badly wrong with Mazod, I knew. Still, this final thought made me feel intensely sad as I surveyed the wreckage of my life.

I knew if I hadn't seen John I'd probably have used the services of the very lowest kind of whore; the very thing for which Mazod had assumed I'd come to Paris. Now I resolved to concentrate on the task ahead of me, seeking to redeem myself in my own eyes, if in those of no-one else. It would be best if I were not distracted by the Paris street cafés, so I decided to call in one of the many small shops I'd passed to buy a bottle of wine and a loaf. I could do this much by pointing. These I'd take up to my room in the *pension*, where I'd stay for the rest of the day so as to come up with a workable plan of what to do tomorrow.

There was an attractive shop on the street corner proclaiming itself to be the business of *Marcel Tresor, Epiciér*. I could see a large stack of loaves and a number of bottles close to the door, so went inside.

A beaming man in a neatly-starched apron, who I assumed to be Marcel Tresor, was the only person in the shop, so I walked up to him and pointed to a loaf.

'You are English, Monsieur? I speak the English very well. You want only the bread?'

'And a bottle of wine.'

'We have much of the wine in the shop. Want you an ordinary bottle of wine, or something that is better? We have the *Fitou* wine here. This one,' he said, proudly displaying an attractive looking bottle. 'Is just thirty francs.'

Thirty francs. Ten times the sum that the woman had wanted. I was to spend the rest of the day alone in my room, so I decided to treat myself.

'I'll take it,' I said.

Marcel Tresor's happy smile became a happier one. He quickly wrapped the bread, and then more carefully the bottle of wine, in tissue. The sight made me feel very pleased with my purchases. The afternoon before me now seemed a more pleasant prospect. I reached inside the pocket of my jacket to pull out my wallet. Monsieur Tresor beamed and held out the wine.

It seemed a long walk back to the *pension*. For the entire journey my mind was filled with anticipation of the crusty loaf and the bottle of *Fitou* that I carried. These would make the next thirty-six hours bearable.

Friday, 31st July, 1914

Today was the day to decide not only my own future but the fate of my world.

This thought should have been enough to make me wake in a state of high nervousness, but I'd slept well and awoke refreshed. The raucous sounds of the Paris streets outside my second-floor window did not rouse me until after nine o'clock. I reminded myself: the task before me was to prevent Raoul Villain from emptying his revolver into Jean Jaurès.

Strange to relate, I now felt calm. I could only do my best.

I'd spent my time since returning to the *Pension* considering carefully what I should do. The plan I'd settled on was very simple: I would leap on Villain as soon as he put a foot into the café. After all, thanks to the photograph I now knew what he looked like. I'd wrestle him to the ground – he was a slight individual, to go from the evidence in front of me – and shout at the top of my voice that Villain had a gun and was out to kill Jaurès. The politician could himself speak English, so Duncan had told me. He would surely heed my cries. Everyone in the café would understand the name of 'Jaurès', even if my French accent would be wayward.

Calmly and rationally, I reasoned that Villain might shoot me instead of Jaurès. This might be one explanation for the appearance of Jet Perkin in the place of Jet Green. No matter; my life would be a small enough price to pay if its ending could bequeath some sanity to the twentieth century. What would a life without Mazod be worth, anyway?

If I didn't die tonight, I'd go back to Greenford rather than try to lose myself in the anonymity of London. I'd then try to start rebuilding my life in the village. My optimism

about being able to do this was not high but I'd do my damnedest.

<div align="center">*</div>

At eight-thirty, as dusk was starting to fall, I walked into the *Café du Croissant*. The timing had to be right. My plan was to be in the café ahead of the murderer and his intended victim, but not so early that I might cloud my senses by drinking too much wine. One glass with my meal would be all I'd allow myself.

I found the café to be even busier than it was earlier in the week. I suppose this was because it was Friday night. I had to squeeze myself into a corner, rather than at the table where I'd formed the habit of sitting. Still, this seat gave me a better view of the whole restaurant. I'd be able to spot Jaurès and Villain as soon as they came through the door.

The waiter approached my table soon after I'd sat down.

'*Monsieur?*'

'*Omelette fromage* and a *coup de rouge,* please.'

With an ostentatious flourish, the waiter made some jottings on his pad. His eyebrows did a dance in barely-concealed amusement at my order. I should have asked for some *crêpes* for a change tonight, but didn't think fast enough. This might have wiped the smile from the waiter's face.

My first task was to study all the seated customers to make sure Raoul Villain wasn't already in the *Croissant*. No-one except me was unaccompanied. Nor was there anyone who looked like the photograph given to me by Duncan or who bore the haunted look he'd described. There was one man I did wonder about. He was thin and wore his hair in the style Duncan had described, though the locks themselves were dark in tint. He wasn't alone; a female companion sat

opposite him. The two of them were in some animated conversation. I'd have described the look in his eyes as 'intense' rather than 'haunted'. Provisionally, I concluded the two were lovers going through a stormy patch, rather than potential assassins. Jet Green had said nothing about a woman, anyway.

Jaurès himself wasn't yet in the café. I was surer of his appearance from the clear photograph in the book I'd bought from Mr Lamb. Anyway, I hadn't expected him to be here so early, going by Jet's brief words on the subject. He'd told me that, at nine-thirty, Villain "*will fire two shots at Jaurès and he'll be mortally wounded.*" How I wished now I'd had the sense to allow him to tell me more!

It was a sultry night, by far the steamiest I'd experienced all summer. Immediately after serving me, the waiter had gone over to draw the curtains across the open windows opposite, near the remaining empty table. The diners at the other tables wouldn't let him do this, presumably thinking uncovered windows would let more air circulate. If this was their reasoning, it was based on a forlorn hope. Not a breath of air blew from the Paris streets.

Then, at a quarter-to-nine o'clock, a group of three men trooped in. The last of these was unmistakably Jaurès. He looked exactly like the picture in *The New Europeans of the Left*, except perhaps a little older and more careworn. Even if I hadn't seen the photograph, I was sure I'd have recognised him, purely from Duncan's description. He did indeed look like a street porter, albeit a very unusual one, dressed as he was in a smart suit and with a piercingly intelligent light illuminating his eyes.

The other diners recognised the new arrivals. Greetings were exchanged. Even a few brief conversations held. I noticed some talking between Jaurès and the dark-haired man. The two were clearly friends. I was sure Jaurès wouldn't be close to a man who had links to the newspaper

Action Française. I dismissed my highly tentative identification of him as a possible murderer, firmly assigning him to his rightful category of intense lover. I kept a closer watch on the door: now I could be sure Raoul Villain had yet to arrive.

The waiter showed the three newcomers to the last vacant places in the *Café du Croissant*, those at the none-too-large table awkwardly wedged into the opposite corner from the one I occupied. He somehow also found room for a low screen. This he placed in front of the open window to give the men some semblance of privacy. Soon after this, four more men arrived. I tensed, ready to spring into action, but they proved to be more friends or colleagues of Jaurès: after one of them lifted a hand in greeting, the four went over to squeeze themselves around the corner table.

All seven ordered meals and drinks amidst much cheerful banter between themselves and the waiter. Now the place was almost entirely full; if Raoul Villain had arrived, he'd have found the only empty seat to be the one opposite me. But nobody else did come for nearly half-an-hour. The few people approaching the door went away when they saw how busy the *Croissant* was. Not one of them had any resemblance to Villain's photograph.

Shortly before nine-thirty, I saw the figure of a man outside the doorway. I could not see him properly; for some reason he was hanging back from entering, as if looking for someone inside. Every muscle I possessed grew taut. At last he stepped forward. I recognised him.

It wasn't Raoul Villain. It was Archie Perkin. He spotted me and walked across to my table. He was stony-faced, and sat down opposite me without waiting for an invitation.

'So you're here' he said, without any kind of preamble. 'Miss Betham told me I'd find you in this café. I located the place on a map, fortunately. If I had to, I'd have

searched in every one of the city's lowest kind of whorehouses to find you.

'And now you're waiting here for your young friend Jet from England, I suppose? Well, you won't be seeing him again. I sent him away with his tail between his legs.'

Seeing Archie Perkin in Paris was a shock. Was all of Greenford here? Hearing him say he'd met Jet – this could only mean Jet Perkin – was alarming. Somehow I regained my composure enough to reply.

'I'm waiting for a man called Raoul Villain,' I said. 'He's not my friend. Look, can't whatever this is about wait? It's something important I'm here to do.'

'No, it can't wait.' Archie Perkin was seething. My ill-chosen words only made him more furious. 'Raoul Villain you're calling him now, are you? He told me his name was "Jet". A ridiculous name. He even pretended he was some sort of relative of mine. The bare-faced cheek of the fellow! Why, he wanted me to go to Paris with him, no doubt for some disgusting purpose. All the time he was mumbling something about you. It didn't surprise me in the least to hear this from his lips. After I'd sent him packing, I saw the sign you'd put on your shop doorway - *"gone to Paris"* and some crude attempts at French. Gone to Paris to commit all manner of beastliness with this Jet or Raoul, or whatever name it is he's using now. That's what you should have said.'

'You don't understand -'

'Be silent! I'm the one who's talking! When I saw Mazod, she told me of your intention to go to Paris. She thought you were coming here for the whores, as I did at first. So, as soon as I came back from Harrow, I went down to your shop to have it out with you. That's when I discovered the even more sickening truth from your young friend and the note. You'd already left. You really wanted him to follow you to this city of iniquity, didn't you? Poor

Mazod! It was then I decided to find you here and teach you a lesson! Step outside this instant!'

Archie Perkin's voice was rising in volume and there was spittle falling from his mouth. Some of the other customers were beginning to look at the angry exchange between two Englishmen. I looked at the clock on the wall. It was nearly twenty-five minutes to ten. Raoul Villain should be here by now.

'Fifteen minutes,' I whispered in as low a voice as I could manage. 'Give me fifteen minutes and I'll do anything you want.'

'Don't try your lewd suggestions with me,' he shouted. 'Outside! Now!'

I tried to think rationally. It would be no use trying to remain seated at the table. Archie Perkin might be under the wildest kind of misapprehension but he was genuinely angry. If I stayed close to the entrance while we spoke, I might be able to reason with him, at least for a few minutes. I'd still be able to stop Raoul Villain coming in to the café.

I stood up, and went to stand by the door. There could be no time to waste. Archie followed me.

'Let me try to explain,' I said. 'It's not at all what you–'

'Defend yourself. I'm going to give you the only kind of lesson your kind understands. A boxing lesson!'

At that moment, I saw out of the corner of my eye a man hesitating outside. I could see without doubt this was Raoul Villain. When he saw two Englishmen in confrontation, he changed his mind about entering, and instead slunk away down the *Rue Montmartre* side of the restaurant. For a moment, I wondered if Archie Perkin and I had changed history in this odd way. I didn't have time to

ponder the thought. Archie was all but dancing up and down with rage.

'This is ridiculous,' I tried to say. 'I –'

I didn't see the punch coming. It was a terrific blow. It must have made me lose consciousness for a second or two. The next thing I knew, I found myself struggling groggily to a seated position against the outside wall, looking up in a daze at Archie Perkin's receding back. He was striding off down *Rue du Croissant*, happy in the knowledge of a job well done.

Then, from the opposite direction, only a short way down *Rue Montmartre*, at the edge of my vision I saw two flashes and heard two gunshots. Villain had fired his pistol through the open window. From inside the *Café du Croissant* there came a woman's scream. Immediately following this there was a clamour of confusion. Events were unfolding as in a nightmare. One voice, I think that of the same woman who had screamed, shrilled above the rest:

'*Ils ont tué Jaurès! Ils ont tué Jaurès!*'

Raoul Villain stood, seemingly bemused by his own actions, on the pavement outside the café window. He looked dazedly at the gun his hand and made no movement as a man tumbled out of the doorway near where I was still sitting. I recognised him as one of those who had been sharing a table with Jaurès. Without hesitation, he felled Villain with a clean blow from the bottle he was carrying. The murderer made not even a token show of resistance.

More men and women emerged from the restaurant, all shouting incomprehensibly. The scene became very confused. Two French policemen in their pillbox hats ran up to the fray. This was quickly enlarged with many passers-by. Soon there was a scrum of excited people around the now-invisible figure of Villain.

All of this time I had remained in my seated position by the doorway. A few people on the street had shown a passing interest in my brief bout of fisticuffs with Archie Perkin. Their attention had been diverted by the shooting. I didn't want to get any more mixed up in this. Least of all did I want anyone to associate me with Villain so struggled to my feet and slunk off in the same direction taken by Archie Perkin only minutes earlier.

I'd failed; I hadn't changed history. In a few years John Jakes and Archie Perkin would be dead. My son, Trevor, would be killed when he was not much above a youth in the war following this one. These two wars and the other things Jet Green had told me would scar the face of the twentieth century. They would leave their mark on the twenty-first century, too.

But perhaps, after all, I had changed history. I had erected a mental barrier against an awful thought. When Jet Perkin came to Greenford in place of Jet Green, I now realised this could mean Jet Perkin was descendant of Mazod Betham as well as Archie Perkin. Trevor and Bertie would be *his* sons, not mine. My own life might be quite different and even worse than the one Jet had outlined for me.

Would this be the way things would be? Had I proven Jet's father's theory of 'the elasticity of time' and his other grand pronouncements to be wrong in a way that could only bring me pain? Was I, even now, on one of these mysterious 'time nodes' Jet had talked about? Everything might depend on what I did next.

I forced myself to consider having no children with Mazod. My future seemed to be brutally mapped out before me, or at least it would be until the 'psi-program' did its work at midnight. Then I'd wonder what I was doing in Paris. I'd return home to be a soldier in the terrible war. In 1917 I'd become an inmate of Hanwell Asylum. Would I be in Hanwell for a matter of years, or for the rest of my life?

Starkly, what was surely the final truth opened up to me. It would all depend on Mazod. What was it that Jet Green had said? *'It's thanks to the support you'll get from Mazod Betham that you'll make a recovery. Otherwise you might have been forgotten within the walls of a mental hospital until you died.'*

This was one more reason for me to get back as quickly as I could. But there didn't need to be another reason. I knew I had to return to Greenford and try to win Mazod back.

Recently by Tom East:

The Eve of St Eligius

The Greenland Party

Coming Soon:

Scenes from Seasons

44056153R00197

Printed in Poland
by Amazon Fulfillment
Poland Sp. z o.o., Wrocław